World of Art

Anne Massey graduated in the History of Modern Art and Design at the University of Northumbria in 1980, and gained her doctorate there in 1984 with research on the Independent Group and post-war British culture. She has written extensively on the history of art and design, and her books include *The Independent Group: Modernism and Mass Culture in Britain, 1945–59* (1996); *Hollywood Beyond the Screen: Design and Material Culture* (2000); *Chair* (2011); *ICA 1946–68* (2014); *Dorothy Morland: Making ICA History* (2020) and *Designing Liners: Interior Design Afloat* (2021). Her co-edited books include *Pop Art and Design* (2017) and *Design History & Time: New Temporalities in a Digital Age* (2019). She also edited *The Blackwell Companion to Contemporary Design (Since 1945)* (2019) and is the author of *Interior Design Since 1900* in the World of Art series.

D1614598

1 Althea McNish in the Bachelor Girls Room at the 'Ideal Home Exhibition', London, 1966

World of Art

Women in Design
Anne Massey

To my mother, Gwen Carr (1935–2021)

First published in 2022 in the United Kingdom
by Thames & Hudson Ltd, 181A High Holborn,
London WC1V 7QX

www.thamesandhudson.com

First published in 2022 in the United States
of America by Thames & Hudson Inc.,
500 Fifth Avenue, New York, New York 10110

www.thamesandhudsonusa.com

Women in Design © 2022 Thames & Hudson Ltd, London
Text © 2022 Anne Massey

Art direction and series design by Kummer & Herrman
Layout by Samuel Clark www.bytheskydesign.com

British Library Cataloguing-in-Publication Data
A catalogue record for this book is available from
the British Library

Library of Congress Control Number 2022931472

ISBN 978-0-500-20482-5

Printed and bound in Hong Kong by Asia Pacific Offset

MIX
Paper from
responsible sources
FSC® C136333
FSC www.fsc.org

Contents

Introduction

Women in Design shines a light on the long-overlooked contribution of women to the history of design. This addition to the World of Art series highlights the pivotal role played by women in the story of modern design, making the invisible visible. For too long this story has been told from the point of view of male protagonists, forming a patrilineage of lone designer heroes. The succession of celebrity designers stretching from William Morris to Walter Gropius, based on the work of Nikolaus Pevsner in *Pioneers of Modern Design* (1936), now needs realigning. Now is the time to look afresh and include women in a new narrative, and not only as singular creative geniuses or heroines of design. *Women in Design* takes a more inclusive view of the history of design, looking at *both/and*, not *either/or*. The solo designer is included, drawing on the growing literature on women in design that foregrounds biographical accounts of the individual. But work that is the result of a joint endeavour, whether as part of a designer couple or a studio-based team, is also included.

The organizing concept for the book is the pioneering professionalization of women in the world of design. *Women in Design* looks at the story of women's contribution to the design process in relation to the considerable barriers to entry. At the start of the Victorian era in Britain, married women could not own property in their own right. Women did not have the right to vote or hold government positions. An all-pervading ideology placed women in the home, and the most that many could aspire to creatively and educationally was in the field of amateur handicrafts. Design education and training was barred

2 May Morris, wall hangings for Melsetter House, Orkney, 1900. The linen hangings were commissioned by Theodosia Middlemore for the home she shared with her husband, and embroidered by Morris in naturally dyed wool with help from her client.

to many women until well into the twentieth century, as was professional membership of and recognition from professional design organizations. The ways in which women squared up to these challenges and overcame them is the subject of the first chapter.

Even when women managed to gain entry to the world of design, their work was frequently uncredited or credited to a man instead, and they were paid less than their male counterparts. Women working behind the scenes is the theme for Chapter Two, which makes the invisible work of women at the Atelier Martine, the Omega Workshops and Monotype Corporation, among others, visible. Women also contributed extensively to the development of modern design, from the Bauhaus to Eileen Gray's design for her own house. Chapter Three unearths and elucidates the untold story of the female pioneers of modern design. The history of design has been so predicated on the male designer as 'hero', celebrating one model of what is perceived as 'good design', that work which is more discursive and decorative is often not included in standard accounts. Modernism, which purported to be eternal and everlasting, was anti-fashion and largely patriarchal, traits reinforced by subsequent histories. The key architect of this modern Darwinism was Le Corbusier, who ridiculed the cheap taste of 'shop girls' for ornament in his book *The Decorative Arts Today* (1925), as a reaction to the *Paris Exposition des Arts Décoratifs et Industriels*. In a highly racialized and sexist statement he described 'Decoration: baubles, charming entertainment for a savage.... But in the twentieth century our powers of judgment have developed greatly and we have raised our level of consciousness. Our spiritual needs are different, and higher worlds than those of decoration offer us commensurate experience. It seems justified to affirm: the more cultivated a people becomes, the more decoration disappears.' Women were identified with decoration, with 'savages' and a lower order of design in the view of Le Corbusier and subsequent modern architects and writers.

Chapter Four considers the women who made a virtue out of necessity, who worked within and were successful across the decorative arts and interior decoration, occupying the gaps between architecture and fashion. Women achieved more success in the brave new world of modern design following the Second World War and subsequent period of decolonization, which is covered in Chapter Five. Professional success was also earned by women working in the era's burgeoning field of branding and corporate identity, with a minority of women gaining entry to the Art Directors Club

(ADC)'s Hall of Fame, which is covered in Chapter Six. Design activism, whereby women have used design to critique existing power structures, has worked to problematize this type of commercial culture, and is the subject of the final chapter. Starting with second wave feminism, design has been an essential part of protest and insurrection. The reclamation of history is an important part of this; Design History emerged as a discipline in the 1970s, and included a feminist agenda from the beginning. There has also been a growing impetus to study the contribution of women to the history of architecture and environmental design, and the history of art has also incorporated a feminist agenda since the 1970s. These areas are all overlapping and have informed the research for this book. *Women in Design* relies heavily on the work of others researching in the field, and I am particularly indebted to design historians Judy Attfield, Cheryl Buckley, Zoe Hendon, Pat Kirkham, Jasmine Rault, Libby Sellers and Penny Sparke. The architectural historians Elizabeth Darling and Lynne Walker have produced key works that this book draws upon, as have the art historians Whitney Chadwick and Griselda Pollock.

Women in Design is broad in its approach, and includes architecture, fashion design, graphics, interior and product design. I have included practitioners who are representative of particular fields or themes, and it has not been possible to include absolutely everyone, which goes to show what a rich vein the history of women in design is. *Women in Design* is structured chronologically, but also thematically, building on the monographic approach to history but augmenting this to reflect the team nature of design production. This is mapped out against a background of political events, socio-economic trends and globalization.

There continues to be a gender imbalance in both the design workplace and design education. Design Council figures from 2018 for the UK reveal that whilst sixty-three per cent of those studying design and creative arts subjects at university are female, seventy-eight per cent of the design workforce is male. Only sixteen per cent of Creative Directors are women and the lack of women in senior positions contributes to a gender pay gap. In the USA, the figures are similar, and until 2018 in some parts of the world women couldn't even hold a driving licence, let alone work as a professional designer. The focus of *Women in Design* is celebratory and will hopefully help to pave the way for more successes in the future, to encourage more women into design.

Chapter One
Shifting Barriers

Design was visibly aimed at women from the beginning. Advertising and the growth of shopping in luxury department stores placed women at the centre of a new consumer culture in the nineteenth and early twentieth centuries.

However, the professional design of buildings, adverts and products was predominately the work of men. Many working-class women were employed in factories owned by men, producing the textiles, fashion items and other consumer goods that were predominately designed by men. Women could be surrounded by available consumer goods, but they had little power over their marketing, function or design. This lack of agency was due to three main barriers that prevented women from entering the design profession. The first was ideological: the expectation in a patriarchal society was that women's main purpose in life was to marry, care for their husband and home and have children. The second barrier, reinforcing this ideology, was structural: most jurisdictions did not allow married women to own and control their own property until later in the nineteenth century. In the UK, the Married Women's Property Act was passed in 1970. The third was educational: women did not have access to the same training and education as men. Even radical movements such as Arts and Crafts excluded female designers from their key organizations. This chapter outlines the many challenges faced and overcome by an elite group of women in design at the start of the last century. This is charted in terms of education, creative success and

3 Alphonse Mucha, poster for the French publisher F. Champenois, Paris, 1898. This colour lithograph of a glamorous woman in artistic dress with a magazine on her lap was used to advertise the company, and typifies the association of women with consumerism.

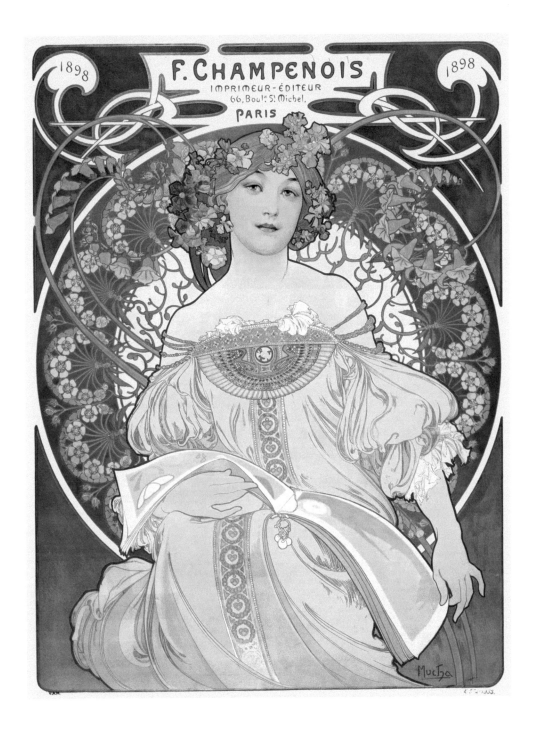

Shifting Barriers

women moving beyond the restrictions of the domestic sphere and patriarchal attitudes. From the first wave of feminism, pioneered by the suffragettes, women eventually succeeded in gaining the right to vote, the right to a design education and access to the design profession. Who were the female firsts in the design profession and what did they achieve?

As Caroline Criado Perez demonstrates in *Invisible Women* (2019), the professional world of design was founded for and by men. The professional identity of the designer was, in the nineteenth century, male by default. Professional structures and educational opportunities were constructed for the male participant; women were not factored into the design system. Design education, starting with the first UK School of Design, founded by the British government in 1837, was for the male student, as were schools of architecture and the apprenticeship system. Trade bodies were a men-only preserve from the very beginning. Women had to make their case to be included and accepted as exceptions to the rule, one by one. These same design structures also formed an important part of the colonization of other nations, and, as shown in the design and building of the Crystal Palace for the Great Exhibition of 1851, aimed to place Britain at the centre of a global empire through design.

During the nineteenth century, middle-class women were associated with delicate hand-work that could be achieved strictly at home, as amateurs. This included needlework, painting ceramics, lacemaking, jewelry, illustration and bookbinding (only of a kind that did not require a specialist studio). By pursuing these areas of skill, women could ensure their respectability by working alone from home. Work undertaken beyond the domestic sphere by those who had less access to these genteel pastimes, generally working-class women and women of colour, was regarded as less feminine. This ideology around the appropriateness of feminine pursuits runs through the history of women in design.

In Japan, the gendered concept of *Shugei*, handicrafts, meant that handwork was often undertaken by genteel women in the home for little or no monetary reward. This was encouraged through popular magazines, advice manuals and education in the late nineteenth and early twentieth centuries, following the opening-up of trade between Japan and the West. Subjects such as embroidery were taught to girls in elementary schools, and specialist colleges were founded, including the Tōyō Women's Crafts School in the late nineteenth century. The curriculum was aimed at self-improvement rather than workplace skills, and included sewing and flower-arranging as well as logic,

English, science and calligraphy. The division of amateur and professional was cleaved along the lines of gender, making it difficult to enter the professional world of design.

A similar situation prevailed in the UK from the nineteenth century onwards, during which time there was an official drive to improve the standard of professional design and public taste. As part of this drive, the Government Schools of Design were founded in 1837. The purpose of the schools was, according to Henry Cole (1808–82), who oversaw them from 1852 to 1873, to introduce an 'ABC of design'. The first was established in London, followed by twenty of the UK's leading cities. Taking inspiration from German technical education, the programme was concentrated on geometric drawing and workshop processes, and directed at a career in industry for young men. The Female School of Design was founded in London in 1842, five years later. But much like crafts education for women in Japan, the Female School of Design concentrated on painting flowers and embroidery for its middle-class female students, aged between thirteen and thirty. It was situated downstairs from the School of Design in Somerset House and run by the painter Fanny McIan (c. 1811–97), with sixty students in the first year. The school moved to Gower Street in 1852 and in 1857 McIan was made redundant by Cole, as he sought overall control of the network of twenty-one government design schools. By this point, she had been elected an Honorary Member of the Royal Scottish Academy in recognition of her painting prowess. The Female School of Design was then moved around the corner to Queen's Square in 1861. The school shared premises with the Central School of Art and Design from 1908 and merged in 1913 with separate provision for female students. This pattern of gender division in technical education was common throughout Europe, and in most of the German Länder, for example, where women were also barred from a technical education.

With these barriers in place, instances of women gaining professional status in the field of design in this period are rare. Two early examples are the interior decorators Agnes (1845–1935) and Rhoda Garrett (1841–82). The cousins established a reputation for themselves as fashionable decorators and furniture designers for the burgeoning Victorian middle class. They were the first British women to serve apprenticeships in an architectural office, that of John McKean Brydon, who was a staunch supporter of the Queen Anne Revival style. The Garretts shared this enthusiasm and launched a successful decorating firm from a headquarters in Bloomsbury, London in 1874 as 'A and R Garrett House Decorators'. The pair designed

furniture in the Queen Anne Revival style, examples of which can be viewed at Standen in West Sussex, now owned by the National Trust.

The Garretts always asserted their professional identity as decorators, likening their trade to that of a medical doctor. This was inspired by the success of Agnes's older sister, Elizabeth Garrett, who battled to become the first female qualified physician and surgeon in Britain. Indeed, Agnes and Rhoda designed the interiors of the home Elizabeth shared with her husband, the ship-owner James Skelton Anderson. Agnes's younger sister Millicent Garrett Fawcett (1847–1929) was the leader of the National Union of Women's Suffrage Societies (NUWSS), founded in 1897, and the elder two Garretts were also active in the campaign for women's right to vote.

The Garretts also succeeded as authors of a popular home-decorating advice manual, *Suggestions for House Decoration in Painting, Woodwork and Furniture* (1876), part of the 'Art at Home' series of twelve volumes published by Macmillan in Great Britain and Porter & Coates in the USA between 1876 and 1883.

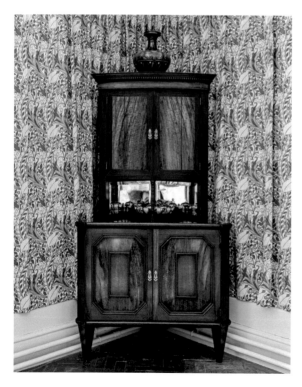

4 Agnes and Rhoda Garrett, mahogany corner cupboard decorated with mirrors and brass, bought by the Beales for their London home in the 1880s and now on display at Standen.

5 Agnes and Rhoda Garrett, *Suggestions for House Decoration in Painting, Woodwork and Furniture* (1876). This household design advice book was the second of the Art at Home series to be published, aimed at a middle-class clientele.

The Garretts' book asserted their own professional status and was respectful of the taste of middle-class Victorian women, which was so often derided by writers and designers such as Charles Locke Eastlake and Christopher Dresser. The Garretts are an early example of women challenging the patriarchal status quo as professional designers, at a time when entry to the Royal Institute of British Architects (RIBA) was impossible for women. The reasons given for this included the inability to climb ladders onsite in long skirts and the lack of female facilities in architects' offices. Women were eventually admitted to the RIBA in 1898, when Ethel Charles (1871–1962) sat and passed the exams, although her entry was not without controversy. Architects at that time served an apprenticeship at a professional practice before being able to register, and such opportunities were few and far between for women. The Architectural Association in London was founded in 1847, but did not allow women entry until 1917.

In America, the situation with the American Institute of Architects (AIA) was similar. The AIA appointed its first female fellow, Louise Blanchard Bethune (1856–1913), in 1888. Very

6 Louise Blanchard Bethune (Bethune, Bethune & Fuchs), *Lafayette Hotel*, Buffalo, NY, 1904. A watercolour rendering of this imposing building, designed by America's first female professional architect. The hotel is steel-framed with a concrete structure, decorated with red brick and semi-glazed white terracotta facing.

much the professional architect, she had established her own practice in 1881 in Buffalo and, when she married a fellow architect, Robert Bethune, the firm of Bethune and Bethune was created. Ten years later the firm's draughtsman was added and the name was altered to Bethune, Bethune & Fuchs. This was a boom time for new building in Buffalo and the firm was responsible for the design of schools and other public buildings. Blanchard Bethune did consider the opportunity to make her work more widely known, by entering a design into the women-only competition to create the Woman's Building at the World's Columbian Exposition in Chicago in 1893, but decided not to submit an entry because women were only paid ten per cent of the fees awarded to their male counterparts. Her most successful commercial design was the Hotel Lafayette in 1904, a seven-storey, 225-room building in Renaissance Revival style occupying a prominent corner plot and fully restored in 2021.

6

The competition to design the Woman's Building was won by a young Massachusetts Institute of Technology (MIT) architectural graduate, Sophia Gregoria Hayden (1868–1953), the first woman to complete the degree there. Hayden had never worked on a live project before, and struggled with impossible deadlines and ridicule in the press. The design was based on an Italianate structure for a fine art museum, created for her final thesis. The three-storey edifice looked out onto the lake, with balconies and a flat roof. The contents of the building were eclectic, from laundry appliances to embroidery, weaving to photography and painting. The American designer Candace Wheeler was appointed Director of Colour for the building, as well as designing the library and acquiring exhibits.

The library contained books written by women, and Wheeler decided to decorate it with dark wood panelling, blue and green curtains and a painted ceiling. Wheeler had visited the earlier, Centennial Exposition of 1876, the first World's Fair to be held

7 Sophia Gregoria Hayden, interior of the Woman's Building, World's Columbian Exposition, Chicago, 1893. This photograph shows a panoramic view of the interior taken from the balcony, looking down on to the central exhibition space of the rotunda.

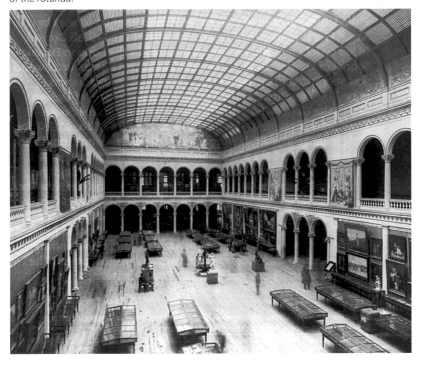

in the USA. Although there was a separate Women's Pavilion, she was particularly struck by the pavilion that displayed the work produced by the newly established British Royal School of Needlework, which had hangings designed by William Morris, Edward Burne-Jones and Walter Crane and executed by women at the School. Inspired by this example, Wheeler then succeeded in gathering together a group of New York-based philanthropists to found the New York Society of Decorative Art in 1877 to support female professional designers. Wheeler also founded L. C. Tiffany and Associated Artists with Louis Comfort Tiffany, the son of the founder of Tiffany & Co., along with artist, decorator and collector of Southeast Asian art Samuel Colman and Lockwood de Forest, a woodwork specialist. Wheeler was responsible for a particular form of textile decoration that replicated painting, and her work included a stage curtain for the new Madison Square Theatre and a hand-worked tapestry for the Woman's Building, based on a Raphael cartoon she had seen at the Victoria and Albert Museum in London. The achievements of the Woman's Building acted as a fitting moment for Wheeler to retire from her life as a leading figure in the world of design, having paved the way for women in design.

By 1893, there were more possibilities on offer in terms of design education for women in the USA. The first was the Philadelphia School of Design for Women, set up in 1848 by Sarah Worthington (née Peter), the wife of the British Consul, in her own home, and very much inspired by the London Female School of Design. In 1856, the Scottish-born Thomas Braidwood was appointed principal of the school, and in 1858 he was joined by a graduate of the London Female School of Design, Mary Jane Greig, who brought the curriculum of the South Kensington system to the US. In 1862, Elizabeth Croasdale (1830-1886) joined the staff, having studied at the co-educational York School of Art and then at the Royal Kensington School of Art. Other schools opened after that, including the New England School of Design for Women in Boston in 1851 and the New York School of Design for Women in 1852, founded by Susan Carter, which eventually became part of the Cooper Institute. In 1892, Ellen Dunlap Hopkins founded the New York School of Applied Design for Women, which taught architecture, bookbinding, interior design and illustration to working-class women. The school eventually merged with the Pratt Institute in 1974.

8 Bertha M. Boyé, *Votes for Women*, 1913. This lithographic poster depicts a woman with agency, holding the campaign banner for female emancipation that was displayed in shop windows throughout San Francisco, which helped white women in California win the right to vote that same year.

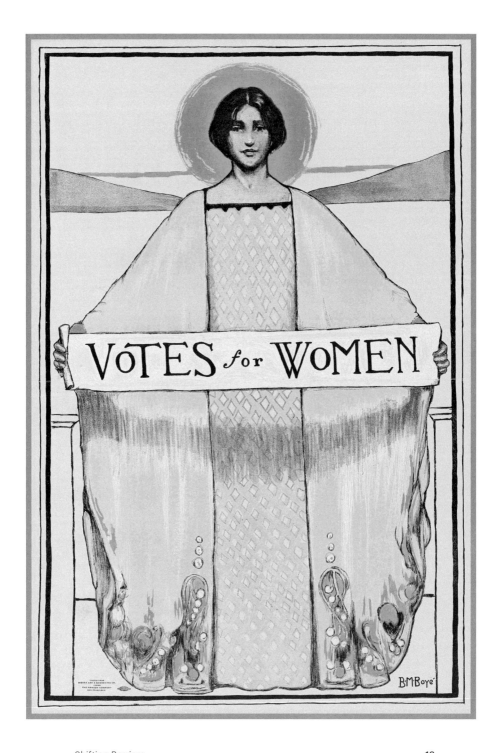

Elizabeth Croasdale's studies at The Royal Kensington School of Art, then renamed the Normal School of Design and newly moved to South Kensington under the direction of Henry Cole, had earned her the Art Master's Certificate, the main offer at this co-educational institution, which enabled graduates to teach art and design in schools. The school was renamed the Royal College of Art (RCA) in 1896, and began to offer art and design courses rather than just teaching qualifications. The suffragette Sylvia Pankhurst studied Decorative Painting at the RCA from 1904 to 1906, but left before qualifying due to the patriarchal attitudes she encountered there. She set up her home as the West London base for the radical Women's Social and Political Union (WSPU), founded by her sister Emmeline Pankhurst in 1903, and designed its logo, the Angel of Freedom mascot in the familiar green, purple and white used by the movement. Green symbolized hope, purple dignity and white purity. The suffragettes supported radical interventions in their activism, and were jailed and force-fed as a result of their activities. Design played a part in this, as Sylvia Pankhurst created a striking brooch to mark the endurance of the imprisoned suffragettes, awarded to those who had been imprisoned at Holloway. It is a tiny, silver object, square in shape and based on the portcullis, decorated with a convict's arrow coloured

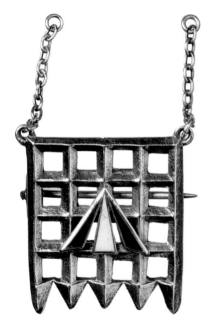

9 Sylvia Pankhurst, Holloway Brooch, 1909. This silver and enamel badge was presented to women by the WSPU upon their release from prison. The portcullis represents the House of Commons, and the suffragette colours of purple, green and white decorate the convict's arrow.

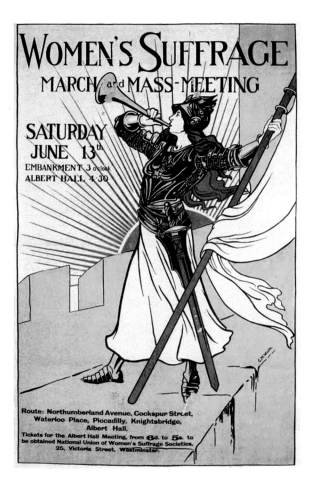

10 Caroline Marsh Watts, *The Bugler Girl,* 1908. This poster was created for a march for the right to vote held in London in 1908 and attended by over 10,000 women. The striking image was used on a multitude of suffragette publications on both sides of the Atlantic.

in purple, green and white and with convict's chains on either side. This was a badge of honour among the suffragettes who had suffered for their cause by serving time in prison, demonstrating the power of design to represent activist ideals.

Partial victory in the UK came for women who met a property-owning criterion and were over thirty in 1918, when women also gained the right to stand for Parliament. Suffrage for all women over twenty-one followed in 1928. In the US, some women gained the vote in 1930, but millions of Black women were still excluded from voting. The majority of African American women in the South, like their male counterparts, were blocked from voting by various means, and Native Americans and Asian immigrants were largely excluded from citizenship entirely in this period.

11 LEFT The English designer and writer May Morris, wearing the loose, medieval artistic dress of the Arts & Crafts movement. This image was used on the cover of the pamphlet for her successful lecture tour of the USA, undertaken during 1909–10.

12 OPPOSITE May Morris, *Honeysuckle* wallpaper, 1883. This subtly coloured pattern was block-printed in distemper on paper and was part of the Morris & Co. pattern book. Morris designed three wallpapers for the firm; this one, which is still available today, was the most popular.

The collaborative activity that characterizes professional design can serve to hide the contributions of women in subsequent accounts. Approaches to documenting design tend to rely on reinforcing the creative, individual-genius model of history, and in identifying and accounting for individual women this book serves to insert named designers into history. However, this approach also needs to be critiqued and supplemented. After all, part of the issue with accounting for women in design is that their work is subsumed by the trope of the male 'hero designer'. The success of women in design has also benefited from group working, offering a level of support and sources of knowledge and confidence that also need to be included. For example, the Women's Guild of Arts, founded in 1907 in London, acted as a rallying point for female design practitioners and was one of the first, if not the first, such organization. The collective was established because the prestigious Art Workers Guild, founded in 1884, did not admit

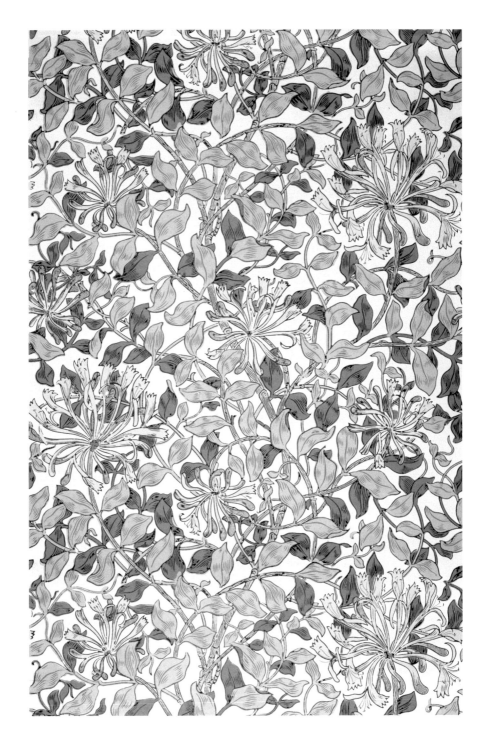

Shifting Barriers

women as members under its rules of governance. The Art Workers Guild was a semi-clandestine organization, set up by young architects working for Richard Norman Shaw. It was modelled on a medieval ideal of a craft guild, with Masters and Brothers responsible for the reintroduction of and support for traditional methods of design and making by hand, which were threatened by industrialization. The Guild was highly selective and exclusive, giving entry to a powerful network of male designers working in the Arts and Crafts style.

Mary 'May' Morris (1862–1938) was one of the leading lights of the Women's Guild of Arts. She had been taught embroidery by her mother, Jane Morris, and her aunt, Elizabeth (Bessie) Burden, who had themselves been taught to embroider by May's father, one of the founders of the British Arts and Crafts movement, William Morris. May idolized her father throughout her life, and privileged his work over her own, which perhaps explains her frequent invisibility in histories of the Arts and Crafts movement. May Morris studied embroidery at the National Art Training School (now the Royal College of Art). She eventually took over the management of Morris & Co.'s embroidery workshop in 1885, an unusual move at a time when women were not expected to play an active part in design or commerce. Her own embroidery work shows skills with pattern and the depiction of natural forms using traditional methods. She also designed wallpaper, jewelry, books and clothing. Her 'Honeysuckle' wallpaper design of 1883, one of Morris & Co.'s bestsellers, is frequently attributed to William Morris. The wallpaper is covered with a repeat pattern of delicate honeysuckle flowers and foliage, in pale yellow, green and brown on a buff background. May Morris also undertook a lecture tour of America and published a book, *Decorative Needlework*, in 1910. She left Morris & Co. when her father died and devoted her time to maintaining his legacy by editing the twenty-four volume *Collected Works* (1910–15). She also set up a workshop and taught embroidery.

Other embroiderers involved with the foundation of the Women's Guild of Arts include Mary Thackeray Turner (1854–1907) and Grace Christie (1872–1953); other members included the calligrapher Florence Kate Kingsford (1871–1949) and the gilder Mary Batten (1874–1932). Entry to the Guild was controlled by presenting work to existing members and then voted on. The membership numbered around sixty at any one time, and it was largely London-based, although membership from further afield was encouraged through a reduced membership fee. The weaver Annie Garnett (1864–1942) joined from her base in the Lake District, for example. The Guild formed an

important support mechanism for women, with meetings 'At Home', lectures and craft demonstrations. The Guild eventually outlived its purpose by the 1930s and ceased to meet, although the Art Workers Guild itself did not admit women until 1972.

In Scotland, an important point of contact for the development and support of women in design was the Glasgow School of Art. Founded in 1845 as one of the first Government Schools of Design, it began as a training college to promote good design for industry along the usual default male lines. But in 1885 a new Headmaster, Francis 'Fra' Newbery (1855–1946), was appointed and began to support and further the interests of women. When he took up his post there were no female members of staff, but by 1910, one-third of the staff were women, a high proportion for that time. Female students studied the same courses as their male counterparts, with the exception of life drawing, which was undertaken from plaster casts. When the School of Architecture opened in 1904, places were open to women. The Applied Design course was a popular choice for women, who saw a professional future in repoussé metalwork, art needlework, bookbinding, illustration, stained glass, china painting and silversmithing. Margaret Gilmour (1860–1942) and her sister Mary Gilmour (1872–1938) succeeded in establishing a studio, and produced Art Nouveau objects with a Celtic twist to a high standard. At a later date, the skills of mosaics, enamelling and gesso were added to the course.

13

13 Margaret Gilmour, repoussé brass and enamel alms dish. Exhibited at the Glasgow International Exhibition, 1901. Specially crafted for this important event, with skilful handwork drawing on Celtic imagery, the dish was inlaid with contrasting blue enamel by this early design entrepreneur.

14 Jessie King, central panel for a walnut-veneer folding screen designed by George Logan, 1901. The image shows three ethereal girls, with long, flowing hair and gowns to match, dancing. The decoration is enhanced with the addition of silver, mother-of-pearl, turquoise, red amethyst and white stones.

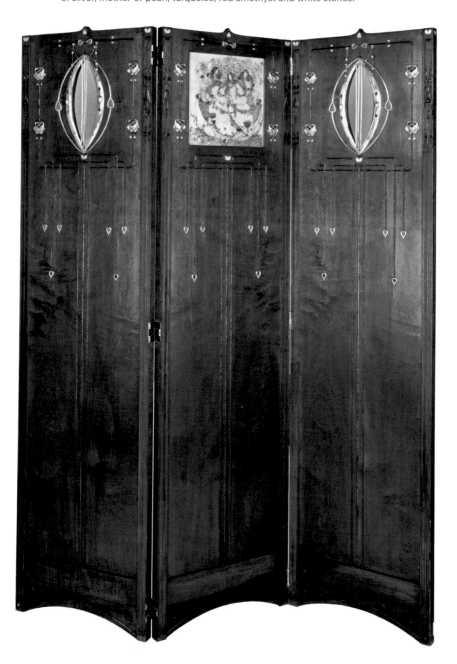

15 Jessie Newbery, cushion cover, embroidered linen with silks and linen appliqué, c. 1900. The stylized flowers typify the Glasgow School aesthetic, secured in Newbery's signature satin stitch. The Latin poem refers to time passing and the need to work every day.

Many of the women who studied at the Glasgow School of Art were subsequently offered teaching posts, building up the balance of female staff. Jessie King (1875–1949) graduated in 1899 and then taught bookbinding and ceramics for almost ten years. She also found professional success as a book illustrator, textile and jewelry designer, producing designs for Liberty's of London in an Art Nouveau style, with exquisite necklaces, brooches, buckles and rings made from silver, enamel and pearl, as well as wallpaper, textiles and a panel for a walnut screen. Jessie Newbery (1864–1948) was a *tour de force* at Glasgow School of Art and a staunch supporter of the suffragette cause. After completing her studies at the school, she taught and established the Embroidery department, where she exercised an open admissions policy, allowing access to classes for those from all walks of life. She used affordable materials and simple techniques such as appliqué to ensure that her students could reach a level of creative expression through handiwork, which was the aim of the Arts and Crafts movement. As the history of the Arts and Crafts remains a male-dominated narrative, with William Morris overshadowing the entire movement, it is vital that the contribution of designers such as Newbery are acknowledged. Her work was bold in outline, characterized by the geometric Glasgow rose in pastel colours.

Newbery retired in 1908, and was succeeded by her erstwhile student and assistant Ann Macbeth (1875–1948). Her conviction was the realization of the Arts and Crafts ideal: 'Beauty must come back to the useful arts and the distinction between

14

15

Shifting Barriers

fine and useful arts be forgotten.' She, like Newbery, was an avid supporter of the suffragettes and was herself imprisoned and force-fed for her activism. She designed objects for the Women's Social and Political Union (WSPU), among them the Holloway Prisoners' Banner, which were sewn in class by her students. This was originally designed as a friendship quilt in simple, bottle-green linen, with the signatures of eighty of the suffragette hunger strikers embroidered onto a separate piece of linen and then onto a buff background in a grid of four by twenty, framed by the traditional purple of the movement. The quilt was offered for sale by Macbeth at the WSPU Scottish Exhibition and Bazaar, held in Glasgow in 1910 to raise funds for the campaign. It was bought by one of the WSPU's leaders, Emmeline Pethick Lawrence. The quilt was then converted into a banner and paraded as part of the 'From Prison to Citizenship' procession in June 1910 in London. Macbeth was a successful educator, producing publications about teaching sewing in schools, including *Educational Needlecraft* with Margaret Swanson in 1911. She also undertook bookbinding work, metalwork and designs for large companies, for example Liberty's of London, the carpet manufacturers Alexander Morton and Co., Donald Bros. of Dundee, and Liberty's & Knox's Linen Thread Company.

As with the Arts and Crafts Movement, where William Morris has become the *de facto* sole representative, work undertaken in Glasgow at the turn of the last century is commonly understood under the heading of another male hero, Charles Rennie Mackintosh (1868–1928). Work by the women at the Glasgow School of Art and further afield has been overshadowed, if not obliterated or even ridiculed. As one piece of art criticism from 2018, titled 'Charles Rennie Mackintosh review, Walker Art Gallery – a timely tribute to the guru of Glasgow style' and reproduced on the Charles Rennie Mackintosh Society website states: 'There's a lot of good support material, though: card stencils used in decorating walls and furniture, beautiful architectural drawings by Mackintosh and a lot of twee embroidery.' As has been demonstrated, women at the Glasgow School of Art contributed and achieved a great deal that deserves greater acknowledgement.

Two of the leading female practitioners at the school were the sisters Margaret (1864–1933) and Frances Macdonald (1873–1921), who both studied there from 1890. At the Glasgow School of Art Club's annual autumn exhibition of 1894, they attracted public attention for their ghostly imagery, elongated figures with death-mask faces, that became their trademark. The pair went on to establish a successful studio in 1896, where they produced

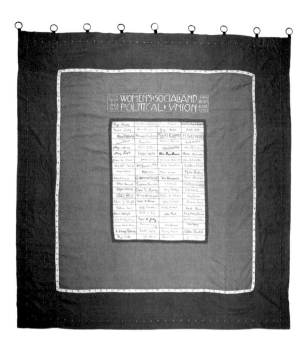

16 ABOVE RIGHT Ann Macbeth, WSPU Holloway Prisoners Banner, 1910. The suffragettes used the genteel art of embroidery to present their political views, overturning traditional ideologies surrounding hand-sewing. This banner uses the language of friendship quilts or signature tablecloths for protest.

17 BELOW RIGHT Macbeth's WSPU Holloway Prisoners Banner is paraded at the June 1910 'From Prison to Citizenship' march. Behind the banner are protestors dressed in white to signify their innocence, in defiance of their recent prison sentences.

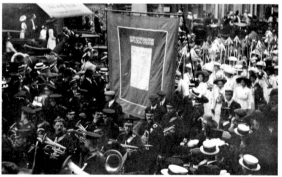

jewelry, posters, metal and gesso decorative panels, embroideries, book-cover designs and clocks, candlesticks and mirror frames as vital ingredients of the Glasgow Style interior. Some of the best-known of these were situated in the tearooms commissioned by the entrepreneur Catherine Cranston (1849–1934).

Part of the Glasgow temperance movement, this series of four stylish refreshment venues provided separate spaces for men and women to imbibe tea and cakes, as well as spaces for mingling. Margaret Macdonald designed *The May Queen* panel for the Ladies' Luncheon Room at the Ingram Street Tearooms in 1900. Created from a mixture of gesso, hessian,

18

Shifting Barriers

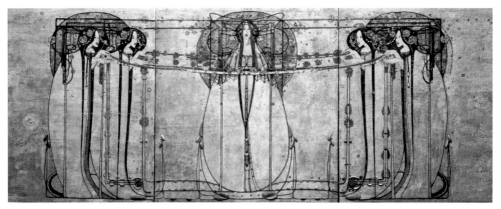

18 ABOVE Margaret Macdonald, *The May Queen*, designed for the Ladies'
Luncheon Room at the Ingram Street Tearooms, Glasgow, 1900. This scrim and
gesso panel is decorated with twine, glass beads, thread, oil paint, mother-of-
pearl and tin leaf.
19 OPPOSITE Margaret Macdonald, linen bed curtains, c. 1902–4. These
elongated, haunting female figures typify the designer's work. Similar hangings
were shown at the Vienna Secession exhibition in 1900, where they were
bought by Emil Blumenfelt, who subsequently showed them at the Turin
exhibition of 1902.

scrim, twine, glass beads, thread, tin leaf, oil paint and steel
pins, the panel is fifteen feet long and features stylized female
figures and geometric shapes in grey to create a mystical scene.
This was also the year in which Margaret married Charles
Rennie Mackintosh, and their close, professional collaboration
flourished. Her sister Frances married Herbert McNair in 1899,
and the two couples were known as 'The Glasgow Four'.

Although Mackintosh is most frequently credited with
exporting the unique Glasgow Style to Austria, Germany and
Italy, the women of the Glasgow scene also contributed hugely.
In 1899, Charles and Margaret designed a living room for the
German publisher Hugo Bruckmann (1863–1941) and his wife,
the salonnière Elsa Bruckmann (1865–1946). Charles designed
the furniture and Margaret three repoussé panels and an
appliqued curtain that created a modern setting for Elsa's
regular soirees. In 1900, Charles and Margaret, along with
Frances and Herbert, were invited to take part in the Eighth
Secession Exhibition in Vienna, the first to include design.
This avant-garde movement spanning art and design had been
established in 1896 in the Austrian capital in opposition to the
conventional Academy. The Secession had their own purpose-
built exhibition space, designed by Joseph Maria Olbrich, and
Margaret Macdonald and her husband filled one room with
artwork, fittings and furniture. *The May Queen* was exhibited

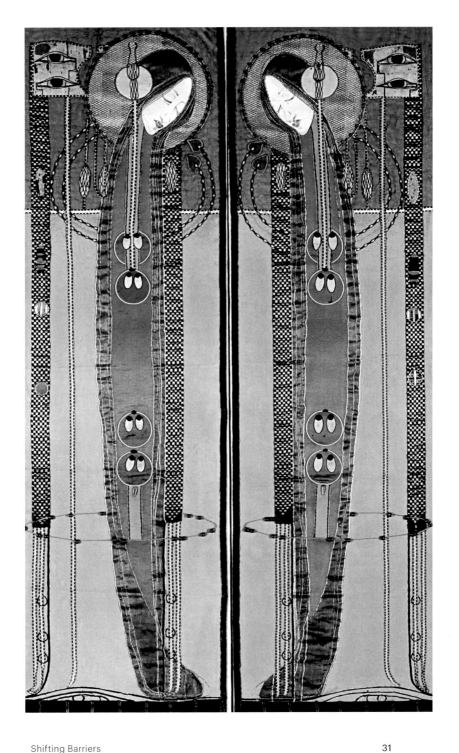

there alongside her embroidery work, a beaten metal fire screen, bed curtains, fingerplates, a clock and watercolour paintings. The display was favourably reviewed in the Austrian, German and Russian press, and many of the reviews concentrated on the haunting imagery used by the designers. It was also a commercial success: Macdonald and Mackintosh had their expenses paid by the Secession, and Margaret herself sold the appliquéd bed curtains and finger plates. The linen curtain panels are embroidered with silk and metal threads, with silk appliqué, glass beads and square linen buttons painted gold. Two mournful faces are painted in watercolour on white kid stretched over card, accentuated against the reflective gold and purple surfaces.

The Glasgow Style had made an impact in the 1900 exhibition in Austria, and in 1902 women associated with the Glasgow School also achieved success in Italy, when both Jessie King and Ann Macbeth were awarded medals at the International Exhibition of Modern Decorative Art in Turin. Fra Newbery was in charge of the Scottish section and Mackintosh designed the three rooms. He and Macdonald designed the Rose Boudoir in one half of the first room, the other half a display of their work, including their portfolio for the *House for an Art Lover* competition, which stipulated that entries be a combined effort between an architect and an artist – Mackintosh could not have entered individually. The Rose Boudoir was designed around two gesso panels by Macdonald on the theme of the rose; the buyer of the two bed curtains shown in Austria lent them for the Turin display. The second room was a library designed by Herbert McNair and Frances Macdonald, and the third room comprised a room filled with objects by Jessie King, Ann Macbeth and Frances Macdonald, among others. Alexander Koch, editor of the art periodical *Deutsche Kunst und Dekoration*, devoted a major article in the September 1902 issue, featuring the Macdonald and Mackintosh contribution. The cover, by Margaret Macdonald, relates to a decorative panel she had designed for a writing cabinet in the Rose Boudoir. The familiar, stylized roses are in evidence in pale pink, surmounted by a purple peacock and art nouveau lines.

Following the Turin exhibition, Macdonald and Mackintosh returned to Glasgow, and Macintosh designed the new Glasgow School of Art, completed in 1909 while Macdonald worked on panels for the Willow Tea Rooms and Hill House in 1903. This was the high point of the pair's career. They eventually relocated to Suffolk in 1914, then to London the following year and on to the south of France in 1923, where they concentrated on watercolour painting. As Janice Helland has demonstrated,

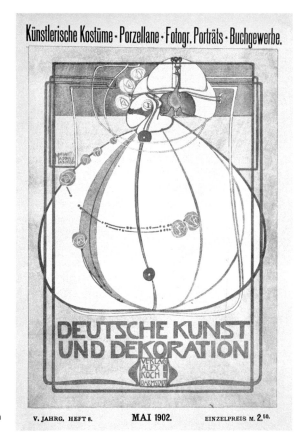

Künstlerische Kostüme · Porzellane · Fotogr. Porträts · Buchgewerbe.

DEUTSCHE KUNST
UND DEKORATION

VERLAG
ALEX
KOCH
DARMSTADT

V. JAHRG. HEFT 8. **MAI 1902.** EINZELPREIS M. 2,⁵⁰.

20 Margaret Macdonald, design for the cover of *Deutsche Kunst und Dekoration*, May 1902. This important magazine was the German equivalent of the British *Studio* and carried news of European contemporary design.

Mackintosh has subsequently been fêted by historians as a proto-modernist architect, while Macdonald's work has been relegated to the realm of the feminine and decorative. But the work of the Glasgow School is more helpfully seen as an important, collaborative effort, in which exciting work was produced apart from the male, modernist canon – a lot of it by women.

The Glasgow School of Art was an exception in its encouragement of women in design at the turn of the early twentieth century. In Vienna, women were not allowed to study at the Viennese Academy of Fine Arts or be members of the Secession. In 1897, the Kunstschule für Frauen und Mädchen (KFM, Art School for Women and Girls, later renamed the Wiener Frauenakademie (Viennese Women's Academy) was founded. The school was imbued with the radical outlook of the Vienna Secession, and aimed to

challenge differences between art and design. Teachers at the school included Adolf Böhm (1861–1927), a founding member of the Secession who facilitated opportunities for his women students at the new Wiener Werkstätte (Viennese Workshops), which were founded in 1903 by the architect Josef Hoffmann, the designer and painter Koloman Moser and the entrepreneur and painter Fritz Waerndorfer following a visit by Hoffmann to Macdonald and Mackintosh in Glasgow in 1902. The idea was to create a studio for the production of design. Women created and sold work through the workshops from the beginning; for example, a wooden chess set created by KFM graduates Fanny Harlfinger-Zakucka (1873–1954) and Minka Podhajská (1881–1963) in 1906. Carved from wood, its

21 tiny figures stand at 2–3½ inches (5–8.7 cm) and are drawn from a fairy-tale kingdom of medieval castles and figures adorned in brightly coloured robes.

 One of the first commissions for the Wiener Werkstätte was the corporate identity and fashion showroom for entrepreneur

22 Emilie Flöge (1873–1952). She is most often remembered as Gustav Klimt's muse, but she ran a successful, high-end fashion salon for almost thirty-five years. Few records remain of the establishment and she destroyed her part of her correspondence with Klimt. However, it is clear that she was the creative head of the enterprise. She supplied reform dress to women of the Austrian elite, which essentially meant

23 flowing dresses that could be worn without a corset, in rich materials with high, tight necklines and fitted bodices. She was aided by the expert weaver Jutta Sika (1877–1964), who with

21 Fanny Harlfinger-Zakucka and Minka Podhajská, wooden chess set, 1905. The group of brightly coloured, turned wooden figures and animals were bought by Otto and Eugenie Primavesi for their daughter at the 'Art of the Child' exhibition in Vienna in 1908.

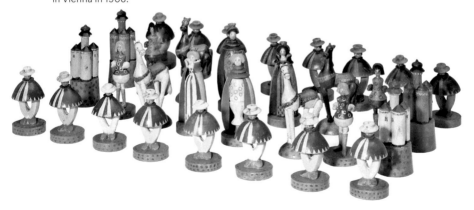

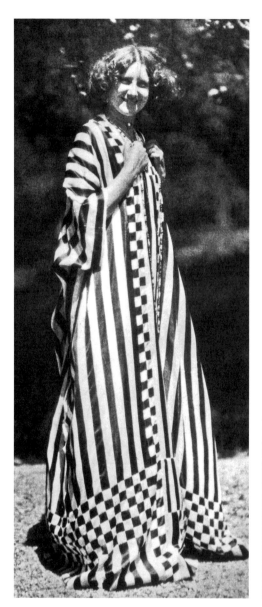 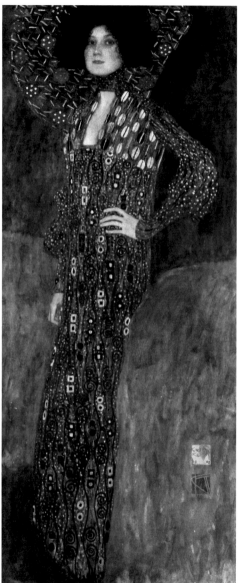

22 ABOVE LEFT Emilie Flöge in a new form of dress, in the garden of Gustav Klimt's studio at Josefstaedter Strasse 21, Vienna. The novel freedom of movement and highly decorative surface were part of her avant-garde style.
23 ABOVE RIGHT Gustav Klimt, *Emilie Flöge*, 1902. Flöge was more than Klimt's muse; she ran a successful design business in Vienna for thirty-five years, until the Nazi invasion of Austria in 1938.

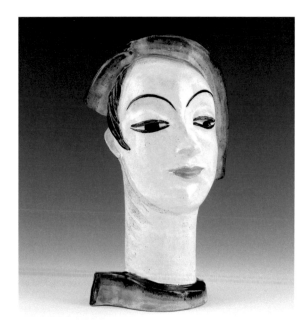

24 Vally Wieselthier, *Girl's Head with Pageboy*, 1928. Made in red pottery with a polychrome glaze, this object was produced and sold by the Wiener Werkstätte. Wieselthier emigrated to New York in 1932, where she achieved success as a ceramicist.

Harlfinger-Zakucka founded the radical Wiener Frauenkunst (Viennese Women's Art) in 1926, an offshoot of the Association of Austrian Women Artists, which had been founded in 1910. Through Wiener Frauenkunst, Sika provided support for her fellow female designers, many of whom were also associated with the Wiener Werkstätte. One such designer was Vally Wieselthier (1895–1945), who designed and decorated vibrant ceramic figures, many based on the 'flapper' jazz-age woman, with bobbed hair, painted eyebrows and jaunty headgear. The Wiener Werkstätte was beset with financial troubles following the First World War and only survived until 1932, when many of the designers, including Wieselthier, emigrated to the United States to find further success in New York.

Women were a central part of commercial culture following the Industrial Revolution. Their imagery was used to sell mass-produced items and new department stores offered easy perusing and purchase. However, women lacked agency in design at the close of the nineteenth and into the twentieth century. This lack of power in a patriarchal society was challenged through access to education, to the means to create design and make an impact on the world. Backed by activist groups such as the suffragettes, women used design to find a voice, and found a voice within design.

24

Chapter Two
Behind the Scenes

The previous chapter looked at women successfully overcoming barriers to become designers and establish a name for themselves as professionals in their own right. The nineteenth century saw women confined to the domestic sphere by a patriarchal power that privileged men within the home, in the workplace and in subsequent histories. Chapter Two focuses on the years just before, during and after the First World War (1914–18), when votes for women were becoming a reality, more women were entering the workforce and more consumer goods were available. It considers the ways in which women contributed extensively to the design process, but were not acknowledged at the time or in later accounts. Behind the scenes, women workers regularly took important creative decisions and worked tirelessly using handicraft processes to contribute to the success of the 'solo', generally male designer. From fashion houses to the Atelier Martine, through the Omega Workshops, the ubiquitous Times New Roman typeface to Wedgwood ceramics and Tiffany lamps, the labour of women lay behind the success of men. The chapter ends with the work of women designers who successfully established their own companies to promote their own designs, but whose work often failed to attract positive comment from the male-dominated design establishment. During the early twentieth century, women worked behind the scenes, with even the contributions of those who did establish their own, named practices pushed to the margins of history. Often associated with the ephemeral and the decorative, the fashionable and the colourful, these female designers' work stands in stark contrast to the permanent white walls and machine aesthetic of modern architecture.

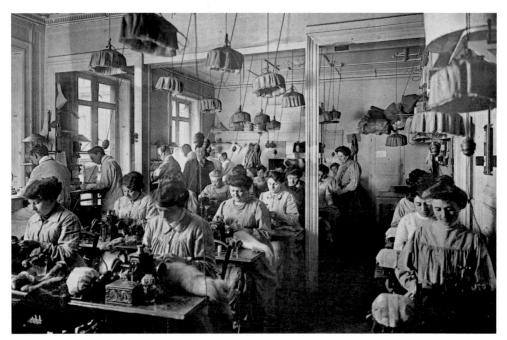

25 Charles Eggiman, photograph of a Parisian furriers' workshop, in *Les Createurs de la Mode* (*The Creators of Fashion*) (1910). A rare glimpse of the anonymous women working behind the scenes to make French fashion.

At the start of the twentieth century, female employment rose significantly. For example, in the field of clerical work, women were valued as typists, with the introduction of the typewriter in the 1880s for the processing of office work. By 1911, a quarter of all clerical workers were women, always on a lower pay compared to their male counterparts. Women working in design were, likewise, typically paid far less than men. Low-paid female workers were a key feature of the *haute couture* economy. A Paris-based fashion house would employ around 800 workers, the majority of whom were women on low wages. This included the front-of-house receptionists, models and sales personnel. Behind the scenes were the women who produced the garments, the seamstresses, pattern cutters and hand-finishers who produced exquisitely made clothing to order. The situation was worse in the cheaper off-the-peg market, where garments were produced in the sweatshops of the East End of London and New York's Lower East Side. The figurehead was usually a man, for example the Paris-based fashion designer Paul Poiret (1879–1944); fashion houses sold clothing on the promise of the individual, male creative genius.

25

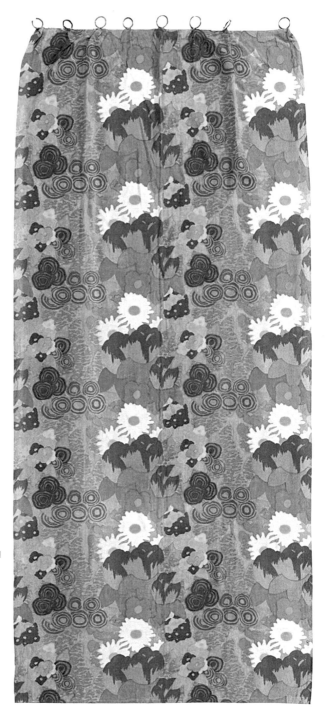

26 Atelier Martine, the workshop of Paul Poiret from 1911–29. This printed cotton curtain, possibly *Les Giroflées* (*The Wallflowers*) c. 1923, was created by this studio of young, unknown women to be sold under Poiret's name. Its vibrant colours and geometric shapes typify their work.

Behind the Scenes

Poiret was highly successful in the field of design, and drew on the shapes and forms of clothing from the Middle East and Asia, as well as the Ballets Russes and the artwork of Picasso and Matisse. He softened the female silhouette and changed the fashionable emphasis from the tiny, corseted waist, exaggerated hips and bust to an Empire line, with loose folds falling downwards, just below the bust. He is also credited with introducing the pairing of harem pants and a flared tunic, the so-called lampshade dress, to Western audiences. Following the success of Poiret's fashion studio, he branched out into home décor. His Atelier Martine decorating studio, named after his daughter, opened in 1912 and was partly inspired by the work of the Wiener Werkstätte and their integration of design forms. On the same premises on Avenue d'Antine, Poiret also opened the École Martine, which provided design training for young, working-class girls, who progressed to working in the Atelier. While Poiret oversaw the design of the Atelier's bold textile prints, his employees created the naïve designs, loosely painted, flamboyant and startling in their colour combinations, and inspired by visits to the local park, markets and zoos. Depictions of fruit, flowers and animals were used to decorate rugs and furnishing textiles. Some of the women of the Atelier Martine progressed to creating murals and tapestries in their own right. Poiret and the Atelier decorated one room in the apartment of the free-spirited American dancer Isadora Duncan (1877–1927); the space was fitted with dark blue velvet curtains and gilded mirrors. But the names of the women who produced these designs have not entered the record books. They were all labelled 'Atelier Martine'. The young women worked hard behind the scenes, but their contribution to design history is as unnamed individuals. Poiret himself was the *King of Fashion*, as his 1931 autobiography proclaimed. Like William Morris and Charles Rennie Mackintosh, one man's name came to stand for a broader and more collaborative creative process, often carried out by women.

Omega Workshops was founded one year later than the Atelier Martine, in 1913, by the modern art critic Roger Fry (1866–1934), the artist Vanessa Bell (1879–1971) and the painter Duncan Grant (1885–1978). Fry had visited Poiret's Paris-based design studio and was impressed by the business model and the impactful, naïve work produced there. The Omega Workshop's three co-directors were a part of the avant-garde Bloomsbury Set, who lived and worked in that area of London. The last letter in the Greek alphabet, Omega was selected as the name and symbol of the company because it represented 'the last word' on a subject. Like the Atelier Martine, none of

26

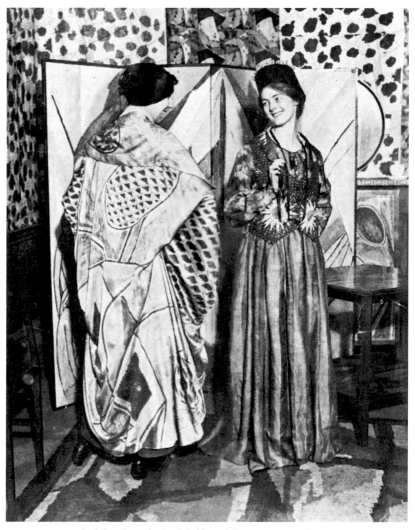

27 Nina Hamnett (right) and Winifred Gill (left) modelling Omega Studio garments in 1913, for the *Illustrated London Herald*. The hand-painted fabrics in a Post-Impressionist style borrow from Poiret's sense of the 'exotic'.

the products bore a signature, only the Omega hallmark. Omega's founders adored the work of the French Post-Impressionists and Fauves, running against the grain of the prevailing Edwardian taste for historic French styles. The items produced at their workshops in Fitzroy Square were boldly coloured and patterned, taking inspiration from the Post-Impressionist canvases by Cézanne, Matisse, Van Gogh,

Gauguin and Vuillard that Fry brought to London. He organised the 'Manet and the Post-Impressionists' exhibition in 1910, and its follow-up, 'The Second Post-Impressionist Exhibition' in 1912.

The workshop was popular among a certain intellectual elite, and many of the clients were wealthy women, including Lady Ottoline Morrell, Lady Desborough, Lady Curzon, Lady Cunard, Lady Drogheda and Gertrude Stein. They purchased fabrics, furniture, ceramics and other decorative items. Behind the scenes, the success of the outfit was guaranteed by the creative and organizational ability of Winifred Gill (1891–1981).

Fry is usually credited individually for establishing the Workshops, but both Vanessa Bell and Winifred Gill contributed enormously. When the Omega Workshops opened, Gill was one of the first artists to be approached. She lived next door to Fry, helped him with childcare and was employed part-time by his sister, Joan Fry, as a secretary. Her father owned and ran an ironmongery shop in Guildford and her family could not afford a full university education, but Gill managed to study Fine Art part-time at the Slade School of Fine Art, which had opened its doors to men and women on an equal footing when it was founded in 1871, and kept herself afloat with part-time jobs. She was the only salaried member of staff at Omega, and worked as an important link between the freelance designers and the three Co-Directors, even sharing an office with Fry. She also contributed to the design process, but like all the women involved at Omega, apart from Vanessa Bell, her time was mostly devoted to translating original designs on to items, rather taking part than in the actual creative process. This would have involved producing technical drawings for rugs, decorating ceramics and lampshades to specified designs and aspects of needlework. Gill did collaborate with Bell on the Model Nursery on the top floor of the premises in Fitzroy Square, and produced jointed marionettes. The décor of the nursery was reported on by *The Daily News and Leader* when the Omega Workshops opened. Roger Fry is quoted as saying: 'We have several lady artists here…and I am struck by the independent manner in which they work. Some years ago, even the cleverest women consciously or unconsciously copied men. Now they never seem to do so. Some of them have very original and novel ideas.' The journalist witnessed the young Gill decorating the model nursery with large, silhouetted animal shapes, trees and mountains, but her name is never mentioned. Other women designers to work at Omega anonymously include the artist and writer Nina Hamnett (1890–1956), who designed clothing and fabrics from 1913 to 1919. She was introduced to the technique for making batik textiles there, and also contributed

27

29

28

28 Model Nursery at the Omega Workshops, December 1913. The mural featuring large silhouetted animal shapes is by Vanessa Bell and Winifred Gill, the *Metachilde* fabric is by Duncan Grant and the rug was designed by Frederick Etchells.

to the commission to decorate a room in the London home of the art dealer Arthur Ruck with brightly coloured murals, working with Fry and another female contributor, the artist Dolores Courtney (*c*. 1890–1975).

Omega Workshops closed just after the end of the First World War in 1919, largely because demand for its goods had gone into decline, but Duncan Grant and Vanessa Bell continued their interest in interior design. Then in an open relationship, they moved to Charleston farmhouse, in the Sussex countryside, in the autumn of 1916. The rambling building became a living painting, as Bell, Grant and others took paintbrushes to walls and furniture. They lived a bohemian lifestyle there, bringing items from the Omega Workshops to make the interior modern and homely. The house is now preserved by the Charleston Trust.

More commercially viable as a fabric design vendor, and hence more profitable, was the London-based Silver Studio.

Still reliant on the labour of women behind the scenes, it supplied mass-market designs to Selfridges, Liberty & Co. and F. W. Grafton & Co. It was founded in Hammersmith in 1880 by Arthur Silver, who was part of the Arts and Crafts circle in London at that time. Arthur died in 1896 and his son, Rex, took over the running of the company until 1963. Rex did not produce designs himself, but relied on designers employed by the firm and freelancers. At first, women were not welcome and an advertisement for designers placed in the *Daily Telegraph* in 1899 specified that 'Ladies need not apply'. This had changed by 1912; the designer Winifred Mold (1894–?) was employed by the firm until 1935. She and her female colleagues worked from home rather than in the actual workshop, which was men-only with the exception of the secretary, Miss Cook, who worked behind the scenes to ensure the smooth running of the firm.

Apprenticeships for women in the design trade were an exception, and Winifred Mold studied at Paddington Technical College as a part-time evening-class student from 1909 to 1912

at her own expense. She studied in the art department rather than the trade school, and developed her design skills in the observation of natural forms and exhibits at the Victoria and Albert Museum as part of her studies. She was frequently called upon to work up floral patterns for the Silver Studio, a result of the lingering Victorian identification of drawing delicate flowers as a feminine skill, and her designs for floral prints were produced for both dress and furnishing fabrics. Mold was responsible for designing children's fabrics, which often represented animals and insects, and also created wallpapers (including those for children), undertook calligraphy commissions and designed the Silver Studio logo, but her name has not, until recently, formed a part of the history of design.

31

32

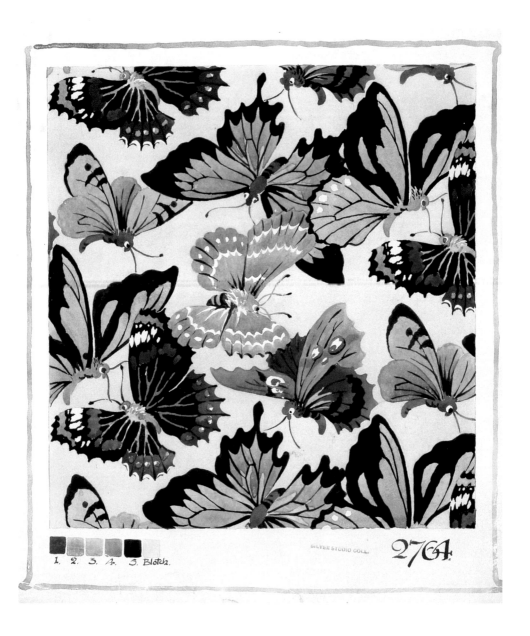

31 Winifred Mold, *Butterflies in Flight*, 1923. This beautiful design for silk was destined to be used for dresses and blouses, in stunning black, red, orange-gold, blue and green on a neutral ground.

Following the First World War, the number of women joining the workforce increased as women sought independence, a necessity partly caused by the loss of so many young men during the First World War. Between 1914 and 1918, women had been drafted to take over professional roles usually occupied by men, particularly in the furniture trade and manufacturing and in 1918, some women (property-owners over thirty) in Britain had obtained the vote, in what was seen as a reward for their war effort. At the Silver Studio more women designers were employed, including Madeleine Lawrence (1896–1952), who designed floral fabrics for Liberty's and, on the 1939 electoral register, identified her profession as 'textile designer'. Evidence of the women designers' work has only come to light because they were barred from working in the commercial premises, and so Rex Silver corresponded with the women about commissions and corrections by mail, which survives in the Silver Studio Archive. Little detail survives about their lives beyond the studio.

32 Winifred Mold, *Wildlife*, 1930. This printed textile design for cotton furnishing fabric, featuring animals of the African savannah on a pale blue background, was specially created for children's bedrooms and nurseries.

In the field of lighting design, the leading company, still emblematic of decorative glassware, was the New York-based Tiffany & Co. Until the early 2000s, it was taken for granted that the designer of their characteristic multi-coloured glass shades was Louis Comfort Tiffany. But research based on correspondence from Clara Driscoll (1861–1944) has revealed that she and her team, known as the 'Tiffany Girls', were responsible for many of these iconic pieces. Driscoll studied at the Western Reserve School of Design for Women (later the Cleveland Institute of Art) before moving to New York. She attended the Metropolitan Museum of Art School and in 1888 was employed by the Tiffany Glass Company, where she worked as a designer and supervisor of the Women's Glass Cutting Department, intermittently, for the next twenty years. Her employment was interrupted by her marital status, as engaged or married women could not work at the company; she left between 1892 and 1899, returning upon the death of her first husband, and stayed until 1909, when marriage forced her departure once more. During her time at Tiffany's she designed a multitude of glass lighting previously attributed to Louis Comfort Tiffany, including her very first, Daffodil, followed by Dragonfly, Wisteria and Poppy, among others.

The field of typography includes another example of women working behind the scenes, unacknowledged during their lifetime and subsequently. The Times New Roman font is one of the most widely used in the world, the default font for mainstream software including Microsoft Word. In general terms, the origins of the typeface lie with Stanley Morrison (1889–1967), who worked as a Typographical Adviser to the London-based Monotype Corporation from 1923 until his death. After critiquing the dated typeface used by *The Times* newspaper, he worked with one of the newspaper's draughtsmen in the publicity department, Victor Lardent, to create the new, clearer type, which was launched in 1932. This is usually as far as the story goes; but in fact, women working behind the scenes were crucial to the success of this typeface and to Monotype Corporation. Morrison, although credited with designing Times New Roman, was not a typographic designer. He and Lardent sketched out the idea, but the hard and precise work of producing the actual character forms was that of the women of the Type Drawing Office (TDO). This included scaling the letterforms and producing different styles such as italics and bold, all by hand.

Beatrice Warde (1900–69) was a core component of the Monotype Corporation from 1927, when she secured the job of part-time editor of the *Monotype Post* after publishing

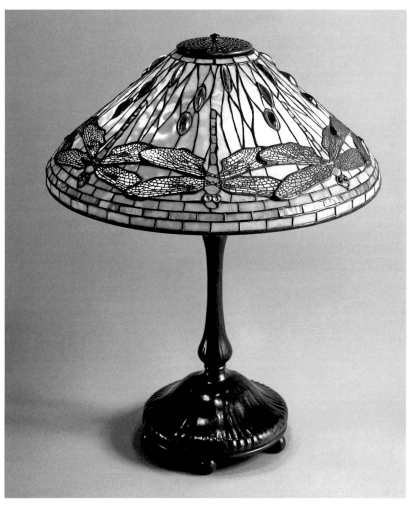

33 Clara Driscoll, *Dragonfly Table Lamp*, 1900, made for Tiffany Studios in leaded glass and bronze. Driscoll was head of the Tiffany Studios Women's Glass Cutting Department, but received little credit for her design work at the time.

her important research about the origins of the Garamond typeface under the male pseudonym of Paul Beaujon in *The Fleuron* in 1926. The London-based Monotype staff were surprised when a woman turned up to take the job. But she proved herself, and was promoted to Publicity Manager at Monotype in around 1929, staying until she retired in 1960. In her first year as Publicity Manager, she worked with Eric Gill (1882–1940) to promote the newly created typeface Gill Sans,

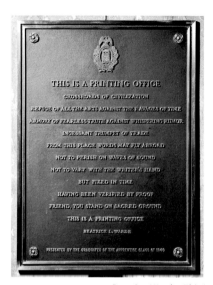
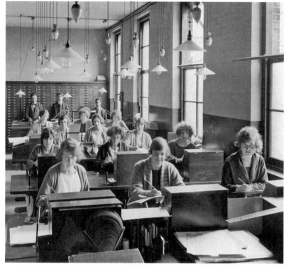

34 ABOVE LEFT Beatrice Warde, *This is a Printing Office*, at the entrance to the United States Government Publishing Office, Washington DC. Warde's manifesto was first published in 1932 to promote the Perpetua typeface, and a new version was published in Albertus in 1935.

35 ABOVE RIGHT View of the Monotype Type Drawing Office, Salfords, Surrey, c. 1928. Women were employed to draw typefaces for Monotype, but were rarely credited for their painstaking work.

which was classical, clear and modern. She was passionate about educating the public and creating legible type for a
34 purpose. Her manifesto, *This is a Printing Office*, set in the new Perpetua typeface and launched in 1932, occupies pride of place at many printers, including the United States Government Publishing Office in Washington DC, and has been translated into many languages.

35 Working behind the scenes at the Monotype Corporation with Beatrice Warde was a group of highly skilled women who receive even less acknowledgement than Warde: the drawing clerks who worked in the TDO, whose involvement was so key to the development of Times New Roman. In 1910, four women were employed in the TDO; by the 1930s, this had risen to more than a dozen. The full-time employment of young, single women had become the norm by this period, and in 1931 three-quarters of all women aged fifteen to twenty were working. The women at the Monotype Corporation, like women employed everywhere at this time, were paid less than their male counterparts, their pay usually amounting to less than fifty per cent of a man's in the same role. Women like Dora Laing (1906–?) were stalwart employees at Monotype. Laing

joined aged sixteen in 1922 and stayed on for the next thirty-eight years, supervising and training the younger staff as well as working on Times New Roman and the entire range of the company. Traces of these women's contribution can be seen in their archived work logs and signed drawings, and their place in design history needs to be recognized.

Much like the fashion industry and the world of typographic design, ceramics companies employed women on lower pay rates to perform skilled work behind the scenes. Women were

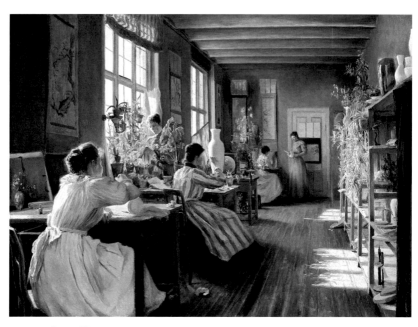

36 ABOVE Emma Meyer, *Women Decorating Porcelain at De Kgl. Porcelænsfabrik* (Royal Copenhagen), 1895. This piece depicts women adding the important decorative elements to white pots.

37 RIGHT Victor Skellern and Millicent Taplin, *Strawberry Hill* vegetable dish and cover in bone china, c. 1957. Printed with a pattern of strawberries and leaves with gilding, this was designed for manufacture by Josiah Wedgwood and Sons Ltd, Etruria.

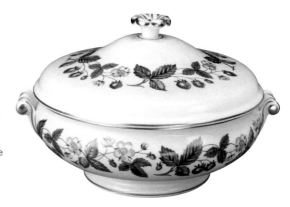

employed by firms such as the Royal Copenhagen Porcelain Factory in Denmark to decorate delicate items. The factory itself had been founded by Queen Juliane Marie of Denmark in 1775 to improve the economy, and women were employed in its studios during the late nineteenth century and into the twentieth to hand-paint the wares. In Europe and America during the nineteenth century, it was widely assumed that women were particularly suited to the delicate art of hand-decorating pottery; women could also order plain pots to decorate at home as a hobby. In the UK, the pottery industry had blossomed in the North Staffordshire area from the Industrial Revolution onwards, and firms such as Dalton, Minton and Josiah Wedgwood and Sons Ltd employed women to paint surface decoration at the finishing stage of production. A husband and wife team, Alfred and Louise Powell, established a studio at the Etruria works at Wedgwood around 1906 solely to train women as freehand painters. One of the most successful of these painters was Millicent (Millie) Taplin (1902–80), who studied part-time at Stoke School of Art then worked at Etruria and Barlaston from 1917 to 1962. She was a prolific and flexible designer, able to create popular and appealing patterns. Women were not permitted to design the three-dimensional form of the ceramic items, and their design and painting often went unacknowledged, with no maker's mark for surface decoration. A pair of lamp stands are a case in point: they are attributed to the designer and works manager, Norman Wilson, impressed on the bottom with 'NW', but Taplin's beautiful silver hand-painting is not acknowledged. In terms of public recognition, her most successful design was the full dinner set 'Strawberry Hill', designed with Victor Skellern, which was awarded a Design of the Year Award by the Council of Industrial Design (COID) in 1957. The year before, Taplin took over the management of the newly merged china and earthenware hand-painting departments, a role she occupied until her retirement in 1962.

Some female painters did manage to make a mark on their work, including Cecily Stella 'Star' Wedgwood (1904–95) the daughter of Major Frank Wedgwood, whose trademark five-pointed star with the initials 'SW' on either side often appears on the base of her work. She also trained in the Powells' workshop alongside other women designers, including Susannah Margaretta 'Daisy' Makeig-Jones (1880–1944), who worked behind the scenes but are rarely acknowledged. This is partly due to the gendered division of labour that dominated the ceramic industry, but also the type of design criticism and the subsequent history that has emanated from it. As Cheryl

Buckley has demonstrated, the emphasis on modernism by a powerful group of writers during the 1930s, including Herbert Read and Nikolaus Pevsner, meant that a certain aesthetic of purism and functionalism was foregrounded and the role of the male designer privileged. At Wedgwood, it was the work of the New Zealand-born architect and designer Keith Murray (1892–1981) that was highlighted in the modern design press, rather than the female painters.

During the 1920s and 1930s, several women designers became less satisfied with the lack of acknowledgment and established their own signature brands. One such designer is Clarice Cliff (1899–1972), who worked at A. J. Wilkinson of Middleport, Stoke-on-Trent, from 1916. She took night classes at

38 Clarice Cliff, *Gibraltar* service, including plates, a Stamford teapot, milk jug, sandwich plate and a conical cup and saucer, c. 1931. This Jazz Age set shows designs and colours typical of the pioneering designer.

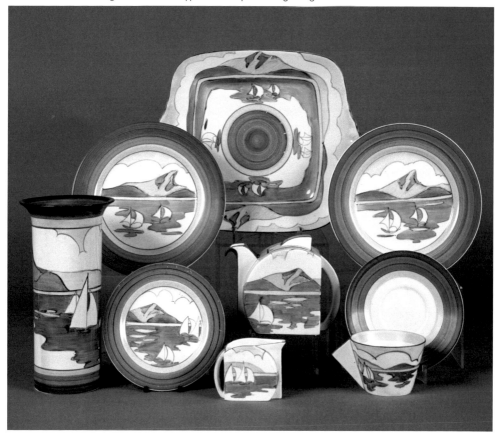

Burslem School of Art after serving a seven-year apprenticeship as an enameller at Lingard, Webster & Co., who made domestic tableware. In the early 1920s, her skills as a designer were recognized and she began to work on small figurines, which she hand-painted in vibrant colours and, vitally, signed. In 1926 she was given her own design studio at the Newport factory next door, where she developed her renowned Bizarre ware, which was stamped 'Hand Painted Bizarre by Clarice Cliff' on the bottom. The range was launched in 1928, and its bold colourways and angular Art Deco shapes and patterns were an instant hit, much to the surprise of the Wilkinson sales team. Cliff then progressed to create the even more poplar Crocus range in 1928, followed by Conical in 1929 and Biarritz and Le Bon Jour in 1933. She successfully harnessed the appeal of Art Deco for the mass market, building up a studio that by 1929 employed seventy hand painters, mainly women, who were playfully known as 'The Bizarre Girls' but still largely unacknowledged individually.

Another exception to this pottery patriarchy is the work of Susan Vera 'Susie' Cooper (1902–95). Cooper was determined not to work behind the scenes. She studied at Burslem School of Art from 1919 to 1922, and was refused entry to the Royal College of Art because she was not working in industry. She went to work at A. E. Gray & Co. Ltd, where she achieved the status of designer by 1924, but grew frustrated with working at Gray's and in 1929 established her own company, Susie Cooper Pottery Ltd. Cooper's designs were simpler and more muted than those of Cliff, using a cream background often with delicate sprigs of flowers, with names such as Dresden Spray, Nosegay and Briar Flowers. She gained increasing acceptance by the design establishment, and was awarded Royal Designer for Industry by the Royal Society of Arts in 1940. She invested tremendous energy into the marketing of her products, opening her own showroom in London and exhibiting at the British Industries Fair in 1931, resulting in a sale of her breakfast in bed set to the Queen. Her company was eventually sold to Wedgwood in 1966, after achieving huge commercial and industry success.

Women were also making a name for themselves in the world of fashion. Elsa Schiaparelli (1890–1973) launched her career as an adventurous, Surrealism-inspired designer in the late 1920s. Born in Rome to well-connected parents, her father was an academic expert in ancient cultures, and she studied philosophy at the University of Rome. She rebelled against her restrictive family life and fled to London at the age of twenty-two, taking a job as a nanny. While attending public lectures in a broad range of humanities, she encountered her future

38

39

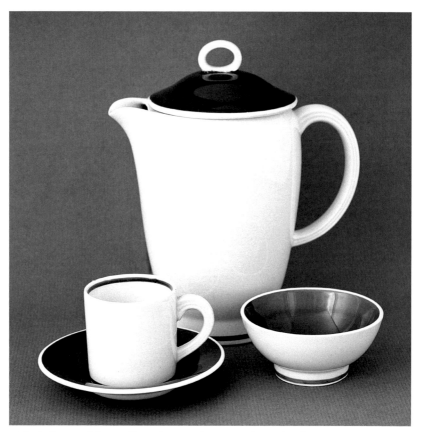

39 Susie Cooper, *Falcon* coffee pot, cup and saucer and sugar bowl, 1938–42. This Chinese blue design on an earthenware set was produced for John Lewis. The classic cream and blue decoration was popular among fashionable newlyweds.

husband, the theosophist and confidence trickster Count William de Wendt de Kerlor. The couple fled to New York at the outbreak of the First World War, where de Kerler left almost immediately after the birth of their daughter. In need of an income, Schiaparelli found work at a boutique run by Gabrielle 'Gaby' Buffet-Picabia, the ex-wife of the Surrealist artist Francis Picabia, and extended her social circle to include US-based Surrealists including Marcel Duchamp, Man Ray and Edward Steichen. After the war, Schiaparelli relocated to Paris with the backing of her wealthy friends, and became acquainted with the French avant-garde, including, in 1927, Paul Poiret. He encouraged her into the fashion business, and she launched her eponymous fashion house with a hand-knitted jumper

40

with trompe l'oeil bow, which appeared in *Vogue*. The garment was a big hit, and Schiaparelli opened her own ready-to-wear outlet, House of Schiaparelli. In 1936 she launched a perfume, *Shocking*, modelling the bottle on the Mae West mannequin she had used when designing costumes for the Hollywood star in the film *Every Day's a Holiday* (1937).

Schiaparelli's arch rival was the fashion designer Gabrielle Bonheur 'Coco' Chanel (1883–1971). Chanel had a less privileged upbringing than Schiaparelli, born in a workhouse and raised in an orphanage in the south-west of France. She learned skills as a dressmaker first at the orphanage, then while working at

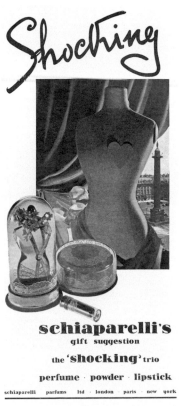

40 OPPOSITE LEFT Elsa Schiaparelli, *Tie* jumper, 1930. This hand-knitted woollen garment displays the designer's Surrealist inspiration, with a tie knitted into the jumper in a trompe l'oeil gesture, building on the success of her earlier *Cravat* design.

41 OPPOSITE RIGHT Elsa Schiaparelli, advertisement for the *Shocking* range. Launched in 1937, these novel products included perfume, powder and lipstick, all marketed on the basis of female sensuality.

42 RIGHT Coco Chanel wearing a stretch jersey sailor's top, c. 1930. With her cropped hair and casual stance, Chanel pioneered a fashion for simple yet classic garments for women.

a local tailor. She moved to Paris at the start of the twentieth century and opened her first boutique there in 1910 under her eponymous brand, Chanel Modes. Just before the First World War she opened a boutique in the fashionable seaside resort of Deauville, where she launched sports and casual garments in a comfortable stretch jersey, including the perennial striped sailor's top. In 1915, she opened an exclusive outlet in Biarritz. It proved profitable, and the Chanel brand was firmly established; she opened a boutique in Paris in 1921 and her popular scent, Chanel No. 5, was launched in the same year. Her clothing, which included the classic little black dress and the cardigan set, remain as popular as the perfume. Her designs continue to carry her name in the form of the famous CC logo, designed by Chanel herself in 1925. Her style and popularity waned

somewhat after the Second World War, with the introduction of Dior's more feminine New Look.

Another Paris-based designer to achieve fashionable success was Sonia Delaunay (1885–1979), who grew up in Russia and attended art school in Germany and then Paris. She pioneered the use of bold, contrasting colours for the decoration of stage sets, clothing and ceramics, and, with her husband Robert Delaunay (1885–1941) and others, developed the avant-garde fine art movement Orphism. In 1917 she opened her first boutique, Casa Sonia, in Madrid, selling fashion and interior design objects. In 1921, the couple relocated to Paris, where she secured textile design contracts and created geometric costumes for the Dada artist Tristan Tzara's play *The Glass Heart*.

The 1925 Paris 'Exposition Internationale des Arts Decoratif et Industriels Modernes' reinforced the French capital as the world centre for women's fashion, interior decoration and luxurious glamour. Delaunay designed one of the attractive boutiques that lined the Pont Alexandre III. The Boutique Simultanée was an Art Deco showcase for Delaunay's designs, created with the furrier Jacques Heim (1899–1967). Her designs used abstract patterns and expensive materials to decorate the female body in contrasting colours. Delaunay's work was admired by the metropolitan elite at the time, but her place in history has taken longer to establish.

43

44

43 Sonia Delaunay, *Boutique Simultanée.* A temporary boutique built as part of the 1925 Paris 'Exposition Internationale des Arts Decoratif et Industriels', it contained her radical clothing, accessories and decorative objects for the home.

44 Sonia Delaunay, bathing suit, 1928–30, in knitted wool with a fashionable halter-neck and vibrant colours. Delaunay translated her artistic interest in colour to fashion design.

The dominant design history of this period has tended to give extensive coverage to the pioneers of modern architecture and design, rather than considering the more decorative and fashionable aspects of the past. As a result, while designers such as Clarice Cliff, Elsa Schiaparelli and Sonia Delaunay did not see themselves as working behind the scenes, they have tended to be written out of later accounts. The situation is changing, however, and in 2021 Cliff was the subject of a biopic, *The Colour Room*, directed by Claire McCarthy and written by Claire Peate. An exhibition of Sonia Delaunay's paintings as well as her design work toured to the Musée d'Art Moderne de la Ville de Paris and Tate Modern, London, in 2015. Schiaparelli's work was displayed at the Metropolitan Museum of Art, New York in 2012 in 'Schiaparelli and Prada: Impossible Conversations', which contrasted the work of the Surrealist designer with the more contemporary work of Miuccia Prada, head of the Milan-based fashion house since 1978. But while it is admirable that these women in design are being newly highlighted, critical caution must also be exercised to ensure that the current tendency to celebrate the individual, celebrity designer does not overshadow the design achievements of other women working behind the scenes.

Chapter Three
Pioneers of Modern Design

The style and ethos that has dominated the history of design since its inception is the Modern movement. The *Pioneers of Modern Design* by Nikolaus Pevsner, first published in 1936, laid the foundations for a view of history that centred on male protagonists in a Darwinian search for the Holy Grail: Modern design. Functional, uncluttered and simple, this design aesthetic took its inspiration from the machine and from new technology. But Pevsner only made fleeting reference to women in his seminal text, identifying designers Margaret Mackintosh twice, her sister Mrs McNair once, and a client, Mrs Kroller-Müller, twice. He also thanked his mother, Frau Annie Pevsner, for 'transforming an illegible into a readable and printable manuscript...' Women's leading role in the movement has been underplayed and less fastidiously documented from the beginning. Their contribution has been overshadowed by that of male partners and/or their importance lost in history. This

45 Paul Klee, Bauhaus Masters on the roof of the Bauhaus in Dessau, December 1926. From left: Josef Albers, Hinnerk Scheper, Georg Muche, László Moholy-Nagy, Herbert Bayer, Joost Schmidt, Walter Gropius, Marcel Breuer, Wassily Kandinsky, Paul Klee, Lyonel Feininger, Gunta Stölzl, Oskar Schlemmer.

chapter shines a light on the female pioneers of Modern design, the New Women who used Modernism to express a new order.

A popular starting point for accounts of Modern design is the pinnacle of pioneering Modernism, the Bauhaus. The founding of the school is usually attributed to the architect Walter Gropius (1883–1969). Again, a single, male figure is used to stand in or gloss over the contributions of many others. The roots of the Bauhaus lie in the royal patronage of William Ernest, Grand Duke of Saxe-Weimar-Eisenach, Germany, who appointed the designer Henry Van de Velde (1863–1957) to found the Grand-Ducal School of Arts and Crafts in 1907. Van de Velde designed the school building and was its first Director until he was forced to leave Germany at the outbreak of the First World War in 1914, at which point he suggested Gropius as his successor. Following the end of the war, the Weimar Republic, the liberal democracy that governed Germany until the rise of Adolf Hitler in the 1930s, was established in the city of Weimar, where the revitalized Grand-Ducal School of Arts and Crafts was merged with the Weimar Art Academy. Gropius was appointed Director of the newly merged institution, to which he added an architecture department.

In his *Bauhaus Program and Manifesto* of 1919, Gropius declared: 'Any person of good repute, without regard to age or sex, whose previous education is deemed adequate by the Council of Masters, will be admitted, as far as space permits.' Many women applied to become students and roughly half of the students accepted were female, which presented a challenge for Gropius. Despite the Bauhaus's revolutionary ethics and radical design curriculum, there were only ever two female masters at the school during its existence. Women were not allowed to study architecture, and Gropius doubted that they could understand complex theory. They were directed to the Weaving School – a suitable place, presumably, for women to use craft skills rather than their intellects. Posing on the roof 45 of the Bauhaus building in the chilly December of 1926, we see the faculty in line. Walter Gropius is at the centre, flanked by Marcel Breuer and Joost Schmidt. The men epitomise Adolf Loos and Le Corbusier's love of the plain, understated tailored suit. The sole woman, placed in the periphery of the shot, is Gunta Stölzl (1897–1983). With her short, shingle haircut and 46 loose-fitting suit, she is every inch the New Woman, confident and ambitious.

Stölzl arrived as a student at the school when it opened, became a teacher in 1922, and was appointed Master of Weaving in 1926, replacing the unenthusiastic abstract painter Georg Muche. She was the only female master and paid less

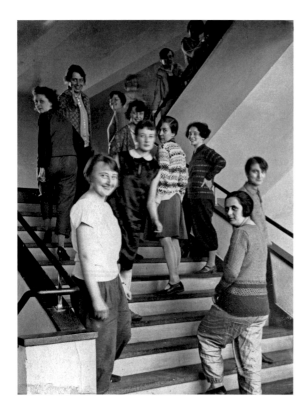

46 Lux Feininger, weaving students on the stairs of the Bauhaus Building, Dessau, 1927. Sporting trousers, bobbed hair and lipstick, this group of 'New Women' exudes confidence.

than her male counterparts. She had already studied at the art school in Munich and enrolled on the preliminary course at the Bauhaus, where her impressive work in form and colour theory earned her a scholarship in the weaving workshop. She and her fellow students became frustrated with Muche's approach, which did not include the technical aspects of weaving, but instead relied on the aesthetics of his own fine art vision. Stölzl had the necessary technical skills, and superseded him after a student revolt. Her work combined technical excellence with a fluidity that challenged the strict geometric lines of Modernist architecture.

47

Her work was first exhibited publicly at the Haus am Horn, a model dwelling designed by Muche for the 1923 Bauhaus exhibition in Weimar, at which the weaving workshop showed rugs, wall hangings and upholstery. These objects proved commercially attractive, and under Stölzl's leadership the weaving workshop was the most profitable of the Bauhaus's disciplines, successfully fulfilling Gropius's stated aim to work with industry. The most critically acclaimed part of the Haus

47 Gunta Stölzl, tapestry, 1922–23. This early work, constructed from cotton, wool and linen fibres, exemplifies Stölzl's command of the loom. In 1926 she became the only female Master at the Bauhaus.

Pioneers of Modern Design

48 Alma Siedhoff-Buscher, *Little Ship-Building Game*, 1923. This imaginative children's toy consists of twenty-two wooden shapes that can be used to form a solid rectangle or rearranged to create a ship with boats and a lighthouse.

am Horn was Alma Siedhoff-Buscher's (1899–1944) nursery cupboard and toys, including the Little Shipbuilding Game, designed from geometric portions of wood, which is still in production today.

 The Bauhaus moved to the more industrial city of Dessau in 1925, and Gropius designed the school buildings and masters' homes in Modernist style, with flush white walls, flat roofs and extensive fenestration. The Weaving Workshop was situated on the first floor, in a large, well-lit studio complete with new looms and a specialist dyeing studio. Women enjoyed a more supportive regime from 1928, when Gropius left to pursue his own architectural practice in Berlin and was replaced by the Socialist architect Hannes Meyer (1889–1954). Meyer allowed women to choose their own studios and opened the architecture programme to them. The first woman to study architecture at the Bauhaus was Charlotte Ida Anna 'Lotte' Stam-Beese (1903–88), who already had an established career as a photographer. Meyer and Beese had a relationship, but as the Director of the Bauhaus was already married, Beese came under pressure to leave. After a period of working unsuccessfully in Meyer's practice, the relationship came to an end. She married the Dutch Modern architect Mark Stam (1899–1986) and settled in the Netherlands in 1934. Meyer's political views were becoming unpopular in the increasingly right-wing Germany, and in 1930 he was replaced by the more moderate Ludwig Mies van der Rohe (1886–1969). A year later, Stölzl left her post and relocated to Switzerland, mainly due to her radical political views. She was replaced by her former student, Anni Albers (1899–1994), who specialized in geometric wall hangings in cotton and silk.

 Other women to successfully study and then teach in the Weaving Workshop include the Croatian designer Otti Berger

49 ABOVE Anni Albers, *Black White Yellow*, 1926. Made from mercerized cotton and silk, the restricted palette and simple rectangles that make up this woven textile create a random, almost textual or mechanized form resonant of the Bauhaus's basic tenets.

50 RIGHT Helen Margaret Post, *Anni Albers at her loom at Black Mountain College, North Carolina*, 1937. Albers left the Bauhaus in 1933 with her husband, Josef, and taught weaving at this new art school in the US, managing to continue her experiments with form, shape and materials there.

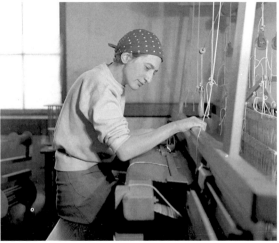

Pioneers of Modern Design

(1898–1944), Benita Koch-Otte (1892–1976) and Gertrud Arndt (1903–2000). Marianne Brandt (1893–1983), meanwhile, was the only woman to graduate from the Metal Workshop, succeeding László Moholy-Nagy as its acting director in 1928. She was an accomplished painter before she became a student at the Bauhaus in 1924, where she succeeded in creating modern metalware in collaboration with industry. One of her first projects was a silver and black enamel tea infuser fashioned in silver and ebony. The Japanese-inspired form stands at only 7.3 cm (2.9 in.) high, with a functional handle situated above rather than at the side. The object as a whole reflects the Modernist aesthetic of geometry and simplicity. The tea infuser was impractical for mass production, but Brandt went on to produce many more easily reproducible designs in metal for lighting, ash trays and table ware. The Kandem bedside light of 1929, co-designed with Heinrich Bredendieck and produced by Körting & Mattiesen in many colourways and materials, sold in its thousands. Brandt left the Bauhaus the same year that the Kandem light was designed, and in 1930 took up a post as head of design at the Gotha-based Ruppel metalwork factory. Ruppelwerke produced many of her designs during her three years there, affording her financial security.

51
52

51 Marianne Brandt, coffee and tea service, c. 1924, in silver with ebony. Brandt excelled in the metalwork department, where she was briefly appointed deputy head between 1928 and 1929. She then worked in industry, taught and curated in the field of product design.

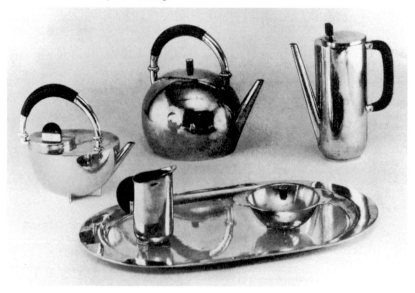

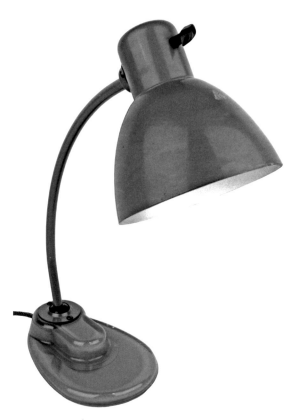

52 Marianne Brandt, desk lamp LBL 1115, made by VEB Leuchtenbau (formerly Kandem) in Leipzig, East Germany, 1951. Based on Brandt's original 1929 design for a bedside lamp, this simple yet elegant model sold thousands before and after the war.

With Mies van der Rohe as the final director of the Bauhaus in Dessau the situation for women remained much the same, with architecture the main focus. Van der Rohe brought in his long-term collaborator Lilly Reich (1885–1947) to head the Weaving Workshop and establish the new Interior Design department, and she also took on responsibility for the day-to-day running of the school. Reich had trained as an industrial embroiderer and worked at the Wiener Werkstätte before the war before returning to Berlin in 1911, where she designed window displays and interiors. She joined the Deutscher Werkbund in 1912 and played a leading part in this important design organization, becoming the first woman to be appointed to the Board in 1920, and its first female director two years later. She met Mies van der Rohe in the mid-1920s, and collaborated with him on, among other projects, the notable German pavilion at the Barcelona International Exhibition in 1929. The pair worked together extensively on interiors and furniture, and it is unclear who contributed what to the process. Needless

to say, Mies van der Rohe is by default named as the sole designer of many projects on which Reich was an important collaborator. The interior of Villa Tugendhat, Brno, now in the Czech Republic, completed in 1930, is a case in point. Although Reich and Mies van der Rohe collaborated on the design of the home, if Reich is mentioned at all, it is often as the designer of the soft furnishings, particularly the striking wall to ceiling curtains. But as Marianne Eggler has demonstrated, both were responsible for the full design, and the curtains were an element they had used for the The Velvet and Silk Café at The Women's Fashion Exhibition, Berlin, in 1927. At the Tugendhat House, the black and grey shantung silk and black and white velvet curtains create a luxurious touch, complementing the expensive building materials, which include macassar ebony and onyx marble. The curtains act as fluid room dividers, screening off or revealing particular spaces.

When the Bauhaus was closed down by the Nazis in 1933, Mies van der Rohe took up the offer of employment in Chicago,

53 Lilly Reich and Mies van der Rohe, interior of Villa Tugendhat, Brno, Czech Republic, 1930. Silk wall hangings and rich marbles were used in this luxurious space to mark out the different functions of the room.

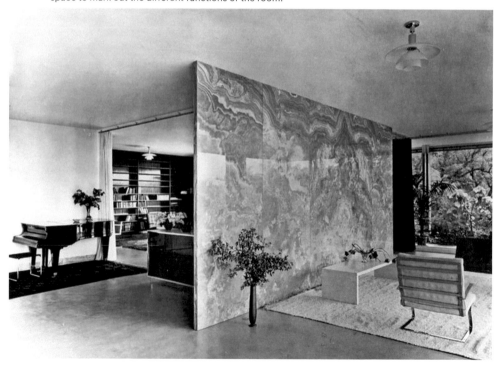

54 Lilly Reich and Mies van der Rohe, The Velvet and Silk Café at the 'Women's Fashion Exhibition', Berlin, 1927. Commissioned by the German Silk Association, discrete areas are created with hanging silks in gold, silver and yellow, with velvets in black, orange and red set at different heights.

where he became the head of the architecture school at the Armour Institute of Technology (which became the Illinois Institute of Technology), while Reich stayed put in Berlin to run his office. When war broke out, she had the foresight to store 3,000 of van der Rohe's drawings and 900 of her own in what would become the German Democratic Republic. She died soon after the war ended, and it took until 1968 for Mies van der Rohe to extricate the valuable archive material and safely lodge it at the Museum of Modern Art in New York.

Beyond the Bauhaus, Modern design was used in a concerted effort to provide decent mass housing in cities across Germany, and in the city of Frankfurt-am-Main in particular, under the leadership of the city architect Ernst May (1886–1970). The new apartments were modest in size, and so efforts were made to provide space-efficient furniture and fittings. Margarete 'Grete' Schütte-Lihotzky (1897–2000) designed the famous 55 Frankfurt Kitchen, which was installed in approximately 10,000 homes. Schütte-Lihotzky was the first female student to study

55 Margarete 'Grete' Schütte-Lihotzky, the Frankfurt Kitchen, designed 1926–27. Designed by the Austrian architect in consultation with female end-users (few men would have entered such a space at this time), this radical kitchen was installed in 10,000 homes in Frankfurt.

architecture at the Kunstgewerbeschule, now the University of Applied Arts, in Vienna. She developed an interest in social housing in her native Austria, working alongside Adolf Loos as well as developing housing for the Austrian Settlement and Allotment Garden Association before being invited to Frankfurt by May, whom she met through Loos. Her functional kitchen design was based upon the theories of the design writer Christine Frederick's (1883–1970) manual *The New Housekeeping*, published in New York in 1913 and translated into German in

1922. Frederick applied the time and motion studies developed in the workplace to the home, and the kitchen in particular. The grouping of types of activity was key, as was the distance between different workstations. Schütte-Lihotzky also talked to women about how they worked in their kitchen areas, and made detailed studies of their usage. The Frankfurt Kitchen had a high stool that revolved, built-in storage, a foldaway ironing board, an adjustable ceiling light and a removable drawer for rubbish. Storage was provided, with large-handled aluminium containers for dry goods like sugar and rice, with a built-in spout for ease of use. Schütte-Lihotsky went on to design kindergartens based on the theories of Maria Montessori, as well as other community projects. In 1930, as the political situation in Germany worsened, the radical Schütte-Lihotzky joined Ernst May and other architects in travelling to the Soviet Union to build twenty modern cities in the Communist state. She left in 1938 and took up a teaching post in the Academy of Fine Arts in Istanbul. With the outbreak of the Second World War, she returned to Vienna and joined the Austrian Communist resistance movement, only to be arrested by the Gestapo. She spent 1941 until 1945 in an imprisonment camp in Bavaria. Following the war, she settled in Vienna, but she found it difficult to secure work and was only honoured by the state towards the end of her life.

Another female pioneer working in modern design to be overshadowed by a male colleague was the French architect and designer Charlotte Perriand (1903–99). At the age of seventeen, Perriand won a scholarship to study on a five-year furniture design course at the Ecole de l'Union Centrale des Arts Décoratifs (UCAD, the Central School of Decorative Arts) in Paris. There, she grew frustrated by the emphasis on traditional skills and longed to reflect the everyday, modern materials she saw around her. She knew of Le Corbusier's reputation in the field and approached him for a job, to which he responded: 'We don't embroider cushions here'. He would, however, retract his statement when he viewed Perriand's exhibit at the 1927 Salon d'Automne, the Bar sous le Toît (Bar in the Attic), which used mirror glass and aluminium, with tubular steel furniture in the form of three barstools. The design was created by Perriand to address the challenge of living in her own small apartment on the Place Saint-Sulpice, and also included shaped, built-in cupboards with sliding doors. In the dining room she installed a wall-mounted, extendable table that could seat up to eleven. Around the table were her own tubular steel swivel chairs, round in form and mounted on ball bearings to allow the seats to move. Perriand also used the ball bearing form in chrome-

56 Charlotte Perriand on the chaise-longue basculante B306, 1928–29. Designed in collaboration with Le Corbusier and Charles Jeanneret, the support is moulded to the shape of the body, and the tubular steel frame can be moved to different angles on the metal base.

56

plate to make a necklace, which she wears while modelling the chaise longue. Le Corbusier had been struggling with the creation of suitable interiors and furniture for his Modernist buildings, using off-the-peg bentwood furniture by Thonet and hospital fittings. After seeing her work at the Salon d'Automne, he offered her a job at his Paris studio designing furniture and interiors, where she was a great success. Along with Le Corbusier's cousin, Pierre Jeanneret, Perriand designed three classic modern pieces of furniture: the LC2 Grand Confort armchair (1928), the B301 reclining chair and B306 chaise longue. The Grand Confort was unusual at the time, as its tubular steel structure was displayed on the outside of the chair, which consisted of large, leather-covered cushions with a slightly tilting back.

These designs were long attributed solely to Le Corbusier, but with monograph exhibitions at the Foundation Louis Vuitton, Paris (2019), and the Design Museum, London (2021), Perriand's long and distinguished career has at last been recognized. This has been reinforced by the dedication of her daughter, Pernette Perriand-Barsac, and partner, Jacques Barsac, who are keen advocates for her work and run her archives in Paris.

For the 1929 Salon d'Automne, Perriand designed a model apartment in Modernist style using glass and tubular steel, entitled Equipement d'Habitation (Living Equipment). She hoped that the furniture designs would be mass-produced, and approached the bicycle manufacturer Peugeot, but they were not interested in the project. Perriand's belief in the supremacy of metal over wood was made in her manifesto 'Wood or Metal', published in the British magazine *The Studio* in April 1929, in which she stated: 'METAL plays the same part in furniture as cement has done in architecture. IT IS A REVOLUTION.' Perriand was also involved with the Congrès internationaux d'architecture moderne (CIAM, International Congress of Modern Architecture), which was founded in 1928 by Le Corbusier and his Swiss patron, Hélène de Mandrot (1867–1948). Although accounts of CIAM rarely mention its female participants, they played an important role. The first meeting took place at de Mandrot's home, the Château de la Sarraz, near Lake Geneva. Perriand contributed to the second, held in 1929 in Frankfurt, Germany, on the theme of 'The Minimal Dwelling'. She produced plans for family living in a tiny flat that formed part of Le Corbusier's unrealized Ville Radieuse (Radiant City) scheme. She also attended CIAM 4, in Athens, on the theme of the 'The Functional City', and was recruited by Le Corbusier to help with the planning of CIAM 5, for which she duly attended a meeting at the Château de la Sarraz to map out the event on the theme of 'Dwelling and Recovery' in Paris in 1937.

By this stage Perriand and Le Corbusier's political views were diverging, with Perriand attending Communist meetings

57 Eileen Gray, *Magicien de la Nuit*, or *Om Mani Padme Hum*, c. 1912. This lacquered wood panel, inlaid with mother-of-pearl, was shown at the 1913 Salon des Artists Décorateurs. It reveals the Irish designer's fascination with Japanese lacquer techniques.

58 Eileen Gray, screen, 1923–25. Made from blocks of black, lacquered wood, arranged in seven rows and held together with vertical, slim metal rods that enable free movement of the components, the piece spans sculpture, design and architecture.

and Le Corbusier pursuing a more liberal agenda. Perriand left his studio in 1937 to work with the more radical Fernand Léger. In the same year, she designed the Manifesto coffee table for Jean-Richard Bloch, the editor of a Communist Party newspaper. The black top was printed with images by Picasso and Léger, denouncing the activities of the Spanish dictator Francisco Franco. During the Second World War she worked as an adviser for two years on industrial design for the Japanese Ministry of Commerce, then spent the remainder of the war years in Vietnam. After the war, Perriand returned to Paris and undertook commissions for Air France, including their offices in London, Paris and Tokyo, as well as designing the ambitious ski resort Les Arcs from 1967 to 1982, creating small, efficient, standardized rooms for 30,000 guests. This was the pinnacle of her career, combining her understanding of living efficiently in a minimal space with a growing appreciation of natural beauty, with every room enjoying a splendid view of the French Alps.

Japan was an important influence for another leading pioneer of modern design, Eileen Gray (1878–1976). Born in

Ireland, she was one of the first women to be admitted to the Slade School of Fine Art in London in 1897. She relocated to Paris and continued her study of the Japanese technique of lacquering, which she had first encountered in London, joining forces with Seizo Sugawara, who had moved to Paris from northern Japan. Gray mastered the painstaking skill, and produced decorative lacquered screens that were at first figurative, then abstract, attracting a wealthy clientele. She designed an entire apartment for the high fashion designer Madame Mathieu Lévy, which included the 'Dragons' chair, an Art Deco tub chair in sumptuous chocolate brown leather with support and wooden armrests painted to resemble leopard skin. The chair was later owned by the fashion designer Yves Saint Laurent. Gray opened her own retail outlet, Galerie Jean Désert, in Paris in 1922, selling her furniture and furnishings, which were a chic combination of Modernism and Art Deco.

57, 58

In 1929, she completed her most adventurous project, a villa on the south coast of France on the luxurious Côte d'Azur, with her partner, the Romanian architect Jean Badovici. Its name, E1027, is code for this: E refers to Eileen, 10 to J for Jean, the tenth letter of the alphabet, 2 stands for B and 7 for G. Badovici was caught up with his work as editor of the magazine

59

59 Eileen Gray, living room in E1027, Roquebrune-Cap-Martin, France, 1926–29. This modern space in the coastal retreat she built with her partner, Jean Badovici, displays Gray's impressive grasp of the modern ensemble.

L'Architecture Vivante, and so Gray took overall responsibility for the project. The design was, however, originally credited to Badovici, with Gray named as its amateur interior decorator, which understandably caused her significant upset. It is an easy, flowing space, with elements that offer comfort and relaxation, as well as practicality in its built-in cupboards and handy additions. Her Bibendum chair is seen to the left and the Transat chair to the right, with a day bed at the back. Gray ensured that light and heat could be controlled with blinds and shutters, and the acoustics were managed through the use of soft rugs and cork flooring. However, Gray's dream home was desecrated by Le Corbusier, who became obsessed with the structure after visiting as a guest of Badovici, and even built a small hut, Le Cabanon, right on the property line in 1952, violating the isolation she had sought. In the late 1930s, after Gray had left the house, he painted seven gaudy, sexually suggestive murals on the walls while naked without Gray's consent. Beatriz Colomina and Jasmine Rault have accounted for this act of sexual violence as triggered by Gray's troubling of patriarchal Modernism and her provocative sapphic lifestyle and designs. Happily, E1027 has since been restored and Gray's career and legacy given due respect.

Another pioneer of Modern design, Varvara Stepanova (1894–1948), is an example of a woman designer using Modernism to revolutionize life and as political propaganda. She trained in Fine Art at Kazan School of Fine Arts just before the Russian Revolution, from 1910 to 1913, and it was there that she met her future husband, Alexander Rodchenko (1891–1956). Rodchenko followed Stepanova to Moscow, where they lived together in an apartment owned by the painter Vassily Kandinsky. The new, revolutionary politics of the October 1917 revolution were aptly represented by the Modernism and Abstraction being developed by Stepanova, Rodchenko and other avant-garde artists, including Liubov Popova. This found a focus at the new research organization of Inkhuk (Institute of Artistic Culture), founded in 1920, which acted as a theoretical research hub for art. When the new Vkhutemas (Higher State Artistic and Technical Workshops) were opened in November 1921, Inkhuk provided the theoretical underpinning for the practical study of art and design, focusing more on form and materials than a traditional history of art. Stepanova herself abandoned her artistic career to focus on productive design work. She became one of the founding members of Productivism, which valued art as a trade, and practical design over academic fine art. With Popova, she was hired to design for Tinsdel, the First State Textile Factory in Moscow. Using simple, bold

РАБОТЫ СТЕПАНОВОЙ

Проэкты спорт-одежды

60 Varvara Stepanova, costume designs for women featured in *LEF* magazine, 1923. The bold colours and simple design signalled a new departure in revolutionary Soviet clothing for women.

60

patterns and primary colours, the designs signalled a new beginning in Soviet life and culture. Her clothing design was also simple, with loose-fitting garments including sportswear that enabled ease of movement and comfort, replacing the stiffness of bourgeois fashion. Stepanova became Professor of Textile Design at the Vkhutemas, before leaving to concentrate more on typography and book design, working on the radical publications *LEF* and *Novyi LEF*.

61

The radical possibilities of Modern design were used by the American architect Amaza Lee Meredith (1895–1984) for the home she designed for herself and her partner Edna Colson (1888–1985) during 1938 and 1939. The two African American women taught at the nearby Virginia State College, which had been founded in 1882 as the first higher education college in the US for Black students. As Jacqueline Taylor has demonstrated, the house, named Azurest South, was made Modern in concept and appearance to reflect a new, modern lifestyle. Distinct from the Colonial Revival buildings of the locality, this example of domestic architecture in the International Style is faced in white stucco, to emphasize the smooth, simple lines of its structure. A ship's ladder leads to the roof terrace, and picture windows punctuate the white walls. The single-storey building

61 Amaza Lee Meredith, Azurest South, Ettrick, Virginia, 1939. Meredith designed this radical modern home, which she also used as a design studio, for herself and her partner, Edna Coulson. Its flat roof and white walls contrasted with the Colonial Revival buildings in the area.

is accented in pale green, playing with the geometric forms that jut against one another.

Meredith initially trained as a teacher; though she had always longed to be an architect, her race and gender made this career path impossible. She studied for a master's degree in art history and art appreciation at Columbia University from 1930 to 1935, and during her time in New York was inspired by MOMA's 'Modern Architecture: International Exhibition' of 1932 and design exhibitions at the Brooklyn Museum. She established the Art Department at Virginia State College in 1935, which she led for the rest of her life. The home she created provided a sanctuary, with a central living space and north-facing studio with built-in furniture and fittings also designed by Meredith. Born at the time of the Jim Crow segregation laws, Meredith and Colson lived to see lawful segregation end with the Civil Rights Act of 1964.

Training for women wishing to enter the field of architecture improved in Europe during the inter-war years, with the Architectural Association in London admitting women from 1917 onwards. The most prominent of these women was Elisabeth Whitworth Scott (1898–1972), who won the prestigious international commission to design the Shakespeare Memorial Theatre in Stratford-upon-Avon in 1928. This was the first major public building in Britain to be designed by a female architect. Her design was chosen from a strong field of seventy-two entries, and drew inspiration from Dutch and Scandinavian Modernism. Scott formed

62, 63

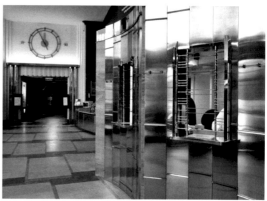

62 ABOVE Elisabeth Scott (Scott, Chesterton & Shepherd), Shakespeare Memorial Theatre, Stratford-upon-Avon, Warwickshire, 1927–32, now called the Royal Shakespeare Theatre. Scott was the only woman to enter the competition to design the theatre, and won in a field of over seventy men. It was the first major public building in Britain to be designed by a woman.

63 RIGHT Scott's original design for the entrance foyer of the Shakespeare Memorial Theatre, 1932. The paybox is on the right, faced with small rectangles of stainless steel, in contrast to the bare red brick of the walls.

the firm of Scott, Chesterton and Shepherd with her former employer, Maurice Chesterton, and fellow architect John 'Jock' Shepherd to complete the project. The river front is heavily fenestrated, and the main structure is built from brick and clearly articulates the functions of the separate areas within. The original auditorium could seat 1,000 in a cinema-style layout. The entrance foyer and corridors are more flamboyant, decorated with mirrors and other Art Deco features. In 1971, the building was awarded Grade II listed status.

The history of design has tended to down play the contribution of women working in heterosexual relationships, in a 'designer couple'. The named, male partner takes centre stage and comes to stand in for both party's work. Aino Marsio-Aalto (1894–1949) is a prime example of this historical sleight of hand. Born in Finland, she trained as an architect at the Helsinki Institute of Technology and qualified in 1920. She had

64 Aino Marsio-Aalto on the Paimio chair, c. 1930. Pictured here as a ghostly figure, Marsio-Aalto designed this chair, which was used to furnish the Paimio Sanitorium, with her husband, Alvar. Her contribution to their work and to their company, Artek, is frequently overlooked.

met Alvar Aalto on the same programme of study and joined his practice in 1924. They subsequently married. The couple were convinced by the aims of the Modern movement, and were part of an international network that included Le Corbusier, László Moholy-Nagy and Walter Gropius. The Aaltos' best-known project is the Paimio Sanatorium of 1933, where they designed everything from the building to its bentwood and tubular steel features and furniture. The Paimio chair, consisting of one sheet of bent plywood fixed to a curved, wooden frame, is possibly their best-known collaborative design. Aino can be solely credited as the designer of their summer retreat, the Villa Flora, of 1926. Located on the banks of Lake Alajärvi in the west of Finland, the simple model structure had a green, living roof. Aino was also the designer of the popular and practical Böljeblick glassware range of 1932, with its ridged profile applied to glasses, jugs and bowls in a range of colours. But most of her work was conducted in collaboration with her husband, including the foundation of the successful firm Artek, established in 1935 by the Aaltos, the art historian Nils-Gustav Hahl and the wealthy philanthropist, Marie Gullichsen. Aino was Creative Director of the organization, which showcased modern interior design for sale to the public. Under her able

62

direction, Artek undertook over eighty interior commissions, including for Helsinki's Malmi airport in 1938 and 1948.

The international reputation of the firm grew, and the Aaltos also raised their profile through the design of the Finnish Pavilion at the New York World's Fair in 1939. With its undulating wooden walls, covered with blown-up black-and-white photographs, it was a fitting structure to symbolize a country that had only gained independence in 1917. Aino died in 1949 at only fifty-four, but her legacy continues through the sustained popularity of Artek and the Böljeblick glassware.

While the female pioneers of modern design have contributed to the sustained success of the movement, the role of the patron should also be considered. Without the support and creative input of a client, the success of modern architecture could not be guaranteed. For example, the feminist and wealthy supporter of modern theatre Aline Barnsdall (1882–1946) worked with the office of Frank Lloyd

65 ABOVE Frank Lloyd Wright, Hollyhock House, East Hollywood, California, 1919–21. Designed in collaboration with his client Aline Barnsdall as a home and arts complex, and named after her favourite flower, the Mayan Revival-style terraces and buildings are now the centrepiece of the Barnsdall Art Park.
66 RIGHT Aline Barnsdall in the grounds of Hollyhock House, East Hollywood, California. The main residence and two apartments were eventually built surrounding a central courtyard, emphasizing a fluidity between outside and inside. Barnsdall exerted a powerful influence over the design.

Wright throughout the early twentieth century to create her vision for a public theatre in Los Angeles. Barnsdall had met Wright in Chicago, and was excited to learn that he shared her belief in the importance of building a new, American culture for the masses. As Alice Friedman has demonstrated, only part of this shared vision was realized when Barnsdall purchased a thirty-six-acre plot of land, Olive Hill, in Hollywood in 1919. Barnsdall had initially imagined an arts complex, with a large theatre at the heart, a home for herself, smaller residences for the principles of the new theatre company, shops and apartments for actors and technicians set in landscaped

65, 66 grounds. Only a residence for Barnsdall – Hollyhock House – and residences A and B were ever completed. The exterior of the house was based on traditional Mayan sources, with smooth plaster walls sloping back at an angle of eighty-five degrees and geometric blocks that echoed the pueblos of southwest America. Barnsdall was definite that the architecture should be distinctly American and be half-garden, half-house. The building was sizeable, with seventeen bedrooms and seven bathrooms, and a range of terraces and outdoor seating areas made possible by the climate. The building sat easily within the flat, dry landscape of California, and was adorned with contrasting greenery, including Barnsdall's favourite flower, the hollyhock, for which it was named. The hollyhock also featured in Wright's stained-glass windows and wall decorations. The most important component of the Olive Hill project, the outdoor theatre, was never built. Barnsdall and Wright could not agree on the design, her core of theatre practitioners had deserted her and the building was thwarted by officialdom and by the client's tendency for prevarication. Barnsdall instead turned her attention to supporting the new Hollywood Bowl, and bequeathed Hollyhock House to the City of Los Angeles. It was initially used as the California Art Club headquarters and is now the centrepiece of the Barnsdall Art Park.

Another important client for modern architecture was the Dutch pharmacist Truus Schröder-Schräder (1889–1985). She was married to a lawyer, Frits Schröder, and lived in his typical, bourgeois apartment in Utrecht. Truus claimed one of the rooms in the apartment as her own, and commissioned the Dutch De Stijl architect Gerrit Rietveld (1888–1964) to execute the interior design in simple, Modernist taste. When she was widowed in her mid-thirties, with three small children, she turned again to Gerrit Rietveld to help her design a daringly modern home that reflected her new lifestyle. The

67 Schröder House was built during 1924 and 1925 in a suburb of Utrecht, and was Rietveld's first commission for a house.

67 Truus Schröder-Schrader with the Red and Blue Chair designed by the architect Gerrit Rietveld in her Schröder-Schrader house. She co-designed the house with Rietveld, also her lover, who eventually lived there from 1957 until his death in 1964.

As an independent woman, Schröder-Schräder dictated the parameters of the brief and was certainly the co-designer of her new home, despite later histories that name only Rietveld as the architect.

Rietveld proposed that the upper storey be a completely open space, without internal walls. However, Schröder-Schräder insisted that she and her children might need some privacy, and so the space was fitted with moveable partitions that divided the area into rooms or not, according to the wishes of the inhabitants. She also designed the built-in furniture to make the best use of the small space while allowing a feeling of light and air, with well-placed picture windows and unadorned walls. The ground floor was more conventional in layout, but the flow of light was engendered by placing a glass partition above each door. Schröder-Schräder lived in the house for the rest of her life. Her daughter, Johanna Erna Elsa 'Han' Schröder (1918–82) became one of the first women to be licensed as an architect in the Netherlands, and would later help to restore her childhood home, now a museum.

Chapter Four
Decorating Women

At the beginning of the twentieth century, the conventional sphere of influence for women was the home, the decorative and the ephemeral. The public world and history of industrial design and architecture has long been closely aligned with male achievement. However, during the first half of the twentieth century, female designers turned this gender divide to their advantage, establishing successful careers in the field of decoration and working in the gaps left by Modernist designers who rejected ornament, most notably Le Corbusier. As Bridget Elliott and Janice Helland argued in 2002: 'Thus softness and interiority, decorative and ornamental all participate in the binary categorizations so familiar to western culture and all collect together as feminine.' This included the so-called 'Lady Decorators', the rather belittling term given to women who were often untrained but traded on their perceived good taste, working with prestigious clients to install decorative schemes in high-end homes. Women also pursued careers in the decoration of public spaces, obtaining contracts to embellish hotels, offices and forms of transport. Women pioneered the field of colour forecasting in design, and women designers' and advertisers' understanding of consumer culture revolutionized the look and appeal of mail order catalogues and the goods represented on their pages.

68 *The House in Good Taste* (1913) was a popular design advice book written by Elsie de Wolfe (1865–1950), arguably the first professional interior decorator and definitely the first 'Lady Decorator'. Taste in the decorative arts had always been invested as a feminine trait, and exercising it in the field of interior decoration was an acceptable way in which to earn a living and gain professional prestige for women throughout the twentieth century. Conventionally marginalized by

68 Portrait of Elsie de Wolfe, c. 1910–15. America's first female interior decorator poses in her signature furs. Originally an actress, she understood how to create a media presence, and worked with wealthy clients on their interior schemes throughout the early twentieth century.

architectural and design history, and indeed by architects and designers, the rich and diverse history of interior decoration firmly situates women in the design world. As a practice it includes the selection of colour schemes, furniture and furnishings, floor treatments and lighting, often complementing the client's existing collection of heirlooms with a new scheme. Interior decorators are rarely involved with the structure of a building, which is the preserve of the architect. The interior design profession, which developed later in the twentieth century, represents a different perspective, and is frequently more involved with the fabric of the building.

The profession of interior decorator grew out of the Victorian supposition that women were inextricably connected with the home and had more refined taste than men. This idea translated into the nineteenth-century obsession with taste and public display, which mirrored social, gender and racial divisions. To possess 'good taste' was regarded as a cultural asset for the middle and upper classes, and the supposed lack

thereof was used as a weapon with which to dismiss the culture of perceived inferiors. Cultural capital came in the shape of historical knowledge about classic styles and materials. Inspired by the novelist Edith Wharton's book *The Decoration of Houses*, published in 1897, Elsie de Wolfe celebrated the tastes of eighteenth-century France in her career as an interior decorator as much as Le Corbusier lauded 'everlasting Modernism' as an architect.

De Wolfe gained notoriety through her first commission, the 1905 interior of the women-only Colony Club in New York City, designed by the architect Stanford White, an acquaintance of hers. The scheme, with its simple décor of pale green trellis-effect wallpaper with a cream background and plain, cane chairs reflected a mood for pared-down design, as opposed to the opulence of the *belle epoque* or the stuffy leather chairs and dark wood panelling of the gentlemen's club. Through this popular commission, in 1913 de Wolfe won the prestigious and lucrative contract to decorate the private apartment in Henry Frick's mansion on Fifth Avenue, buying antiques on his behalf for a generous commission of ten per cent of costs, which came to a hefty 1 million dollars. She made trips to Paris to purchase genuine antiques, mainly from Lady Victoria Sackville-West, and shipped these back to New York. De Wolfe had been an actress on stage and screen, and this celebrity status only enhanced her reputation, although she was more revered for her taste in dress than her acting skills.

69 Elsie de Wolfe features in an advert for 'The Colony Club', in *The Topeka State Journal*, 12 September 1907. Her first public commission, in 1905, was to decorate the women-only club in New York.

The House in Good Taste built on de Wolfe's earlier published writing for *Good Housekeeping* and the *Delineator*, where she shared her views on décor. She was clear that it was the preserve of women: 'We take it for granted that every woman is interested in houses – that she either has a house in course of construction, or dreams of having one, or has had a house long enough wrong to wish it right. And we take it for granted that this American home is always the woman's home: a man may build and decorate a beautiful house, but it remains for a woman to make a home of it for him. It is the personality of the mistress that the home expresses. Men are forever guests in our homes, no matter how much happiness they may find there.' She illustrated her guide book to good taste with images of her own home in New York, which she shared with Elisabeth Marbury (1856–1933), her lifelong partner and a wealthy literary and theatrical agent who represented Oscar Wilde and George Bernard Shaw, amongst others. De Wolfe enjoyed a comfortable lifestyle, with a string of commissions, eventually settling at Villa Trianon, a small house on the edge of Versailles, France, that she and Marbury had acquired in 1905.

Other women to forge successful careers as interior decorators in the US include Nancy Vincent McClelland (1877–1959), who established a decorating service, Au Quatrième, at Wanamaker's Department Store in New York in 1913, the first of its kind in the world. McClelland studied English and Latin at Vassar College and wrote for the *Philadelphia Press* before joining the advertising department of Wanamaker's Department Store in Philadelphia in 1900, where she was responsible for arranging store displays and window treatments. The turning point came in 1907 when she travelled to Paris, known as the centre of modern taste, as a representative of Wanamaker's. There, she studied the history of art and visited museums and chateaus, which inspired her enthusiasm for historic wallpapers and interiors. Au Quatrième, opened on her return to the US, supplied French, English and American antiques and offered advice about placing the items in the clients' homes. As a result of its success, McClelland set up her own decorating company in 1922, specializing in historic interiors for homes and museums. She also published extensively, and earned a reputation as an expert on the history of wallpapers with her first book, the classic reference work *Historic Wallpapers* (1924). She attracted important clients such as John D. Rockefeller and restored a range of house museums, including Mount Vernon in Virginia. McClelland was a strong advocate for the professionalization of interior decoration, was instrumental in the founding of the American Institute of

Interior Decorators (AIID) in 1931 and in 1941 became its first female president.

70 McClelland's role at Wanamaker's in New York was taken over by the author and critic Ruby Ross Wood (1881–1950). Wood had ghostwritten the *Good Housekeeping* articles published under de Wolfe's name and repackaged into *The House in Good Taste*, and she published her own guide to taste, *The Honest House*, in 1914. This was illustrated with images of her own home at Forest Hills on Long Island, which was more modest than de Wolfe's New York mansion. Wood had founded her own design company, Modernist Studios, inspired by the Wiener Werkstätte, in the same year as the publication of her book, but it had failed. At Wanamaker's, Wood managed to popularize not only English but also American eighteenth-century furniture. Wood left Wanamaker's in the 1920s to set up another decorating firm, and went on to design the interiors of Swan House, Georgia, incorporating antiques, for Edward and Emily Inman, the beneficiaries of a cotton brokerage fortune. The commission was completed in 1928, Wood working with the architect Philip T. Shutze, who designed many buildings in and around Georgia in Renaissance revival style. This was her only commission in her home state, and she continued to earn a living decorating mainly second homes in Miami and New York State with tasteful antiques.

71 Eleanor MacMillen (1890–1991), known as Eleanor MacMillen Brown from 1935, wanted to professionalize interior decorating and move it away from the preserve of tasteful Lady Decorators.

70 Ruby Ross Wood sitting at her desk in 1948. Among the original American interior decorators, Wood began her professional career as a journalist, ghost-writing articles for Elsie de Wolfe. She then designed interiors for wealthy clients, including Swan House in Atlanta.

71 Eleanor McMillen, sitting room for the socialite Mrs Millicent Rogers, late 1920s. McMillen founded her own company, McMillen Inc., in 1924; the first professional interior design firm in the US, it provided a total service, from architecture to financial management.

She studied art history and business, before founding McMillen Inc. in 1924 as 'the first professional interior decorating firm in America'. The firm still exists today, and from its beginning has specialized in producing schemes that combine French and English antiques with characteristic, historic wall treatments.

The classical 'good taste' of the founders of interior decorating in America quickly began to be challenged by women who sought a less reverent, more playful approach. Dorothy Tuckerman Draper (1889–1969) worked with unexpected combinations of inside/outside and scale in her commissions, including the Arrowhead Springs Hotel in Southern California. She was one of the best-connected interior decorators in the US, and in 1925 opened the Architectural Clearing House, which paired clients' architectural aspirations with the most appropriate practice for the job. In 1930, she opened Dorothy Draper and Company, which offered a full design and decoration service. Following a divorce, she needed to support herself financially, and, like de Wolfe before her, saw the career of interior decorator as a suitable way to fulfil this aim. As she stated: 'There are two types of women, those who are happily married and those who are decorators.' She favoured

the Baroque mode, and used the familiar scrolls of the style in blown-up, oversized plaster decorations. Her 1937 design for the Hampshire House, overlooking Central Park in New York, was the big contract that put her name on the map. The public spaces, apartments, restaurant and entertainment suite were designed in eye-catching, overblown Baroque with strong colour schemes. This led to further prestigious commissions, including Arrowhead Springs Resort near San Bernardino, California in 1939, the Quitandinha Resort in Brazil in 1944 and the Greenbrier Resort in West Virginia in 1948. As well as her apartment and hotel designs, Draper reached out to American homemakers throughout the Depression with her newspaper column 'Ask Dorothy Draper', which appeared in seventy-seven newspapers. She advised her readers to paint their doors red, which many did, and created a ready market for her 'cabbage rose' pink chintz, which sold over one million yards. Her reputation has recently been revived, with reprints of her 1941 advice book *Entertaining is Fun! How to be a Popular Hostess* in 2004 and 2016, and an exhibition devoted to her work at the Museum of the City of New York in 2006.

72

More flamboyant even than Draper was Rose Cumming (1887–1968). Born in Australia, Cumming emigrated to New York with her sister, the Hollywood film actress Dorothy Cumming, in 1917. She opened her first shop in 1921, selling French antique furniture alongside smaller merchandise, and became well-known for leaving her shop window lights on all night to advertise her wares. As a decorator, she favoured Chinoiserie, reflective surfaces, including a metallic wallpaper of her own invention, and gold veined mirrors, all in a sultry, Venetian style. She counted the Hollywood aristocracy among her clients, including Mary Pickford, Marlene Dietrich and Norma Shearer.

Hollywood during the 1920s and 1930s was a male-dominated industry, with women finding work as actresses, chorus girls, script writers and gossip columnists. The directors, producers and art directors were predominately male. One notable exception was the art director and costume designer Natacha Rambova (1897–1966). Born Winifred Kimball Shaughnessy in Salt Lake City, she left with her mother, also Winifred, following the latter's divorce. They made their way to San Francisco, where the elder Winifred married Edgar de Wolfe, the brother of interior decorator Elsie de Wolfe, in 1907. This afforded the young Rambova a privileged insight into the world of culture and fashion, as she visited her step-aunt at the Villa Trianon; through her, she met one of her greatest design influences, Paul Poiret. Although Rambova's mother was to remarry for a third time, Rambova's relationship with Elsie de Wolfe continued.

72 Rose Cumming, bedroom in her New York apartment, 1946. A flamboyant decorator, here she deployed blue metallic wallpaper with matching blue lamé curtains and a Persian children's bed used as a table.

It was after seeing a performance of *Swan Lake* in Paris with de Wolfe that Rambova decided to become a professional dancer. She travelled to New York to become part of the Imperial Russian Ballet Company under Theodore Kosloff. By the time film mogul Cecil B. DeMille offered Kosloff work dancing in and choreographing his films, Kosloff and Rambova were in a relationship. The pair moved to Los Angeles in 1917. Rambova worked as Kosloff's researcher and in 1920 designed sets and costumes for DeMille's *Forbidden Fruit*, although it was Kosloff who received full credit. Rambova subsequently entered a fruitful partnership with the Russian-born actress, producer and director Alla Nazimova (1879–1945). Her first project was *Billions* (1920) and the pair then started work on a production of the sultry *Aphrodite*. Rambova designed costumes inspired by carefully researched Greek, Aztec and Egyptian models, but the studio, Metro, decided not to progress with the final production due to worries over censorship. Rambova and Nazimova then collaborated on two classics, *Camille* (1921) and *Salomé* (1923). The sets and costumes of *Camille* are inspired by

73

Decorating Women

73 Natacha Rambova, art direction and set design for *Camille*, 1921. Although best known for her marriage to the screen icon Rudolf Valentino, Rambova was a pioneering art director in early Hollywood. She used simple, Art Deco lines combined with rigorous historic research.

the Art Deco chic of 1920s Parisian high style, where the silent film was set. On set, Rambova began a relationship with her future husband, *Camille*'s leading man, Rudolf Valentino. It is for this association, rather than her design work, that she is best known. Her work on *Salomé* was inspired by the work of the Victorian Art Nouveau illustrator Aubrey Beardsley, with all of its erotic undertones. While neither film was a commercial success, their artistic achievement was great. Rambova continued unsuccessfully with film work after the end of her marriage in 1925, but found success later in life as a published author on Egyptology.

Syrie Maugham (1879–1955) was a London-based interior decorator who counted Hollywood glitterati including the screen actresses Tallulah Bankhead and Jean Harlow among her clients. She found fame with the design of her 'All White Room' in 1927, which she launched with a midnight party for her well-connected friends. The room featured numerous shades of white, cream and taupe, with a specially designed rug by Marion Dorn (1896–1964), white upholstered seating and a glamorous, mirrored screen. The space was accentuated

with vases of extravagant white lilies, chrysanthemums and gardenias. The overall look was one of classic chic, and Maugham pursued a successful and lucrative career on both sides of the Atlantic. Her social contacts were mainly supplied by her short-lived second marriage to the novelist Somerset Maugham. As part of the 1928 divorce settlement, Syrie took possession of 213 Kings Road, where the All White Room was

74 Syrie Maugham, the All White Room at her house, 213 Kings Road, London, 1933, which was launched at a midnight party in 1927. Maugham was at the centre of a transatlantic network of socialites including Cecil Beaton and the then Prince of Wales.

situated, a Rolls Royce and a generous stipend. By 1930 she had showrooms in London, New York and Chicago and employed twenty staff. She made a particular name for herself by stripping antique furniture of its brown varnish and staining the wood white, or 'pickling' it, as it was known. She also used modern fabrics to upholster antique furniture for use in her decorative schemes.

A contemporary of Syrie Maugham, Lady Sibyl Colefax (1874–1950) also specialized in high-end domestic interiors. She entered the profession aged fifty-five out of financial necessity: she had lost most of her fortune in the Wall Street Crash of 1929 and her husband could no longer work due to disability. Colefax was already known as a society hostess, entertaining the likes of Winston Churchill, Fred Astaire, Charlie Chaplin, Maynard Keynes, Virginia Woolf and Neville Chamberlain at the couple's Palladian Argyll House on King's Road, London. When her husband, Lord Arthur Colefax, died in 1936, Sibyl had to sell her home, moving to a modest flat in Westminster. She had established her own business in 1930, supported by the purchase of the decorating part of the antiques firm Stair and Andrew and a partnership with Peggy Munster, later Countess Ward. Lady Sibyl Colefax Ltd specialized in comfortable interiors based on the English country house style mingled with touches of Regency in the pale, tasteful colour schemes inspired by Adam. Sybil Colefax also specialized in English chintz, and her business became so lucrative that in 1938, after Munster had left, she took on a new partner, the decorator John Fowler. At the end of the second world war, Colefax sold her share of the business to Nancy Lancaster (1897–1994), the niece of the American Lady Astor. The firm continues today as Colefax & Fowler, an exclusive interior decorating company based in London, still selling Sybil's signature chintzes.

Betty Joel (1896–1985) was a visionary designer of interiors and furniture who understood marketing and popular taste. She did not share the social standing of either Syrie Maugham or Sibyl Colefax, and wanted to design stylish yet functional furniture and spaces for everyone. As she argued in 1935: 'It is quite wrong to sneer at mass-production. Half the time this is sheer snobbery.' She established the business Betty Joel Ltd with her husband, David Joel, in 1919, prompted by her unsuccessful attempts to buy appropriate furniture for her own home. She had no training, but understood the needs of the new, growing consumer market for stylish furniture and interiors. The target market for Betty Joel Ltd was the middle-class housewife, and furniture was produced to her designs at the 'Token Works', the company's factory on Hayling Island near Portsmouth.

Each piece carried her signature along with that of its maker. The furniture was made by joiners who normally worked as yacht fitters, and were skilled at producing work with a seamless finish in oak and wood veneer. The venture was so successful that a larger factory was opened in Kingston-upon-Thames in 1929, and the original showroom in Sloane Street was replaced by a complete house at 25 Knightsbridge, where the couple also lived. The premises had room sets and a gallery space for customers to view Joel's wares alongside French Art Deco objects, modern prints, textiles and rugs. Betty Joel also undertook individual commissions, including the Harley Street office for the eye specialist F. A. Williamson-Noble. The furniture is now in the collection of the Victoria and Albert Museum, and includes an Art Deco curved desk with matching wastepaper bin in oak with metal finishes. Perhaps Betty Joel's most prestigious commission was for the decoration of Lord Louis Mountbatten's Mayfair penthouse in 1937. The living

75

75 Betty Joel, study in Lord Mountbatten's apartment, 1938. This modern flat, decorated in pale woods by the pioneering furniture and interior designer, included a relief map of the world on the wall.

room featured a stylized map of the world on the wall and had peach built-in seating with a coffee table formed of glass rods that supported a circular, wooden top. This was to be one of Betty Joel's last commissions, as she retired from the design world following her divorce in 1937. David Joel kept the furniture business alive until the 1950s.

While Betty Joel was inspired by the fine cabinet-making skills of yacht fitters, Elsie Mackay (1893–1928) designed the interiors of ocean-going liners. Both designers were dismissed by the design establishment, but their work reflected the popular taste for Art Deco, and in the case of Mackay, for the recreation of historic interiors. Mackay was the daughter of Lord Inchcape, chairman of the shipping firm Peninsular and Oriental Steam Navigation Company (P&O), a company born out of the particular geography of the British Empire. It specialized in travel by ship from Great Britain to destinations in Africa, Asia and America. Travelling with his wife and children, Lord Inchcape had been made aware of shortcomings including lack of hanging space for clothes, badly placed mirrors and lighting, and dated décor that did not match the luxury of liners serving the transatlantic route. He therefore employed his youngest daughter, Elsie, as an interior decorator, to advise on matters of taste. In common with many of the 'Lady Decorators', she had no training and gained the work through her social position, though she had acted in silent films and understood something of set design. In 1925, she worked on the four 'R'-class ships, the *Rawalpindi, Ranchi, Ranpura* and *Rajputana.*

Mackay's best-known work was for P&O's first turbo-electric ship, the *Viceroy of India*, in 1929. For the liminal space of the verandah café, she chose to draw on features of Islamic architecture, with pointed arches surrounding the windows and ceiling mouldings based on the *Rub el Hizb* symbol of two overlapping squares. First-class passengers could move from the café through to the first-class smoking room, which was decorated in a Jacobean style, inspired by the seventeenth-century State Room of the Old Palace in Bromley-by-Bow, which had been created for James I and reconstructed at the Victoria and Albert Museum. Such interiors offered passengers a sense of comfort and distraction from the risks and tedium of lengthy ocean travel. The décor was criticized in the design press, although McKay was never credited by name for designing it, apart from in P&O's in-house magazine, *The Blue Peter.* The owner of the rival Orient Line, Colin Anderson, commented on the design and included a photograph of it in *The Journal of the Royal Society of Arts*: 'In the early 1920s a palatial grandiosity still pervaded even the architect-designed rooms I am speaking

76 Elsie Mackay, first-class smoking room on board the P&O ocean liner RMS *Viceroy of India*, 1929. This baronial pastiche was an early and rare example of a woman designing ship interiors.

of. They tended to have classical pillars, rich metal balustrading and a high central area. We were probably the only shipowners who did not provide those favourite shipboard aids to gracious living, armour and baronial stone fireplaces.' Sadly, Mackay never experienced the final results of her work, as she died in 1928 while attempting to be the first woman to cross the Atlantic by air.

Other women involved in the decoration of ocean liners included the Scottish sisters Doris Clare Zinkeisen (1897–1991) and Anna Katrina Zinkeisen (1901–76), who trained first at Harrow School of Art and then the Royal Academy, and developed skills as fashionable, figurative painters. They also designed posters for London Transport and decoration and costumes for stage and screen. They saw nothing wrong with producing work in both spheres; as Anna declared in an interview with *Eve* magazine in 1926, 'You needn't cast aside your great ambitions and your dreams of pure Art because you

work in an economic and competitive commercial world as well; the idea that the two things are incompatible is wrong'. The pair were approached by the luxury transatlantic liner company Cunard, who were building their most prestigious ship to date, the *Queen Mary*, which launched in 1936. The American architect Benjamin Wistar Morris (1870–1944) worked as an advisor on the interiors of the *Queen Mary*, and wrote to the Cunard Board in 1935: 'I believe for business reasons it is highly desirable that cultivated feminine thought should have expression if it can be done in a practical way. For example, it would seem that Miss Doris Zinkeissen [sic]....[has] many of the required qualifications.' Doris and Anna were employed to decorate the first-class verandah grill, the top nightspot on the ship, which served as the *à la carte* restaurant and cocktail bar. Doris undertook the main design work, specifying black Wilton carpet to surround a small dancefloor in pale, sycamore parquet. She also chose cream furniture with white upholstery to stand out against the dark carpet, along with crisp, white tablecloths. The curtains were red velvet with gold stars and the lighting, also chosen by Doris, changed colour with the beat of the music on the dancefloor. Doris painted a thirty-foot mural for the space, entitled *Entertainment*, which consisted of lyrical, carnivalesque figures and took her three months to complete. Anna painted six panels for the ballroom, based on the theme of the four seasons.

The designer Marion Dorn (1896–1964), meanwhile, designed a series of rugs for the Orient Line's iconic ship *Orion*, which launched in 1935 to serve the route from the UK to Australia. The brief was to design a more modern ship than the likes of the ostentatious *Viceroy of India* or *Queen Mary* (for which Dorn had also received a commission). Dorn's floor coverings and fabrics were used to enhance many a modern interior, be it on ships, trains, buses or in hotels or homes. Born in San Francisco and trained in graphic design at Stanford University, she first pursued a career in textile design, particularly batik. In 1923, Dorn visited Paris with the American textile designer Ruth Reeves (1892–1966). Reeves remained in Paris until 1927 and studied at the Académie Moderne under Fernand Léger. Upon her return to America, her best known commission was the Art Deco carpeting and wallcovering for the Radio City Music Hall, New York, in 1932. Marion Dorn, however, travelled on to London with the American designer Edward McKnight Kauffer, where they set up home.

Dorn received coverage of her work in *Vogue*, then edited by Dorothy Todd (1883–1966) with Madge Garland, her partner, as fashion editor (1898–1990). *The Studio Yearbook* and *Architectural*

77 Madame Yevonde, photograph of Doris Zinkeisen, 1936. The artist is shown on board the Cunard ocean liner RMS *Queen Mary*, where she is decorating the chic Verandah Grill with images of jazz musicians and dancers.

Review also featured her work and demand for her striking, modern rugs and textiles grew. As well as ships, she specialized in hotel commissions, including work for the Berkeley Hotel and Claridge's. Perhaps her best-known commission came from Oliver Hill, for carpets and rugs for the London Midland Scottish Railway Company's Midland Hotel in Morecambe, Lancashire, from 1932 to 1933. The most prominent element was

78

78 LEFT Marion Dorn, large, circular rug in the foyer of the Midland Hotel, Morecambe, Lancashire, 1934. The leading textile designer created two hand-knotted, circular rugs for the space, with brown wavy lines inspired by the nearby coastline.

79 BELOW Enid Marx, *Shield* moquette, shown here in a 1938 carriage refurbished in 1949 by London Transport. Marx's vibrant red and green geometric pattern was complemented with green armrests. It is her best-known design.

two hand-knotted circular rugs for the spectacular entrance hall. They were almost five metres (15'6") in diameter and decorated with interlocking, wavy lines that referenced the sea outside, in brown and brick red against a cream background.

79 In 1936, Dorn was hired by Frank Pick, along with another woman designer, Enid Marx (1902–98), to design new, modern fabrics for the London Passenger Transport Board (LPTB). The textile was moquette, a hard-wearing woollen fabric not unlike carpet in its density, yet velvet-soft to the touch. Dorn produced eight designs for LPTB, including the well-known *Colindale* and *Chesham* patterns in dark reds and greens to blend with the red leather-effect trim. At the outbreak of war, Dorn and McKnight Kauffer were forced to return to America, where their careers failed to match their heyday of the 1930s.

Enid Marx designed seven fabrics for LPTB, four of which were selected for use. Marx had studied at the Central School of Arts and Crafts and the Royal College of Art, before joining the textile design studio of Phyliss Barron (1890–1964) and Dorothy Larcher (1884–1952) from 1925 to 1927. Barron and Larcher were the leading exponents of hand-block printing throughout the 1920s and 1930s. Marx then established her own studio, which became famous for its block-printed textiles. She also designed postage stamps and worked as a book illustrator. She held a lifelong fascination with folk art, and collected objects as well as publishing books on the subject with her creative partner, the historian Margaret Lambert (1906–95). Their comprehensive collection is now housed at Compton Verney in Warwickshire.

80 Phyllis Barron and Dorothy Larcher, cushion cover, 1925. An early example of the pair's experiments with delicate natural dyes and hand-block printing for furnishing fabrics.

Textile design was also an area in which women were able to specialize in Scandinavia. Many women set up studios for the production of handmade cloth during the inter-war years, and one such woman designer, Greta Skogster (1900–94), led the field of Finnish textile design. She employed twenty-three weavers and used a range of power looms in her workshops to produce large orders of textiles for a range of clients, including the Finnish Steamship Company and Finnish Railways. Skogster's contribution to these public interior design schemes are often left unattributed, however. As Leena Svinhufvud has demonstrated, her work for the headquarters of the paper-mill company Enso-Gutzeit in 1935 is recognised only in terms of a tapestry '"woven by the artist", but fails to notice furnishing fabrics, curtains and carpets she had designed, as if they formed a naturalized part of the architecture'.

Constance Spry (1886–1960) had a considerable influence on the design of both homes and gardens through her advice books, broadcasts, education, lecture tours and demonstrations. She revolutionized the world of flower design by advocating the use of more natural displays, using a range of everyday, unusual components such as baking trays and kale. Her career began in 1927, when she was awarded the contract to supply flowers to the British Granada Cinema chain, as well as providing four window displays for the perfumier Atkinsons in London's West End. In 1929, she opened her first shop, Flower Decorations, and her work started to draw attention. So successful was her business that by 1934 she was employing seventy people and had moved to larger premises in Mayfair, where she opened the Constance Spry Flower School. She designed the flowers for aristocratic weddings, beginning with The Duke of Gloucester and Lady Alice Montagu Douglas Scott in 1935 and the Duke and Duchess of Windsor in 1937, creating informal bouquets using water lilies and tulips. Spry was also popular in the US, where she undertook lecture tours there before the war, opening Constance Spry Inc. in New York in 1938. The shop was furnished with items from Syrie Maugham's New York store. Serious consideration of Spry as a designer has been controversial, and when an exhibition devoted to her work took place at London's Design Museum in 2004, it resulted in the resignation of James Dyson, then-Chair of the Board of Trustees, and criticism from Terence Conran and Stephen Bayley, the museum's founders. As Deborah Sugg Ryan has argued, this type of work was not perceived as good design, and so led to a storm of controversy in the press 'predicated on out-dated paternalistic modernist, middle-class notion of taste, favouring industrial design'. The situation changed in

81 The pioneer of floral arrangement as modern decoration, Constance Spry creates a centrepiece for her home, Winkfield Place in 1953. Irregular branches of magnolia are arranged in a mirrored vase with other foliage to create maximum impact.

2021, when the Garden Museum in London staged an exhibition devoted to her work.

Women were also important clients and co-designers of interior decorating schemes, which were often used to express individual style and subvert traditional values. For example, the Surrealist artist Eileen Agar (1889–1991) was instrumental in the design of her apartment and studio in London. Agar had studied at the Slade School of Fine Art and visited Paris during 1927, where she mingled with abstract artists and the Surrealists, eventually becoming a member of the *Cercle et Carré* (Circle and Square) group, which also included the Swiss-born artist and designer Sophie Taeuber-Arp (1889–1943). Taeuber-Arp was married to the abstract artist Hans Arp, and when the pair settled in Clamart, near Paris, in 1929, she designed a home for them. Complete with a separate studio and living space, it was equipped with modular furniture also designed by her. Meanwhile, Agar returned to London in 1930 and approached the architect Rodney Thomas, whom she knew through the Slade, to design her own apartment and that of her partner,

82

Decorating Women

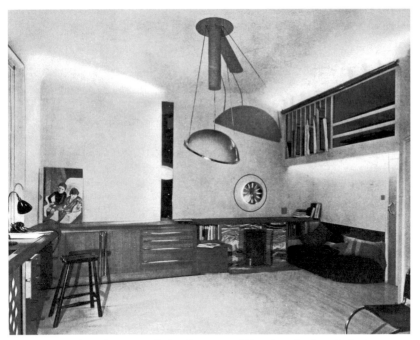

82 Rodney Thomas, studio for Eileen Agar, 47 Bramham Gardens, Earl's Court, London, 1930–32. The Surrealist touches, including an eyeball-shaped clock and an eyelid form for the ceiling light, were introduced by the client, a leading avant-garde artist.

the Hungarian writer Joseph Bard, in a Victorian building in Earl's Court. The flats were designed along the Modernist lines of Wells Coates' Minimum Flat of 1933. However, Agar added Surrealist touches: the circular clock on the wall resembles an eyeball, and echoes the shape of the ceiling light. She drew on the Surrealist method of collaging images for the walls, and painted the inside of the front door to resemble a face, with the letterbox as a mouth. When the British organizers of the International Surrealist Exhibition, Herbert Read and Roland Penrose, visited Agar at home, the flat's décor secured her a place in the landmark exhibition. Agar also expressed her Surrealist challenge to normality in her dress, wearing Schiaparelli kid gloves with sewn-on red leather fingernails to the opening of the 'Surrealist Objects and Poems' exhibition at the London Gallery in 1936. The subject of a retrospective at the Whitechapel Gallery in 2021, she challenged convention through subversive artworks and designs, including her 1936 *Ceremonial Hat for Eating Bouillabaise*, now in the collection of the Victoria and Albert Museum.

Helena Rubinstein (1872–1965) founded her eponymous cosmetic company in Australia in the early twentieth century. She had fled from her native Poland to avoid an arranged marriage, and once in Australia made use of the country's abundant supply of lanolin in her popular skin cream. She moved to Europe with her husband, the Polish writer Edward William Titus, in 1908, before, on the outbreak of war, fleeing to New York, where she opened a beauty parlour in 1915. Rubinstein's cosmetics empire was to make her one of the richest women in the world. Always in competition with fellow cosmetics businesswoman Elizabeth Arden (1881–1966), she was the grand dame of the beauty world, overseeing her enterprise until her death. Like Eileen Agar, she was intrigued by Surrealism, and employed Salvador Dalí to design a powder compact for her company and to paint her portrait. She was also a keen collector and philanthropist, amassing a collection of African art that she displayed in her specially designed, Art Deco apartment in Paris. Rubinstein and Arden were both

83

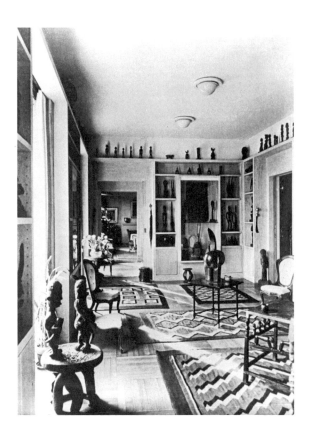

83 Helena Rubinstein, African Art Room in her Paris apartment, with rugs from Mexico, c. 1950. The cosmetics queen was an avid admirer and collector of modern art and art from the African continent.

responding to a growth in American consumer culture that met the desires and aspirations of a female market. This age was ably illustrated by the graphic designer Nell Brinkley (1886–1944), whose cartoons, most famous for the carefree, independent 'Brinkley Girl', featured in mass-circulation periodicals such as *The Evening Journal, Harper's Bazaar* and *Good Housekeeping.*

Mass-circulation publications were also the business of Australian commercial artist and designer Thea Proctor (1879–1966). Trained first at the Sydney School of Art and then in London at the St John's Wood School of Art, she returned to Australia with firm ideas about style, fashion and design. She is best-known for her cover designs for the woman's magazine *The Home*, which portrayed youthful, independent women pursuing sporty, outdoor pursuits. The magazine was a high-quality lifestyle magazine aimed at middle-class Australian women; Proctor's work suited its modern image and appealed to the readership throughout the 1920s and 1930s.

84 BELOW LEFT Nell Brinkley, *The Brinkley Girl*, published by Cohan & Harris, New York, NY, 1908. An early version of this leading graphic designer's popular portrayal of the carefree young American woman.

85 BELOW RIGHT Thea Proctor, cover for *The Home* magazine, 1 July 1927. Proctor brought the covers of women's magazines alive in the inter-war years, with colourful depictions of active, confident women with agency.

86 Margaret Hayden Rorke, Standard Color Card of America, Ninth Edition. Created and Issued by the Textile Color Card Association of the United States, Inc., 1960. This sturdy board reference book carries silk samples for the coming season, a system pioneered by Rorke, the world's first colour forecaster.

The story of the growth of consumer culture in the US is usually told through the lives and careers of freelance design professionals such as Henry Dreyfuss and Raymond Loewy. But there is a different story to be told through the achievements of women such as Margaret Hayden Rorke (1883–1969), the first professional colour forecaster as well as a suffragette and author of the *Letters and Addresses on Woman Suffrage* (1914). Rorke joined the Textile Color Card Association of the United States (TCCA) in 1918 and became its first Managing Director in 1919, developing the company into a major influence on colour trends and their standardization in fashion and manufacturing. She also advised on colour for the United States Army, the American flag and the establishment of the British Colour Council. She retired from the TCCA in 1959, having worked there for over forty years.

Anne Swainson (1890–1955) also enjoyed a powerful position as the first female in an executive position at the mail order company Montgomery Ward & Co. She was educated at the universities of Columbia and Chicago, taught applied arts at Illinois State University in Chicago and, from 1919, held a post in the design department at the University of Berkeley in California. After travelling in Europe, she moved to New York and worked as design director for the Chase Brass & Copper Company, where she turned the fortunes of the company around by selling stylish, modern objects. Swainson was then snapped up by Montgomery Ward, and became head of their Bureau of Design in 1932. She pioneered a redesign and representation of the firm's 40,000 items and introduced the idea of models interacting with the products in the mail-order catalogues, as well as consistent graphic design.

86

87

87 LEFT Anne Swainson, Montgomery Ward & Co. mail-order catalogue, 1940, showing the Roto Dial radio from the Airline range. Swainson pioneered a new approach to mail-order selling, using models to demonstrate the goods.

88 BELOW Ellen Manderfield, drawing for a Montgomery Ward & Co. toaster, 1950. Manderfield was Swainson's protégé, and in 1957 was the first woman to be admitted to the American Society of Industrial Design (ASID).

Swainson trained and encouraged a number of young industrial designers who would become famous in their own right during the 1950s and 1960s. One such designer was Ellen Birbaum Manderfield (1916–99), who pursued a career in houseware design until the 1980s. Trained at the Academy of Fine Arts, Chicago, and Syracuse University, she joined Montgomery Ward as Senior Product Designer in 1947. She left in 1951 to work as an industrial designer at General Electric Company (GEC) until, in 1956, she was appointed senior industrial designer at Oneida Ltd, New York, where she stayed for thirty years. In 1957, she was the first woman to be admitted to the elite American Society of Industrial Design (ASID). Thirty years later, she reflected: 'There is much to be said for the industrial design profession, and there is room for the feminine touch – with a sincere approach and the right attitude, one can go far.'

Chapter Five
Partners in Design

The outbreak of the Second World War (1939–45) triggered
a revolution in women's roles, creating greater access to
the working world beyond the home. As the working male
population was mobilized into combat, women took on
their traditional roles, stepping into their work-boots in
shipyards, factories and farms across countries including
America, Australia, Canada and Great Britain. The end of
global conflict opened up an atmosphere of optimism and
regeneration, in which design played a key part. The locus
of Modernism moved to the US, along with many of its key
European exponents, as America's power ascended on the back
of the Marshall Plan. Another part of this global picture was a
concerted push towards decolonization, as formerly colonized
countries demanded independence and their colonizers were
forced to confront a very different international role and
identity. Modern design was increasingly combined with local
traditions by architects such as Minnette de Silva (1918–88),
who returned to her birthplace of Sri Lanka in 1948 and
helped to rebuild the modern, newly independent nation,
and Lina Bo Bardi (1914–92), whose first building in Brazil was a
majestic, modern art museum. But these women were outliers:
in general, the brave new world of post-war reconstruction
encouraged women back into the domestic sphere, as men,
returning from the war, took up the lion's share of professional
work in the peacetime economy.

Many female designers of the post-war era were married
to fellow designers, their contribution to shared design work
frequently overlooked. This was the era of the designer couple.
Foremost among these couples were Ray (1912–88) and Charles
Eames (1907–78). They met at Cranbrook Academy of Art,
Michigan, in 1940, when Ray was a student and Charles a tutor,

and married the following year. Their design careers merged from the moment they met. Ray's initial training was in fine art, and she brought a strong sense of colour and form to the partnership, while Charles focused on structure and materials. Ray's expertise in the visual is exemplified for her wartime
designs for the cover of the important design journal *Arts and Architecture*. The combination of photographic imagery with curving, amorphic shapes in sage green was trailblazing in the production of commercial design publications. Like many design partnerships – for example Aino and Alvar Aalto, pp. 79–81 – a default male bias has meant that the woman's contribution to the outfit was constantly overshadowed, and collaborative work frequently credited only to the man. All of Aino Aalto's work was produced under the name Alvar Aalto Architects; Ray and Charles Eames worked under the Eames Office. Advertisements from the 1950s and 1960s boast 'Designs by Charles Eames for Herman Miller', when in fact Ray Eames had played an important role in the pieces. Later in the twentieth century, the equal contribution of Ray to the design

89 Ray Eames, cover design for *Arts and Architecture,* April 1943. Ray designed covers for this important design journal during the Second World War, combining colour with photography.

90 Ray Eames holding the *Dot Pattern* design that she created in 1947, possibly inspired by the shadows cast by the metal legs of the Eames's DCM chair on to a white floor.

process began to be acknowledged through the work of scholars such as Pat Kirkham and through the Eames Office itself, run by their daughter, Lucia Eames, and their five grandchildren.

In 1942, Ray and Charles received a contract from the U.S. Navy to produce plywood splints to support injured service personnel. The supports they designed for arms and legs went into mass production, and beginning in 1945, they applied similar technology to their Plywood range of seating. The range was put into production by Herman Miller, the company that would go on to produce their Plastic Shell seating, designed between 1948 and 1950. The standard plastic shell could be placed on a number of different bases, including a rocking structure, depending on the clients' needs. Ray's Dot Pattern textile of 1949 was inspired by these metal structures. Ray and Charles produced an aesthetic that represented the post-war modern world as relaxed, colourful and fun. They went on to produce toys and furniture that spearheaded an informal, Californian way of living which inspired designers and delighted customers in the US and

91 LEFT The Pacific Design Center complex in West Hollywood, 2012. Norma Merrick Sklarek was the production designer for this monumental building, with most of the credit for the building accorded to César Pelli.
92 BELOW Norma Merrick Sklarek in the meeting room at Gruen Associates, c. 1960. Sklarek was appointed the company's first female vice president, and was the first African American woman to qualify as an architect in New York.

beyond. They were prodigious filmmakers and creators of multimedia events. Their film installation *Glimpses of the USA*, comprised of 2,200 images shown in 12 minutes, was first displayed at the American National Exhibition in 1959. The work, sponsored by the US Department of State, made a huge impact internationally.

The post-war era also saw the entry of African American women into the world of professional design. In 1954, Norma Merrick Sklarek (1926–2012) became the first African American woman to qualify as an architect in the state of New York. She studied at Columbia University and went on to work at several architectural practices in New York City before, in 1960, moving to Los Angeles for the role of vice president at Gruen and Associates. She was Gruen's first female vice president, and the only Black woman in the firm. There, she supervised architectural projects including the U.S. Embassy in Tokyo. She worked with César Pelli on the design of the building, and he is frequently named as the main architect, obscuring Sklarek's contribution.

91, 92

49, 50

As part of the pattern of emigration created by the rise of Fascism in Europe, many designers relocated to the US just before or during the Second World War and contributed to its post-war design heyday. The Bauhaus weaver Anni Albers (1899–1994) and her husband, the artist Josef Albers (1888–1976), relocated to Black Mountain College in North Carolina, where they both taught. She developed innovative textiles incorporating materials such as lurex and cellophane, and, in 1965, published *On Weaving*, which remains a key text in textile art and design. Eva Striker Zeisel (1906–2011) was born in Hungary and studied at the Royal Academy of Fine Arts in Budapest. She then embarked on an apprenticeship in ceramics and worked as a designer for various porcelain manufacturers in Budapest, Germany and Soviet Russia, where she was imprisoned for sixteen months for allegedly attempting to assassinate Stalin. Once released, she returned to Budapest and married the sociologist Hans Zeisel. They fled Europe and Nazi occupation on the last train out of Austria, emigrating to the US. There, she forged a successful career in ceramics, creating

93

tableware in flowing, simple lines, including the Town and Country dinner set of 1947. Eszter Haraszty (1920–94) was, like Striker Zeisel, born in Hungary. She emigrated to the US just

93 Eva Zeisel, Town and Country tableware manufactured by Red Wing, c. 1950. The Hungarian designer emigrated to the US just before the Second World War, after a period of imprisonment in Russia. She contributed to the creation of the mid-century modern aesthetic in the US.

after the war, working in textile design and rising to become head of the Knoll textiles department in 1950. She brought a bold mix of colourways to the Knoll palette, including pink with red, and also experimented with new, synthetic fibres. Haraszty then left Knoll to establish her own practice, working freelance for IBM and Victor Gruen Associates. In later life, she concentrated on making fine art with embroidery, and was the author of two books on the subject.

The Marshall Plan of 1948 organized extensive financial support from America for post-war Western Europe, and stimulated a design renaissance. Though male-dominated, there were some women who succeeded in the Modernist, masculine arena of design at the time. The Marshall Plan-funded Hochschüle für Gesaltung (HfG, School for Design) in Ulm, then West Germany, has become notable in the history of design for the teaching and practice of stripped-back Modernism and design theory. The impetus behind its opening in 1953 came from Inge Scholl (1917–98), who despite post-war austerity measures managed to raise one million Deutschmarks in memory of her younger siblings, Hans and Sophie Scholl, who had been executed for high treason in 1943 for distributing anti-Fascist literature. The Modernist architect Max Bill (1908–94) designed the minimalist building for the school and was also its first Rector. Of the 642 students, ninety-eight were women, and there were a handful of women teachers, including the literary philosopher Käte Hamburger (1896–1992) and the filmmaker Beate Mainka-Jellinghaus (b. 1936). Of the 177 employees, eighty-nine were women; eighty-five were employed in administration or the cafeteria and four were assistants, heads of workshops or members of development staff. The school folded in 1968, as it was perceived to be too politically radical, more of a 'talking shop' than a centre for manufacturing design.

While in many ways HfG was pioneering in its teaching of the theory and practice of design – if not in its gender balance – in Italy, opportunities for training were more restricted; until the 1970s, there was no design training available in the country. In the early post-war years, Italy was recovering from wartime devastation, transitioning from Fascism to a republic. Women had not played a significant role in design during the pre-war era, as legislation barred women from entering skilled professions. After the Second World War, architectural training at centres such as the Politecnico di Milano (Milan Polytechnic) was opened to women. The furniture designers Margherita Bravi (1921–2006) and Luisa Castiglioni (1922–2015) both studied there, graduating in the

94

94 Eszter Haraszty, *Triad* textile, 1955, produced by Knoll as a screenprint on cotton. Haraszty was head of the Knoll textiles division from 1950–55, and introduced strong colour combinations to enhance their stripped-back interiors.

late 1940s. In 1951, the pair contributed a display to the Triennale di Milano, an important exhibition of contemporary design. Their contribution consisted of a Modernist built-in wardrobe with sliding doors and a wooden table surrounded by traditional, woven straw chairs. But as the design scholar Catharina Rossi has demonstrated, it remained extremely difficult for women to succeed in the male-dominated world of Italian furniture design and architecture.

Lora Lamm (b. 1928) found greater success in Italy in the field of graphic design. Born in Switzerland, she studied graphic design at the Kunstgewerbeschule (School of Arts and Crafts) in Zurich from 1946 to 1951, which grounded Lamm in the Swiss School of graphic design, with its clear, sans serif typefaces and strict grid layouts. In 1953, she emigrated to Milan in search of more exciting commissions. She was taken on by Studio Boggeri and set to work designing the packaging for Motta, the Italian manufacturer of panettone. Her best-known work was for the department store La Rinascente, which had its own advertising department. Lamm flourished there, producing publicity materials that succeeded in attracting a young, female audience to the store by illustrating women taking part in fun activities, part of the new Italian lifestyle concept of the 'Dolce Vita'. In 1958, she took over the running of the entire advertising team, as well as responsibility for the store magazine, *Cronache*. Lamm also took on freelance work, designing for the likes of Elizabeth Arden, Olivetti and Pirelli in the same joyous, colourful style. Lamm returned to Zurich in 1963 and hoped to travel and work in the US. However, this did not come to fruition, and she instead joined a Zurich-based advertising agency founded by Frank Thiessing, whom she later married. Lamm began to gained significant recognition in the 2010s, with exhibitions devoted to her work at the M.A.X. Museo in Chiasso, Switzerland, in 2013, and at the Museum of Design in Zurich from 2015 to 2016.

The architect Jane Drew (1911–96) contributed to the war effort in London with her 1943 exhibition 'Rebuilding Britain' at the National Gallery, which included plans and models for peacetime reconstruction. Drew had trained at the Architectural Association in London from 1929 to 1934, and entered into a partnership with the Modern architect Maxwell Fry, whom she married in 1942. Drew continued her interest in rebuilding Britain with her contribution to the Council of Industrial Design (COID) exhibition 'Britain Can Make It' at the Victoria and Albert Museum in 1946, and the Festival of Britain in 1951. These exhibitions promoted Modernism combined with a touch of British tradition as an important

95 Lora Lamm, Pirelli poster design, 1959. This joyful representation of the freedom offered by the Italian scooter and Pirelli tyres was shown at the eleventh Milan Triennale.

part of the reconstruction of Britain. The exhibitions also aimed to promote the export of British design as a part of the country's economic recovery, in a new world without empire. The Festival of Britain was organized by an all-male network of twelve middle-class, privately educated Oxford and Cambridge graduates. Few women were involved. Drew was one of only two female architects to contribute to the festival's main site on London's South Bank, where she designed the Thameside Restaurant, the Harbour Bar and the New Schools pavilion with Maxwell Fry. The other was Ursula Bowyer, who worked on the Sports pavilion with her husband, Gordon Bowyer. A minority of women designers also worked on the Festival of Britain project. At the Lansbury Housing project, a public housing estate built as part of the celebrations, Jacqueline Tyrwhitt (1905–83), the seminal theorist of urban renewal, contributed to the display and wrote the script for the Town Planning pavilion. The textile designers Lucienne Day (1917–2010) and Jacqueline Groag (1907–86) also worked on the festival.

Lucienne Day studied at Croydon School of Art and then at the Royal College of Art, where she specialized in textile design. During the war, she married the furniture designer Robin

96 Lucienne Day with her prizewinning textile design *Calyx*, 1951. This bold fabric design was shown at the Festival of Britain and produced by Heal's. The abstract pattern was based on a part of a flower, in contrast to the floral chintzes prominent at the time.

Day (1915–2010), and in 1946 they established a design studio together based on their shared enthusiasm for Modernism. An early commission was for two screen-printed furnishing textiles for the Edinburgh Weavers. These striking mid-century modern designs were noticed by Anthony Heal, owner of the prestigious Heal's furniture store in London. He agreed to produce Calyx, Lucienne's best-known design, as part of Robin Day's room-set for the Festival of Britain Homes and Gardens Pavilion. It represented a departure for British textile design, with its playful, abstract forms inspired by Joan Miró and Paul Klee. The design went on to win the Gold Medal at the 1951 Milan Triennale and the International Design Award at the American Institute of Decorators in 1952 – the first time a British designer had won the award. Throughout the post-war years, Day developed a strong, personal style in textile design, based on her fascination with the natural world. In 1962, Lucienne and Robin Day were appointed design consultants

for the John Lewis Partnership – the bastion of middle-class British good taste – a role they enjoyed for twenty-five years.

Jacqueline Groag was born Hilde Humberger in Prague, and worked with Josef Hoffmann at the Wiener Werkstätte, designing textiles for the fashion houses Worth, Schiaparelli and Chanel. Her work was awarded at the Paris Exposition Coloniale Internationale (1931), and she won a gold medal at the 1933 Milan Triennale and another for textiles at the 1937 Paris Exposition. Two years before war broke out, she married the architect Jacques Groag. She changed her name, and the couple emigrated from Vienna to London to escape the impending Nazi threat. In the post-war era, she again established a thriving career as an influential freelance textile designer, contributing to the Festival of Britain and designing for clients as varied as the Edinburgh Weavers and the British Overseas Airways Commission (BOAC). Her design for the moquette D78, used in the 1970s, is generally misattributed to Misha Black, head of BOAC's Design Research Unit.

97 Jacqueline Groag, D78 moquette, c. 1975. Most often attributed to the man who commissioned its design, Misha Black, this design by Groag graced the Routemaster buses and District Line underground trains of London throughout the 1970s and 1980s.

98 Jane Drew, Higher Secondary School, Sector 23, Chandigarh, India, 1956. Drew was responsible for schools and housing for the new city and administrative centre, commissioned by Prime Minister of India Jawaharlal Nehru in the aftermath of Partition. Features like this concrete sunscreen took local conditions into account.

The Festival of Britain supported a handful of women in design, and Jane Drew in particular carved out an impressive career in the new, post-war world. Apart from the festival, during the war she worked for the Foreign Office on town planning and air raid shelters, and from 1947 to 1955 she and her husband, Maxwell Fry, worked on the building of new schools in Ghana, then still a British colony. Drew was paid £100 less than her male counterparts; this was at a time when female teachers in art schools were routinely paid less than their male colleagues, and women had to resign from posts in the British Civil Service if they married. Drew is best known for

98

her involvement in the building of the new city of Chandigarh, northern India, with Le Corbusier, his cousin Pierre Jeanneret and Fry. She brought an awareness of the local culture and climate to her projects, and published on the subject of Tropical Modernism. At this moment of decolonization, she worked with the forms of Modernist architecture to express a brave new world, and a new image for Britain as the centre of a commonwealth rather than a colonial power.

After the end of the war, servicemen from many of Britain's remaining colonies in the Caribbean emigrated to the UK, given free passage on ships such as the *Empire Windrush* as

100

workers. The leading Black designer Althea McNish (1930–2020) was born in the British colony of Trinidad, in the capital of Port of Spain. Her family was descended from Merikan settlers, who had been African American slaves freed after fighting for the British in the 1812 war against America. McNish's father was a writer and publisher, and her mother was a garment worker. McNish was a talented artist, and applied to study in London because there was nowhere in Trinidad to extend her studies. She was awarded a seven-year scholarship and started

at the London College of Printing and Graphic Arts in 1951 (now the London College of Communication, University of the Arts London), before enrolling at the Royal College of Art to study textiles. Her best-known work, *Golden Harvest*, was made during her final year and produced in four colourways by Hull Traders. McNish went on to become a successful textile and wallpaper

99 RIGHT Althea McNish, *Golden Harvest*, 1959. McNish was the first female African Caribbean designer to gain an international reputation, and this design, produced in satin cotton, was partly inspired by the Essex countryside and partly by the sugar plantations of Trinidad.
100 BELOW Althea McNish in the Bachelor Girls Room at the 'Ideal Home Exhibition', London, 1966. McNish designed this room set as an expression of a creative, independent woman, surrounded by her paints, brushes, swatches and objects.

designer, working for Edinburgh Weavers, Liberty, Zika Ascher and Lightbrown Aspinall, part of Wallpaper Manufacturers Ltd (WPM).

Minnette de Silva (1918–98) was the first Asian woman to be elected to the Royal Institute of British Architects, in 1948. Born in Sri Lanka, then the British colony of Ceylon, de Silva trained in India and then at the Architectural Association in London. In 1947, she was present at the CIAM meeting in Bridgewater, Somerset, which was organized by the town planner Jacqueline Tyrwhitt. The British Aeroplane Company's factory for manufacturing temporary, aluminium housing was based there, as well as the first Arts Council local arts centre, which had opened in 1946. The event looked forward to a new world order and a huge programme of reconstruction. Tyrwhitt went on to establish an important network for transnational urban development. Other women designers who attended included Grete Schütte-Lihotzky, Jane Drew and Lotte Stam-Beese, who had divorced Mark Stam and led on the rebuilding of the badly bombed Rotterdam.

De Silva returned to Sri Lanka in 1948, eager to contribute to the construction of a new nation, and established a practice in the city of Kandy. Her practice combined elements of Modernism with the local culture and climate, labelled as critical regionalism, in mainly domestic commissions including the Asoka Amarasinghe House in Columbo in 1960. The interior is a fluid space, adaptable for use by the residents for Buddhist festivals, with portable screens and lightweight furniture. There is also an open courtyard or Kandyan *mada*

midula within the structure, and greenery populates the inside as well as the outside of the dwelling. De Silva was never really able to fulfil her ambitions, finding herself overshadowed by the better-known Geoffrey Bawa, but her legacy has recently been revived and a book based on her life, *Plastic Emotions*, was published in 2019.

Lina Bo Bardi was one of the most important architects of the twentieth century. She spent most of her creative life in Brazil, designing a host of impressive private and public buildings. Born in Rome, she studied at Rome College of Architecture and graduated in 1939. She moved to Milan, where she worked on influential design publications such as *Lo Stile* for Gio Ponti. Bo Bardi then married the Rome-based writer,

102 Minnette de Silva, Asoka Amarasinghe House, Colombo, Sri Lanka, 1954. Traditional forms such as the 'lounger', the Sinhalese *hansi putuwa*, are combined with Modernism in this example of critical regionalism.

103 Lina Bo Bardi, The Glass House, São Paulo, Brazil, 1951. The architect's home and first completed work, set high up on the hillside near the city, among dense foliage, blurred the boundaries between exterior and interior space.

curator and collector Pietro Maria Bardi, and the pair travelled to Rio de Janeiro, where they settled in the late 1940s. Bo Bardi designed the *Casa del Vidro* (Glass House), set on a hillside just outside Rio de Janeiro, as their private residence. This glass and concrete structure is mounted on blue pilotis, with the outside and the interiors intermingling through picture windows and a central courtyard. She wrote about the house in *Habitat* magazine: 'This residence represents an attempt to arrive at a communion between nature and the natural order of things; I look to respect this natural order, with clarity, and never liked the closed house that turns away from the thunderstorm and the rain, fearful of all men.' She became a Brazilian citizen in 1951, and in the same year designed the famous *Bowl* chair, which featured in the glass house. The semi-spherical seat can be adjusted to different angles on its metal frame, and is now sold by Arper. Bo Bardi's biggest project was the São Paulo Museum of Modern Art, a bold, Brutalist building, in 1968. The concrete structure hangs from four massive, red pilotis to create a public space beneath. For the cultural centre SESC Pompeia, also in São Paulo and completed in 1986, Bo

103

Bardi repurposed a concrete former glass factory, retaining many of the original features. With a passion for Brazil and environmental issues, alongside her husband she also founded the important design magazine, *Habitat*, which ran from 1950 to 1953.

The design media was an important outlet for women working in design, and the publications surrounding the design process are a significant part of the history of design. The mid-twentieth century was a golden age for the monthly design magazine, as public and professional interest in the subject soared worldwide. One prime example of a woman working in this realm is Elizabeth Gordon (1906–2000), who was the Editor-in-Chief of the mass-circulation American lifestyle magazine *House Beautiful* from 1941 to 1965. In its pages, Gordon promoted the American Style of home design, merging modern comfort with familiar, traditional touches. Pitched roofs and wooden cladding featured alongside generous fenestration and

104

105

104 BELOW LEFT Lina Bo Bardi, cover of the first issue of *Habitat* magazine, October/November 1950. Bo Bardi founded the magazine with her husband, Pietro Maria Bardi, and the design and contents encapsulated her interdisciplinary passions and avant-garde stance.

105 BELOW RIGHT Elizabeth Gordon, *House Beautiful*, Pace Setter House, 1958. The Pace Setter Houses programme was introduced by Gordon, the magazine's Editor-in-Chief, to promote an American Modern way of living. She eschewed European Modernism in favour of the ranch-style home.

simple forms. The lifestyle promoted was centred around the white, middle-class nuclear family, with plenty of space inside and out, packed with labour-saving devices. This American Dream dominated the Western imagination throughout the 1950s and 1960s. Gordon's controversial treatise 'The Threat to the Next America' appeared in *House Beautiful* in 1953, an open critique of European Modernism and the clean lines of the International Style, which Gordon argued threatened a homegrown American look in the growing suburban landscape.

In Great Britain, women were able to make an impact in the lively design press. The newly formed Council of Industrial Design (COID) founded the monthly magazine *Design* in 1949, to promote 'good design' to designers and manufacturers. The majority of the editorial staff were men, but Gillian Naylor (1931–2014) was one exception. After studying at Oxford University, she moved to London and initially worked for *Who's Who*. In 1957, she joined the staff of *Design* magazine as Editorial Assistant. She was frequently asked to cover supposedly 'female' subject matter, particularly textile design, but also covered the HfG in Ulm and interviewed the then-Principal of the Royal College of Art (RCA), Robin Darwin. Naylor was forced to resign in 1963 when her son was born, following the rules of all Civil Service roles. She continued to write for the magazine on a freelance basis, but went on to pursue a career in design history, teaching at the RCA from 1981 and setting up the MA in Design History, on which she taught until her retirement in 1996.

Sadie Speight (1906–92) was a leading practitioner and writer on modern design, whose work tends to be overshadowed by her husband, the architect Leslie Martin (1908–2000). She graduated with a first-class honours degree from the University of Manchester in 1929, received a Silver Medal from the RIBA in 1930 and was elected an Associate in 1932. She worked in practice with her husband, designing Brackenfell in Cumbria in 1938 for the textile designer Alastair Morton (1910–63), but she is frequently uncredited. Also in 1938, the couple designed the Good Form modular furniture, which has also subsequently been credited to Martin alone. Speight and Martin were involved in the establishment of the Circle group in 1936, and in its subsequent publication, *Circle: International Survey of Constructivist Art* (1937). But while both Speight and the sculptor Barbara Hepworth were central to the efforts, it was only Martin, Naum Gabo and Ben Nicholson who were given credit. Martin and Speight also collaborated on *The Flat Book* (1939), which advised apartment dwellers on the arrangement and furnishing of their home, though Martin is credited as the sole

author. In 1943 Speight was a founding member of the Design Research Unit (DRU), the first multi-disciplinary design agency in Britain, for which she designed small electrical appliances. She also designed the Rosy Lee Tearoom in the Lansbury Housing Estate at the Festival of Britain.

From 1944 until 1946, Speight was the co-editor and compiler of the *Design Review*, which appeared as an addition to the monthly magazine *Architectural Review.* She was the only woman to write for the publication at that point, with the other female employees working in administration or as secretaries. *Design Review* included the best of modern design, was available for purchase by the general public, and drew inspiration from the earlier *Flat Book.* The main, credited editor was the architectural historian and Assistant Editor of *Architectural Review*, Nikolaus Pevsner. Correspondence between Speight and Pevsner, held in the Leslie Martin archive, reveals the tense working relationship between the two and Speight's continued frustration at a lack of recognition. Although the lifespan of *Design Review* was brief, it was pivotal in laying down a blueprint for recognising 'good design' in the post-war era that was very much taken up by the newly formed COID. Much of Speight's later life was devoted to preserving and documenting her husband's career, including his design of the Royal Festival Hall of 1951, and as Chief Architect at the London County Council from 1953 until he took up the role of Chair of the School of Architecture at Cambridge University in 1956.

Monica Pidgeon (1913–2009) was the long-serving editor of the main rival to *Architectural Review*, *Architectural Design*, from 1941 to 1975. Under Pidgeon's leadership, the magazine became hugely influential internationally, promoting and featuring the work of early-career theorists and designers. Pidgeon was born in Chile into a comfortable, expatriate lifestyle, with a Scottish mother and French-German father. In 1929, she enrolled at the Bartlett School of Architecture in London, but changed to interior decoration after a year, because she had been advised that architecture was not a suitable occupation for women. She undertook a handful of design commissions before meeting the Editor of *Architectural Design and Construction*, Frederic Towndrow, socially in 1938. With Towndrow's commitment to wartime work, Pidgeon and his secretary, Barbara Parnell, began editing the journal on his behalf. Her work on the journal became her life. Pidgeon relaunched the magazine as *Architectural Design* in 1946, and in 1953 Barbara Parnell left and the publishers decided to bring in a Technical Editor. The first in the role was the architect and theorist, Theo Crosby (1925–93),

architectural design

September 1966 Price 5s.

106 LEFT Cover of *Architectural Design*, September 1966, a Special issue compiled by Peter and Alison Smithson and devoted to an 'Eames Celebration'. Edited by Monica Pidgeon, the magazine was an important vehicle for the leading lights of London's avant-garde.

107 BELOW Alison and Peter Smithson, Hunstanton School, Norfolk, 1954. The married couple, in which Alison was always an equal partner, won the competition to design this school early in their careers. It paved the way for New Brutalism in architecture and across the arts.

PANTRY WITH GAMMA-RAY-
TREATED MILK AND FOOD
IN SEALED CONTAINERS

SHOWER-CUM-DRIER

TRANSPARENT
PLASTIC WALL

EYE-LEVEL BUILT-IN
COOKERS. ONE – ELECTRIC
WITH SPIT. TWO–FOR
COOKING BY MICRO-WAVES

PLASTIC FINISH
MOULDED WALLS

WORK TABLE

GARDEN SURROUNDED
BY THE HOUSE

ALL-NYLON
CLOTHES

COLOUR TV/RADIO
REMOTE CONTROL

AIR-CONDITIONING
CONTROLS AND LOUD-
SPEAKING TELEPHONE
WHICH RECORDS
MESSAGE

CUPBOARD
AND DRAWERS
WHICH OPEN
IN KITCHEN
TOO

'POGO' FOLDING
CHAIR IN PERSPEX

GLASS REINFORCED
CHAIRS

3-D COVER
MAGAZINE

TABLE RISES FROM
FLOOR TO DINING
OR COFFEE LEVEL

TROLLEY WITH WARMED
COMPARTMENT AND INFRA-
RED GRILLER

108 Alison and Peter Smithson, The House of the Future, 'Daily Mail Ideal Home Exhibition', London, 1956. The bunker dwelling, a fantasy project informed by Independent Group events, was filled with gadgetry such a television remote control, which was demonstrated by futuristically dressed models.

who provided a valuable connection between *Architectural Design* and the Institute of Contemporary Arts (ICA). The nerve centre of the avant-garde in London, the ICA was a conduit for the latest thinking in terms of architecture and its cultural context, and Pidgeon and Crosby embraced this. It was also the meeting place of the Independent Group from 1952 to 1955, which included the female architect Alison Smithson (1928–93) along with her husband, the architect Peter Smithson (1923–2003).

Crosby was living with the Smithsons at this time, and they were frequent contributors to and subject matter for *Architectural Design* articles. Alison Smithson contributed text on aspects of furniture and interior design in particular, and the architectural style New Brutalism, created by the couple, was frequently covered, including their famous design for Hunstanton School. In September 1966, they also edited a special issue of the magazine, featuring the work of Ray and Charles Eames. In 1953, the magazine reviewed their exhibition

107

106

at the ICA, 'Parallel of Life and Art'. The show explored the landscape of the photographic image, with a host of black-and-white, blown-up photographs hung from the ceiling and propped up against the wall. Three years later, Alison and Peter Smithson designed the House of the Future for the Ideal Home exhibition, the only part of the show to receive positive coverage in *Architectural Design*. This futuristic bunker had space-age furniture, built-in storage and new gadgetry. The Smithsons went on to design the Economist Building in London in 1964 and the residential estate Robin Hood Gardens in 1972. The couple expressed their ideas on culture and architecture through their prolific writing in the architectural press and beyond. Alison Smithson also published in her own right, including a novel, *A Portrait of the Female Mind as a Young Girl*, in 1966.

The Zambian-born American architect Denise Scott Brown (b. 1931) and her husband Robert Venturi (1925–2018) are most famous for establishing postmodern architecture with their book *Learning From Las Vegas*, the result of a student project set while the couple were teaching at Yale University and first published in 1972. With Steven Izenour, they criticized modern architecture and made the case for an appreciation of popular taste. Scott Brown had studied architecture in South Africa before gaining admittance to the Architectural Association in London, where she graduated in 1955. She was influenced by the work of the Smithsons, particularly their inclusive approach to culture. In 1955 she married a fellow student, Robert Scott Brown, and relocated to Philadelphia, Pennsylvania to study urban planning. When her husband was killed in a car crash one year later, she undertook several university teaching roles, including at Philadelphia. It was there that she met Robert Venturi, whom she married in 1967. She felt continually overlooked in favour of her husband and professional partner, despite even his own best efforts. Also in 1967, she became a partner in Venturi's architectural practice, Venturi and Rauch, as head of Urban Planning. The practice was renamed Rauch and Scott Brown in 1980, and eventually Venturi, Scott Brown and Associates in 1989. They undertook a range of prestigious projects for universities, the Nikko Spa and Resort in Japan and the Sainsbury Wing of the National Gallery in 1991. That same year, Venturi was awarded the Pritzker Architecture Prize, and controversy arose when Scott Brown boycotted the ceremony. In 2013, a petition to have her name recognized as equal to Venturi's was launched by the Women in Design activist group, led by Arielle Assouline-Lichten and Caroline James at Harvard Graduate School of Design. It attracted 20,000 signatures.

108

109

109 Denise Scott Brown in front of the Las Vegas Strip in 1968. *Learning from Las Vegas,* which she co-wrote with Robert Venturi and Steven Izenour, was published in 1972, but despite her equal contribution, Scott Brown is frequently overshadowed by Venturi in citations and awards.

The pair received equal recognition in 2015 with the award of The American Institute of Architects (AIA) Gold Medal, and in 2017, Scott Brown was awarded the Jane Drew prize by *Architects Journal*. She had reflected on her experience of being the 'architect's wife' in an article written in 1975, 'Room at the Top? Sexism and the Star System in Architecture', but did not publish the piece until 1989, fearing it would damage her reputation.

The star system is one that permeates design history, with one person often supposedly responsible for the entire look and construction of a building, a room or an object. This has been not only applied to architecture but to other branches of design, overshadowing the collaborative effort that design practice necessarily is. Harvey Earl (1893–1969) is often lauded as the sole creator of the car designs that typified the American consumer boom in the 1950s and 1960s. Based in Detroit, he was appointed head of General Motors' Art and Colour Section in 1927, renamed the Styling Section in 1938. In the late 1930s, Earl was promoted to design president and no longer did a great deal of design work himself. Helene Rother (1908–99), a German

110 Six of General Motor's 'Damsels of Design', c. 1955. From left: Suzanne Vanderbilt, Ruth Glennie, Marjorie Ford Pohlman, Harley Earl, Jeanette Linder, Sandra Logyear, Peggy Sauer. These women were among those responsible for the interior styling of Detroit's cars.

emigré, was appointed to the interior design section of General Motors, responsible for designing features such a lighting, upholstery and seating. She left in 1947 to establish her own successful consultancy. In the mid-1950s, the ever commercial-minded Earl created the group of women designers known as the Damsels of Design. A collection of recent graduates from the Pratt Institute and Cranbrook Academy of Art, Suzanne Vanderbilt, Jeanette Linder, Ruth Glennie, Sandra Logyear, Marjorie Ford Pohlman and Peggy Sauer designed the interiors of the General Motors vehicles, but had no involvement with their exteriors or technical specificities.

The origin of the star system is arguably classic Hollywood cinema. The auteur theory of film privileges the frequently male director, with those such as Alfred Hitchcock or William Wyler receiving star billing and their collaborators following in their wake. But filmmaking is a group effort, with screenwriters, camera operatives, make-up artists, set designers and actors all part of the process. Edith Head (1897–1979) is one of the best-known costume designers of this era in Hollywood. She had studied languages to master's level at Stanford University and had no design training as such, instead learning

from Howard Greer, a costume designer at Paramount Pictures, in the 1920s. She went on to design the signature outfits for Dorothy Lamour in *The Jungle Princess* in 1936 and Audrey Hepburn in *Sabrina* in 1954. In total, she designed costumes for over a thousand Hollywood films, and won eight Academy Awards for best costume design. Zelda Wynn Valdes (1905–2001) was a leading costume designer for performing artists

111

112

111 Edith Head, costume design for Audrey Hepburn, star of *Sabrina*, directed by Billy Wilder, 1954. Although Head took the credit for the costume designs in this film, the designs were based on those by Hubert de Givenchy, Hepburn's preferred couturier.

112 Zelda Wynn Valdes opened the first Black-owned fashion house on Broadway in 1948. In 1949 she formed the National Association of Fashion and Accessories Designers, to help other Black female designers establish networks and build confidence.

including Ella Fitzgerald and Mae West. In 1948 she opened a fashion store on Broadway called Zelda Wynn, the first Black-owned business in that area of New York. Her biggest claim to fame is the commission to design the original Bunny Girl outfit in 1960 for *Playboy*'s Hugh Hefner. She also worked with Arthur Mitchell, the first African American dancer to join the New York City Ballet, designing costumes for his new Dance Theatre of Harlem. From 1970 until 1992, she designed costumes for over eighty productions.

Chapter Six
Brand New Women

The idea of building a brand identity, whereby buildings, products and logos are designed to sell a particular product and image, gathered huge momentum in the post-war era. In one sense, women had always been at the centre of branding: images of beautiful women had been used to sell products from Alphonse Mucha's 1896 poster for Job cigarette papers to the idealized housewife of the 1950s in home cleaning product adverts. This chapter traces the hidden contribution of women to the development of branding, rather than simply its passive embodiment. Creating and developing a brand gave women agency in the design world, whether through an eponymous fashion brand, publishing, events or computer user interfaces in the new digital age.

Early examples of branding used fictional characters in advertising and packaging to build trust in the brand and increase sales. One such example is Betty Crocker baking products. The character was created by the Washburn-Crosby Company in 1921 to promote their Gold Medal flour, but it was Marjorie Husted (1892–1986) who brought their fictional baking expert to life. A qualified home economist, Husted headed Washburn-Crosby's Home Service Department, renamed the Betty Crocker Homemaking Service in 1929. The department comprised forty staff who they spent their time answering baking questions from the general public, which totalled around 4,000 a day. Husted also wrote radio scripts for Betty Crocker and was her on-air voice, in the first example of a broadcast cooking show. By the early 1940s, Betty Crocker was appearing on television and known to ninety per cent of US households. The fame of the brand spread globally, and Husted spearheaded a publication campaign, beginning with *Betty Crocker's Good and Easy Cookbook* in 1950. That year, she left the

company to found her own consultancy. She had been paid far less than her male counterparts in the marketing department, despite leading the way in popularizing the brand worldwide. She served on the American Association of University Women (AAUW) committee on the Status of Women and contributed to their publications until the mid-1950s.

Another woman to spearhead the popularization of a brand was Brownie Wise (1913–92). She was the first woman to appear on the cover of the American trade journal *Business Week* in 1954, for her success in marketing Tupperware. The airtight, plastic household storage system had been invented by Earl Tupper (1907–83) just before the Second World War. Plastics were used in a variety of ways during wartime, but were not a common sight in the home. Tupper tried to sell his products in stores with limited success. It was Brownie Wise who hit on the idea of party-plan marketing. She moved to Florida and set up the business Tupperware Patio Parties, selling the range through a network of self-employed hosts and hostesses who invited their friends around to their homes to sample and purchase the wares. Tupper learned of her success and employed her as Vice President in charge of marketing in 1951, after which Tupperware was withdrawn from retail outlets and only sold through Wise's party planning model. By 1954, Tupperware was selling $25 million worth of goods and enhancing the party-plan selling model through newsletters and the inspiring media presence of Wise. Tupper began to resent the association of his invention with Wise, and dismissed her in 1958. She received a year's salary for her efforts in building the successful brand, and continued in her own consultancy.

The office design and furniture brand Knoll Associates, founded by Florence Knoll (née Schust, 1917–2019) and her husband Hans Knoll (1914–55) in 1946, became particularly renowned in the mid-twentieth century. Both had been trained in the Modern idiom. Florence was orphaned in 1930 and attended Kingswood, an all-girls' school in Cranbrook, Michigan, from 1932 to 1934. It was while working with the school's art director, Rachel de Wolfe Raseman, a trained architect, that the young Florence Schust was inspired to become an architect. The pair designed a house together, which attracted the notice of architect Eliel Saarinen. Florence then studied with Saarinen at Cranbrook before enrolling on the architecture course at Columbia University in 1935. But her studies were cut short by an operation and she did not return to Columbia in 1936, enrolling instead on the architecture course at Cranbrook. She undertook extensive travel in 1938, staying at

136 Chapter Six

113 Women arriving for a Tupperware Party in suburban America in the 1950s. Brownie Wise was the woman behind the success of the plastic storage system, Tupperware, which was sold through her party-plan model.

the Saarinen family home near Helsinki, where she met Alvar Aalto, who advised her to study at the Architectural Association (AA) in London.

Florence benefited greatly from her time in London, learning about modern architecture through hands-on projects and visiting tutors such as Maxwell Fry. When war broke out, she returned to the US and worked briefly for Marcel Breuer, before enrolling at the Illinois Institute of Technology, where she studied with Mies van der Rohe, graduating in 1941. By this time, she knew many of the leading Modernist architects and designers. She started work as a designer in New York, where she met and, in 1946, married Hans Knoll, who had already established the furniture business Hans G. Knoll Furniture Company. Knoll's father had produced modern furniture for Mies van der Rohe, Marcel Breuer and Gropius. Hans's company became Knoll Associates Inc. on the couple's marriage; Florence headed the Knoll Planning Unit, which oversaw the design of the Knoll showrooms and offices worldwide. She brought a contemporary look to the company, using a palette of black, white and grey with accents in primary colours. Their first important commission was for the Columbia Broadcasting System (CBS) between 1952 and 1954, and this Planning Unit was used for publicity purposes in the design press. Knoll Associates had acquired the rights to produce

114

114 Florence Knoll, entrance to Knoll Planning Unit showroom, San Francisco, 1954. The showrooms were the primary focus for early commissions for the Planning Unit, and this former warehouse was kitted out with Knoll furniture in a modern setting to promote the brand.

Mies van der Rohe furniture in 1948, and their schemes frequently featured the iconic Barcelona Chair.

During the 1950s, the company opened showrooms across America and in Paris and Milan and became the brand of choice for corporations worldwide. When Hans was killed in a car accident in 1955, Florence Knoll was left to run the business alone. She drew on her network of contacts to commission leading Modernist designers to create new textiles and furniture for the Planning Unit, including those she had met during her education: Mies van der Rohe, Henry Bertoia and Eliel Saarinen. She also designed furniture herself, and was responsible for almost half of the Knoll range of products. Knoll was always keen to assert that she was not only a furniture designer but also an architect and an interior designer, at a moment when the field of interior decoration was becoming increasingly professionalized as interior *design*. Indeed, the National Society of Interior Designers had broken away from the American Institute of Decorators in 1957. Florence Knoll sold her company to Art Metal in 1959, but remained as Director of Design until 1965. In 1958, she married Harry Hood Bassett, whom she had met while working on

the interiors for his First National Bank of Miami. She moved to Miami and completed outstanding Knoll Planning Unit commissions from there, finishing with the CBS skyscraper in 1965. Without her clear vision and leadership, Knoll Planning lost its direction, and the company folded in 1971. She had succeeded in developing a brand that perfectly expressed the values of corporate America, itself heavily reliant on branding.

Margaret Calvert (b. 1936) is a British graphic designer who, like Knoll, had a clear vision for the use of modern design for brands. The brands in this case were public services such as Gatwick Airport, the British Transport Department, British Rail and the Tyne and Wear Metro. Calvert was born in South Africa and moved to London in 1950. She trained at Chelsea College of Art, where her tutor Jock Kinneir invited her to work with him on the design of signage for the new Gatwick Airport. The pair came up with black type on a yellow background for the illuminated signs, for which they designed a grid system. Through this commission they were approached by Colin Anderson, then head of the shipping company P&O, who asked them to design luggage labels for porters who could not read English. Anderson had been appointed Chairman of the Ministry of Transport's Advisory Committee on motorway traffic signs, and, based on their previous work together, he asked Kinneir and Calvert to design the signage. They developed their own sans serif typeface, Transport, with the colour scheme of white against a blue background taken from German *autobahn* designs. This signage has been used on Britain's motorway system from 1958 onwards.

115 Margaret Calvert, 'Men at Work' road sign for the Department of Transport, UK, 1965. Calvert designed these ubiquitous warning signs for Britain's roads with Jock Kinneir, although she has only recently received due recognition.

This commission led to Margaret Calvert and Jock Kinneir's best-known work, the design of further signage for Britain's roads, which was introduced in 1965. Their triangular warning signs included children crossing, with a graphic based on a childhood image of Calvert holding her younger brother's hand. Although the two designers had renamed their practice Kinneir, Calvert and Associates to reflect Calvert's equal input, the design press at the time attributed the work solely to Kinneir. The duo went on to design signage for British Rail and for the Tyne and Wear Metro network, which was to be their last project. Calvert taught at the Royal College of Art and in 2016 was recognized with an OBE. An exhibition of her work at London's Design Museum followed in 2021.

While Margaret Calvert remained very much behind the scenes until later in life, designers such as Mary Quant (b. 1930) confidently used their own personae to represent their brand. Quant studied at Goldsmiths College of Art, where she met her future husband, Alexander Plunkett Green. In 1955, with financial backing from Plunkett Green and her business manager, Archie McNair, Quant opened the boutique Bazaar on London's King's Road. She began by making dresses herself on a domestic sewing machine, but later established a more efficient production line. The shop window startled established Chelsea residents with its Surrealist leanings, and young women flocked to the shop to buy her latest creations,

including miniskirts and hotpants. Her designs captured the mood of the British capital, with a young generation eager to break away from the strictures of their elders, of wartime, rationing and the old way of life. Quant symbolized what would come to be termed Swinging London, with its emphasis on pure pleasure and delight in the colourful, playful and naïve. Young women were finding ways to have fun on their own terms, creating a new identity in part by not wearing versions of their mothers' clothes, as had previously been the norm. With her short, geometric Vidal Sassoon haircut Quant was the picture of an apparently classless, young, creative London. She expanded her brand by licensing her designs internationally and opening a new boutique in Knightsbridge, but the model of the young, trendy clothes shop instigated a much broader trend on the streets of London and beyond. In 1962 she sold a series of her designs to the American chain store J. C. Penney, and in the following year launched the Ginger Group as a mass-market fashion label, available in 160 department stores. Her black-and-white daisy logo was registered in 1966, communicating a young and vibrant image, and she continued to experiment with new materials in daring combinations

116 Mary Quant, minidress and PVC boots, 1967. The epitome of the Quant brand, with the simple daisy logo and a model in a casual pose wearing a striped minidress and adaptable, shiny boots. Pale lips and dark eyes complete the look.

and colourways, producing shiny, bright PVC ankle boots lined with cotton jersey in 1967. She expanded her brand and licensing operation in the 1970s, covering toys, tights and make-up with her distinctive daisy logo. In 2000, she sold her cosmetics business to a Japanese buyer.

Barbara Hulanicki (b. 1936) was another London fashion pioneer. The daughter of a Polish diplomat whose family moved to London after the Second World War, she studied at Brighton College of Art and gained employment as a fashion illustrator, her work appearing in magazines such as *Vogue.* She grew frustrated with the lack of fashionable, keenly priced clothing for herself and saw a gap in the market. With her husband, the advertising executive Stephen Fitz-Simon, she launched a fashion mail order business, naming it Biba, a pet name for her younger sister Biruta. Biba's first success was a pretty pink and white gingham dress with matching headscarf, which was featured in *The Daily Mirror* newspaper in 1964. The orders flooded in, with 17,000 aspiring to this fresh, youthful look. The popularity of her designs assured, Hulanicki opened her first boutique on small premises on Abingdon Street that same year. The shop was dark and mysterious, with clothes hung

117 Barbara Hulanicki, Biba ruffle dress, 1978. Available through a mail-order catalogue, this loose shift dress, trimmed with ruched edges, is worn with ballet pumps and pictured against the prominent Biba logo, reinforcing the successful brand's identity.

from Victorian hat stands and loud music blaring out. Biba attracted a celebrity following, including Twiggy, Julie Christie and Cilla Black. In 1966, the shop moved to a former grocer's on Kensington Church Street. Hulanicki, who oversaw the interior design, stipulated that none of the original fittings be removed. The windows were painted black with the Art Nouveau-inspired Biba logo picked out in gold. Another move to a much larger shop in a former carpet warehouse followed in 1969. Finance came from Dennis Day Ltd and the high-street fashion retailers Dorothy Perkins Ltd. The interior mingled Victoriana with Art Deco glamour, partly inspired by the mock Egyptian pillars that Hulanicki and her team discovered when they removed some plasterboard cladding in the space.

By this stage, Biba's mail-order business had also increased in popularity, with its brand identity secured through its distinctive catalogues and specially designed delivery boxes. Hulanicki also launched a successful cosmetics range in 1969, with daring colours including vampish purple and black nail varnish. With the move to its final space, the Art Deco Derry & Toms department store, in 1973, Biba became a victim of its own success. A total of five million pounds was lavished on the project, with Biba offering foodstuffs in the basement and refreshments on the roof terrace. The clothes by this point also

117

recreated Art Deco, Hollywood glamour, with satin, silk and lace, full, puffed sleeves and sweeping lines. The colours were muted purples, plums and browns, accented with cream. Biba models never smiled, but looked mysterious, with their faraway eyes outlined in black. The shop closed its doors for good in 1975, following disputes between the owners, British Land, Dorothy Perkins and Hulanicki. Hulanicki is now based in Miami and continues to work in the fashion industry.

Very different in emphasis and tone was the eponymous brand of Laura Ashley (1925–85), launched in 1953. Laura Ashley (née Mountney) was born in Wales and served in the Woman's Royal Naval Service during the Second World War, during which time she met her husband, Bernard Ashley. After the war, she took a job as secretary with the Women's Institute (WI), an organization founded in Britain in 1915 to bring women together and support their interests, particularly in the domestic sphere. When attending a craft exhibition organized by the WI at the Victoria and Albert Museum, Laura was particularly disappointed at not to being able to buy contemporary examples of the historic floral fabrics on display. The Ashleys set about recreating them at home in London, with Laura creating the designs and Bernard providing technical support in terms of printing. They initially made scarves with traditional, fine prints, sold through outlets such as Heal's and John Lewis. In 1958, they opened the first Laura Ashley showroom in South Kensington, London, and, with a growing family, relocated to Machynlleth in Wales, where they opened

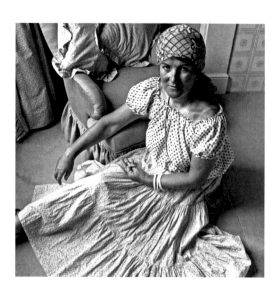

118 A portrait of designer Laura Ashley in the 1970s. Wearing contrasting floral prints with rustic headscarf, this nostalgic styling was the foundation of her empire.

a shop. This rural enterprise sold Laura Ashley-designed items including smocks alongside local products such as honey. The smocks were popular, and Ashley moved into designing and producing leisure wear, particularly long, floaty dresses with leg-of-mutton sleeves and pintucked bodices in tiny prints.

The company moved into home furnishings in the 1970s, with Laura Ashley's fabric designs printed on wallpaper and wider, light cotton for curtains and upholstery. Patchwork quilts in Laura Ashley fabrics were also available. The colourways were pastel, soft and gentle compared to their competition. By 1985, the company had grown to comprise 180 shops globally, with their distinctive forest-green frontages and a white logo bearing the name and a simple bunch of white flowers. The company had moved from a rural, cottage look to a more English country-house feel by this time, its grander styling reflecting Laura Ashley's success, and her purchase of a French chateau. She died aged sixty, and her company was floated on the stock exchange. It is now owned by the Malaysia-based firm MUI. Laura Ashley succeeded in providing a very different look and feel to the edgier styles of Quant and Biba, her revival of Victorian country house style serving the tastes of the prosperous 1980s, the so-called designer decade.

The groundbreaking Japanese fashion designer Rei Kawakubo (b. 1942) chose not to use her own name for her fashion brand, instead calling it Comme des Garçons (Like Some Boys). Paris was still regarded as the capital of high fashion when she founded her company in 1969 in Tokyo, and a French name carried greater cachet. Kawakubo had studied art history at Keio University and, after graduating in 1964, worked in the advertising department of Asahi Kasei, a large chemicals company that produced synthetic fabrics for the fashion industry. Kawakubo left in 1967 to establish herself as a stylist, but she could not source the types of garments she wanted to use, so began to design them herself. Her work was popular enough that she was able to open a boutique in Tokyo in 1975 to sell womenswear, and she added menswear to her portfolio in 1978. Comme des Garçons showed in Paris in 1981, its collection going against the grain of the dominant, glitzy aesthetic of the time. Her monochrome outfits were asymmetrical and loose, concealing the body rather than revealing it. Kawakubo was adamant that clothes for women in particular should be comfortable and not overly revealing, and

119 Rei Kawakubo, Comme des Garçons ensemble, Spring/Summer 2018. This collection overturned Kawakubo's usual monochrome look, with bright pinks and reds inspired by cartoons. However, her theme of draping the female form rather than revealing it remained.

her models never wore high heels on the runway. That same year she opened her first Paris shop, and in 1982 showed the Destroy collection, which consisted of dark grey, deliberately frayed and ragged clothes, with jumpers punctuated with large holes. By 1985, she had 150 shops in Japan and an annual turnover of $30 million annually.

Kawakubo succeeded in combining avant-garde art with fashion, and in 1988 she launched her magazine *Six*. 'Six' referred to the sixth sense. The magazine featured only images, running to eight issues in total. Kawakubo's most controversial collection was the Spring/Summer 1997 Body Meets Dress, Dress Meets Body: a simple, gingham-print dress, mutilated with strange tumours emerging from various parts of the garment. Kawakubo also launched more affordable lines, including for the high street store H&M in 2008, as well as a perfume range. She held various pop-up stores around the world and founded Dover Street Market in London in 2004 with her partner, Adrian Jotte. Comme des Garçons garments were sold on the ground floor of the Regency townhouse, while other fashion retailers occupied the upper floors. The space was also thrown open to art exhibitions, combining fine art with clothing in an innovative way. In 2014, I co-curated an archival exhibition on the history of the Institute of Contemporary Arts (ICA) at Dover Street Market, where blown-up fragments of images from the history of the organization were displayed among couture clothing in a novel combination. Subsequent Dover Street Markets were opened in Tokyo and New York, and Kawakubo's contribution to fashion and culture was marked with an exhibition at the Metropolitan Museum of Art in New York in

119 2017. Comme des Garçons's Spring/Summer 2018 collection saw her use inspiration from traditional Japanese kimono, blended with a cute, anime face in a riot of colour.

The Finnish textile designer Maija Isola (1927–2001) also used adventurous colours in her work, a staple of the Marimekko brand. Marimekko had been established by the textile designer Armi Ratia (1912–79) and her husband, Viljo, in 1951. Isola was first offered work by Armi in 1949, while still a student at Institute of Industrial Arts in Helsinki, after winning a competition to design a printed fabric. She would go on to

120 design over 500 fabrics for the company, but it was Unikko (Poppy) that became synonymous with Marimekko. Ironically, Armi Ratia had ruled out any florals for her range, but Isola defied her edict and came up with the magenta, red and orange floral bloom that became their trademark and bestseller. It has since been reformulated into eighty different colour combinations and, during the 1960s, sold 1,500 metres a day.

120 Maija Isola, *Unikko* (Poppy) pattern for Marimekko, 1964. This vibrant design became an international bestseller for the Finnish designer and company. It was eventually reformulated into over eighty colourways and used to decorate, among other things, the exterior of Finnair planes

Originally destined for table coverings, blinds and parasols, the pattern has graced the sides of Finnair planes, the interiors of train carriages, bed linen and homeware. Isola was a versatile designer, and also took inspiration from paisley patterns, the Beatles, Arabic designs and the philosophy of Kant, among other interests. Other Finnish women to design for Marimekko include Vuokko Eskolin-Nurmesniemi (b. 1930) who worked for the company throughout the 1950s – her best-known design is for the Jokapoika (Everyboy) striped shirt from 1956, which is still in production today. Annika Rimala (1936–2014) worked for Marimekko from 1960 until 1982, and in 1968 introduced the cotton jersey broad stripe Tasaraita (Even Stripes), which was used to create simple tops that perfectly matched the then-newly popular blue jeans. There was no danger of these women being lost to history or their work anonymized, as each designer's name is printed on the selvedge edge of the lengths of fabrics.

The Italian designers Lella (1934–2016) and Massimo Vignelli (1934–2014) both studied at the Venice School of Architecture, and married in 1957, when they left to work in America – Lella as a junior designer at the leading American architectural practice Skidmore, Owings & Merrill in Chicago, Massimo at the Container Corporation. Their design aesthetic was modern, elegant, cool and calculated, and always based on a grid system. In 1960, they returned to Milan and set up the Massimo and Lella Vignelli Office of Design and Architecture, working on corporate designs for Olivetti, Pirelli and Rank Xerox and designing stacking tableware for Heller. They decided to return to America in 1965, and co-founded Unimark, one of the first design agencies to offer brand identity overhauls that covered all aspects of design. As Libby Sellers has pointed out: 'company law at that time forbade Lella from holding a position in the same firm as her husband, so she had to contend with working from behind the scenes in a freelance consultancy role.' Unimark was highly successful, designing the familiar American Airlines logo in 1966 and working with Knoll Associates from 1967. In 1971, the Vignellis formed Vignelli Associates, attracting clients such as the New York department store Bloomingdale's, the automobile and motorcycle manufacturers Lancia and Ducati and, in 1997, the train liveries and interiors, staff uniforms and corporate identity for British Great North Eastern Railways (GNER). Although Massimo is frequently credited as the main designer for many of these projects, he tried to set the record straight in 2014, when he published the book *Designed by: Lella Vignelli*.

121 Lella and Massimo Vignelli, Colorstone Dinnerware, designed for Sasaki, Japan, 1985. The glaze has been removed from the edges of the plates and vessels, revealing the white stoneware beneath as an elegantly simply decoration.

122 Lella Vignelli lounging on her *Ara* sofa at the Driade showroom, Milan, Italy, 1974. Inspired by the work of Charles Rennie Mackintosh, this sofa is formed from wooden slats that surround the seating area, scattered with colourful cushions.

The Art Directors Club of New York (ADC) had been established in 1920 as the professional organization for advertising in the US. Women were permitted to join in 1942 and in 1971 the ADC established its prestigious Hall of Fame awards – the Oscars of the advertising industry, presented at an illustrious dinner in New York. Massimo Vignelli was inducted into the Hall of Fame in 1982 as an individual designer, although his biography on the ADC website mentions Lella's contributions. Of the 175 awards given between 1971 and 2012, 152 were presented to a single male, twenty-two to a single woman and one to a couple. This gives an accurate representation of the overall situation of women in branding and graphic design, often overlooked or seen as the invisible half of a couple, or situated on the margins as a sole practitioner.

From the 1980s onwards, the situation began to change when a small group of American women began to make a mark on the traditionally male field of graphic design, with a particular specialism in corporate identity and branding. This was the moment of the powerful women's liberation movement and a growing confidence that women could be equals in a man's world. It was also the moment when new technology challenged the old hierarchies that existed in the design business, and

123 Paula Scher, Citibank brand identity. Citicorp and Travelers Group merged in 1998 to form the world's biggest financial company. Scher's logo represents trust and protection, with the red umbrella shape supported by the blue 't'.

designers who understood and could work with new digital media were better able to succeed on their own terms. The leading American graphic designer Paula Scher (b. 1948) was inducted into the ADC Hall of Fame in 1998. A partner in Pentagram, the largest independently owned design studio in the world, she was the first ever female partner to join the firm in its New York office in 1991. She trained in illustration at the Tyler School of Art in Pennsylvania, graduating in 1970, and began working at the publisher Random House on children's books before moving into the music business as a designer in the advertising and promotion department at CBS in 1972. After two years she moved to Atlantic Records, where her award-winning saw her promptly hired back as East Coast Art Director at CBS in 1974. Over the next eight years she oversaw the design of 150 covers per year, alongside advertising and posters. Perhaps her most famous was for the rock band Boston in 1976, featuring three guitars illustrated as spaceships, blue flames emanating from the sound holes. Scher's marriage to the artist and founder of Push Pin Studios Seymour Chwast ended in divorce in 1982, and she left CBS in the same year to establish her own company. She joined forces with fellow Tyler graduate Terry Koppel, creating Koppel & Scher in 1984. The pair undertook commissions for the Swiss watch manufacturers Swatch, including a controversial reworking of Herbert Matter's 1934 Swiss Tourism poster, in which Scher altered Matter's photomontage to superimpose two Swatch watches onto the arm of the figure in the foreground. This was an example of postmodern appropriation or sampling, and when Scher joined Pentagram as a principal, she continued to draw inspiration from both street style and classic, Modernist graphics. In 1995, her poster for the Public Theatre in New York combined the red and black letterforms of Dutch De Stijl with a yellow background, rather than the usual white. She has also designed logos for Tiffany's, Citibank and Microsoft's Windows 8.

123

Another of the few female members of the ADC Hall of Fame is the graphic designer Muriel Cooper (1925–94), who

primarily worked for the publishing arm of the Massachusetts Institute of Technology (MIT). After studying design at Massachusetts College of Art, she started work at the MIT Press Office of Publications. She spent time in Milan on a Fulbright scholarship in 1958, just as Italian design was breaking new ground, and on her return to Boston she set up her own business. MIT was one of her leading clients; in 1962, she designed the famous MIT press logo, seven white vertical blocks that both resembled book spines on a shelf and spelled out an abstracted 'MITP' against a black background. The colophon is still in use today, and epitomizes the inventive use of visual communication that led to Cooper's appointment as the first art director at MIT Press in 1967. Among the over 500 covers she designed were Hans Wingler's major work on the Bauhaus in 1969 and Denise Scott Brown et al's *Learning From*

124 RIGHT Muriel Cooper, MIT Press logo, 1962. One of the most recognizable university press logos, the seven blocks are a distilled version of the initials 'MITP', and also resemble a row of books or skyscrapers.
125 BELOW Muriel Cooper in an unconventional pose in 1972, talking through a problem with colleagues at MIT. The leading graphic and digital designer understood the importance of user interface design for the digital age.

Las Vegas in 1972. Cooper was able to use her position at MIT to jointly found the Visible Language Workshop (VLW) at their Media Lab in 1984 with the designer Ron MacNeil, at which point she left publishing. She was the only female professor in MIT's department of science and technology, and relished the opportunity to bring an open, humanities-informed approach to the world of technology. VLW eventually merged with the Media Laboratory department, which taught and explored technology and design with new media. This was at the dawn of the digital age, and Cooper realized the importance of user interface design. She relished the challenge of designing for the computer screen, with its multitude of layers and offer of different ways through for the user, compared to the linear form of the printed page. One of her last collaborative projects was Information Landscapes, made with David Small, Suguru Ishizaki and Lisa Strausfeld, which was launched at the 'TED 5' conference in 1984. This explored the interface between the digital and the typographic and challenged the rather paltry efforts of mainstream computer interface design at the time. Cooper's contribution to book and digital design has been increasingly recognized, and her work is now featured in the collection of MOMA in New York.

A more traditional form of graphic design was used by Carolyn Davidson (b. 1943), creator of the original idea for the

Nike 'swoosh'. This now-ubiquitous tick shape was drawn by Davidson as a student at Portland State University in 1971. Phil Knight, the co-founder of Nike, learnt that Davidson was in need of some additional cash and hired her at $2 per hour to work on the business idea: one of the most successful logos in the world was originally bought for $55. Its upward motion symbolizes speed and movement, while the tick itself represents positive acceptance – a 'yes'. The symbol needed to fit onto the side of a shoe, so Davidson drew her ideas on tracing paper and placed them against the trainer. She went on to work for Nike for many years, and in 1983, the company gave her a swoosh shaped gold and diamond ring and 500 shares. The value of the latter now runs to hundreds of thousands of dollars.

126 Carolyn Davidson, Nike 'Swoosh' logo, 1971. Davidson drew the tick on tracing paper and held it against a trainer; thus one of the world's most recognizable logos came into being. The upward tick is a positive affirmation and symbol of action.

127 Deborah Sussman, Los Angeles Olympics, 1984. Along with Paul Prejza, Sussman designed a post-modern environment for this world event using pink, orange, red and turquoise rather than the traditional American flag colours of red, white and blue.

Deborah Sussman (1931–2014) entered the ADC Hall of Fame in 2012. Her forte was the new field of environmental graphics, developed on the basis of her studies at the Institute of Design in Chicago, the 'New Bauhaus'. It was there that she met her major inspirations, Charles and Ray Eames, who subsequently offered her an internship that lasted from 1953 to 1958. She left the multidisciplinary practice to take up a Fulbright Scholarship, travelling to Europe to take up a place at the Ulm School of Design and subsequently working in Milan and Paris. She returned to the US – and the Eames office – in 1961, to work on the 'Mathematica' exhibition at the California Museum of Science and Industry, commissioned by the IBM Corporation. This gave Sussman a grounding in the use of graphics in three-dimensional space. She left Eames in 1967 to start her own business, and designed catalogues, gift bags and invitations, many using the then-new fluorescent inks, for the Los Angeles County Museum of Art (LACMA). She met her future husband, the designer Paul Prejza, in 1968, and her company was renamed Sussman/Prejza in 1980 to reflect their professional partnership. Their most notable project was the designs for the 1984 Los Angeles Olympic Games. In collaboration with the Jerde Partnership, she created a multicoloured, festive environment that reflected the spirit of the city. Her collection of finished

127

work is now owned by LACMA, while her extensive archives have been acquired by the Getty Research Institute (GRI).

Susan Kare (b. 1954) is primarily an artist, but her understanding of the need for user-friendly computer interfaces led to the commission to design the icons for the first Apple Mac computer, which launched in 1984. She had studied fine art followed by a PhD on caricature in sculpture at New York University, and worked as a curator of sculpture at San Francisco Museum of Modern Art before being approached in 1982 by an old schoolfriend, Andy Hertzfeld, to work at Apple. The icons she created drew on a huge range of sources, from Swedish road signs to hieroglyphics, needlework to mosaics. The graphic interface created a user-friendly, fun set of tools, with smiley faces, rubbish bins and cartoon bombs. Compared to the businesslike IBM, their youthful, witty aesthetic added to the attractiveness of the Apple brand and played a major part in the success of the

128, 129 ABOVE Susan Kare's 'Happy Mac' greeted users with a reassuring smile as they booted up their computers. The 'bomb icon' in Mac OS is a symbol that was displayed inside the System Error alert box when the 'classic' Macintosh operating system had a crash which the system decided was unrecoverable, 1984.

130 RIGHT April Greiman, 'Does It Make Sense?', fold-out poster for *Design Quarterly*, issue 133, 1986. This groundbreaking poster is a life-size representation of the graphic artist's naked body. The pixellated image is interspersed with a chronology on one side and a quote from Wittgenstein.

company. In 1986 Kare joined Apple founder Steve Jobs at his new business, NeXT, as Creative Director, before leaving to form her own company in 1989. She has been responsible for much of the visual landscape of our screens, including the Microsoft Windows 3.0 operating system and the icons used on Facebook, including the birthday cake. She is now creative director at Pinterest, and sells prints of her best-known icons as artworks.

Rather than designing *for* computers, April Greiman (b. 1948) was one of the first designers to realize the potential of designing *with* computers. She trained in typography at the Allgemeine Kunstgewerbeschule (School of Arts and Crafts) in Basel, Switzerland and in 1971 took up a post at the Philadelphia College of Art while also setting herself up in practice in New York. Five years later she moved to the California Institute of the Arts (CalArts), where she joined forces with Jayme Odgers. Working under the title Visual Energy, they developed the technique of amalgamating found imagery with typography and painting in a collage, then re-photographing it after airbrushing. This postmodern fusion posed a challenged to the safe and staid graphics of the original Modernists. Greiman acquired her first Apple Mac in the early 1980s and began experimenting with the mistakes she could make and turn to her advantage, including obvious pixellation and grainy images. 130 In 1986, she created a fold-out poster based on her own naked body for the magazine *Design Quarterly.* Entitled 'Does It Make

131 Marina Willer, Tate logo, 2000. As Creative Director at Wolff Olins, Willer led on this rebranding campaign, which successfully brought a sense of unity to the four different Tate venues and merchandising operations.

Sense?' and created on her 512k MacPlus computer linked to a video camera, It heralded the new digital age and challenged the design establishment. She courted controversy again in 1995, when she designed a postage stamp in her characteristic collage style to mark seventy-five years since the passing of the Nineteenth Amendment, which gave votes to women. The first US postage stamp to be designed digitally, it included the silhouette of protesting women at President Woodrow Wilson's inaugural parade in 1913 superimposed with an image of the 1976 march for the Equal Rights Amendment in Springfield, the words Equality, Freedom and Progress set across the top in varying combinations. Her largest work is the two-part mural *Hand Holding a Bowl of Rice* (2007), which adorns the Wiltshire/ Vermont Metro Station in Los Angeles.

One of the most successful rebranding exercises in the twenty-first century has been that of the Tate group of galleries in 2000, to coincide with the opening of Tate Modern in London. The extensive rebranding was led by Marina Willer (b. 1965), then Creative Director at Wolff Olins. A successful Art Director in her native Brazil, Willer grew bored, and, seeking a change, studied for the MA in Graphic Design at the Royal College of Art in London. Her work at Tate was executed alongside the major stakeholders, and its key idea was 'look again, think again'; hence, the four logos for the four Tate sites at St Ives, Liverpool, Tate Britain on Millbank and Tate Modern on Bankside all differ slightly. In 2012, Willer left Wolff Olins to become a partner at Pentagram, where one-third of the twenty-four partners are women, including Paula Scher in New York. Since joining the Pentagram office in London, Willer has designed the corporate identities for Battersea Animal Rescue, Maggie's and Rolls Royce.

131

While branding is a central and vital part of communication design, and women are now finding a place within that industry, it is also part of three-dimensional product design. This is a field in which women have traditionally not been visible, but this is starting to change. Mimi Vandermolen (b. 1946) designed for the Ford Motor Company. A handful of women had joined the Ford Motor Company's Design Studio on its creation in 1935, to make up the shortfall in male labour, but they quickly departed. Vandermolen was appointed to the studio on a long-term basis in 1970. Born in the Netherlands, she studied industrial design at Ontario College of Art and Design, one of the first women to do so. She went straight from college in 1969 to work for the Ford-owned appliance manufacturer Philco, before transferring to become a trainee

132 Mimi Vandermolen posing with the Ford Granada, 1975. Vandermolen was one of the only women to work in the Ford Design Studio, introducing the idea of ergonomics to the company and designing for female end-users.

133 Elsa Peretti wearing the silver *Bone Cuff* bracelet that she designed in the 1970s. This edgy design, which could be worn as a pair, was a bestseller for Tiffany's, and modernized their image.

on the redesign of the Ford Mustang, which was launched in 1974. In 1979 she was promoted to Design Specialist, and introduced the field of ergonomics to the design of the interior of the new Taurus sedan. She was then promoted to Design Executive in 1987, the first woman to hold such a position in the North American car industry. She developed the new sports coupé, the Probe, which launched in 1993 to wide acclaim. Male designers on her team wore fake nails to trial their models from the woman's point of view. She always insisted that cars be designed from the perspective of women, adamant that this would benefit men too.

Another woman who succeeded in the world of three-dimensional design was the Italian Elsa Peretti (1940–2021), who made a major contribution to the Tiffany jewelry brand. She began life as a fashion model in Barcelona and New York, and was part of the Warhol Studio 54 set. She began designing jewelry in 1969, when she developed the idea of a miniature flower vase, hung on a silver chain and with a single flower placed in it. She formed an alliance with the New York designer Halston, who in 1974 introduced her to the CEO of Tiffany & Co., who were aiming to expand their customer base and include more affordable items. Peretti was contracted to design jewelry,

133

and objects for Tiffany & Co. Although her preferred medium was sterling silver, Peretti also designed with gold, platinum and diamonds, travelling around the world to source unique natural materials such as jade and lacquer and to meet craftworkers. She subsequently generated around ten per cent of Tiffany's turnover and in 2012 they renewed her contract for another twenty years and paid her £34 million. Her love of Spain led her to devote her lifetime to restoring the Barcelona village of Sant Martí Vell. She was also committed to the Nando and Elsa Peretti Foundation dedicated to her father, Nando Peretti.

Carole Bilson succeeded in the corporate world of industrial design, and remains one of the very few African American designers to do so. She studied industrial design and graphic design at University of Michigan and worked for the global brand of photography supplies giant, Eastman Kodak Worldwide, from 1980. As Product/ Marketing Manager for the Consumer Imaging – Digital Products business she led on the

development of the very first Kodak Picturemaker Kiosk system,

134 Carole Bilson, Kodak Picture Maker, 1995–97. This modern kiosk in familiar Kodak corporate colours was placed in shops, and allowed customers to order and produce their own copies or enlargements of photographs in minutes.

amongst other product lines, which allowed consumers to copy or enlarge their own photographs in three minutes, earning Kodak over $1 billion in sales during the 1990s. She then led several major software projects and is now President of the Design Management Institute.

matali crasset (b. 1965) is a French product designer who trained at the École Nationale Supérieure de Création Industrielle in Paris. She moved to Milan when she graduated in 1991, where she worked with the architect Denis Santachiara, before returning to Paris to lead Philippe Starck's design studio. She then founded her own company, and in 1998 showed her remarkable collection Quand Jim monte à Paris (When Jim

135 matali crasset, armoire for IKEA, 2014. Designed for the Swedish furniture giant as part of the 'On the Move' PS range, this versatile storage piece has a hanging rail, but clothes can also be hung from the metal framework.

136 Nipa Doshi and Jonathan Levien, Le Cabinet, 2017. Designed for Manufacture de Sèvres, the cupboard carries ceramic symbols of Le Corbusier's work at Chandigarh, including the chair, and is part of Doshi's ongoing dialogue with postcolonial India.

Comes to Paris) with Domeau & Pérès at the Milan Furniture Fair. She received international orders to produce the first run, which consisted of a bed roll, alarm clock and plug to accommodate house guests without the need for a spare room. She has also designed for the mass market, creating the *Armoire* for IKEA in 2014, which consists of a wire cage that can be adapted for different storage needs.

The Indian-born, London-based designer Nipa Doshi (b. 1971) works with her partner and husband, Jonathan Levien, at their eponymous design company Doshi Levien. She studied at the National Institute of Design (NID) in Ahmedabad, established in 1961 following a report by Charles and Ray Eames, and subsequently at the Royal College of Art, London, where she met Levien. The couple were commissioned by Tom Dixon to design glasses and cutlery for the high-street brand Habitat, but they are best known for their own Mosaic range of cookware, which draws on the colours and forms of a global range of cuisines. Their 2007 Chaproy (meaning 'four legs') range of seating for the Italian manufacturers Moroso is based on the idea of the Indian daybed. Each of the small sofas is covered with hand-embroidered textiles that include the name of the craftworker who made it and the date of completion. Doshi Levien continue to thrive, working for Kvadrat, B&B Italia, Cappellini and Swarovski, epitomizing the transnational status of branding and the global spread of consumer culture with a woman playing an equal part, and being acknowledged as such.

Chapter Seven
Design Activism

Design activism dates from the early 1970s, and encompasses a wide range of socially and environmentally responsible actions taken as part of the design process. It is Victor Papanek (1923–88) who is usually feted as the father of design activism, but in fact women have also worked as design activists from the beginning, concerned with problematizing the design business as well as with feminism, identity politics and representations of the body in their design work. Beginning with second wave feminism in the 1970s, women used design to express their frustrations and aspirations while living in a patriarchal society. By the later 1980s and the 1990s, design activism had expanded to include concerns for ecology and for marginalized groups, particularly in relation to race, gender and sexuality. The escalating global environmental crisis has been a growing concern over the past twenty years, and designers have sought ways to negate their impact and raise awareness through actions such as repurposing buildings rather than demolishing them and promoting greater consideration of the design life cycle. The discipline of design history was also founded during the 1970s, and challenged the academic status quo by considering mass-produced objects and popular culture as worthy of serious study, often from a feminist perspective. Craft is another area that has attracted serious study, becoming a particular focus for feminist and ecological critique, as well as a valuable consideration when reclaiming overlooked subjects as part of an activist design history.

The women's liberation movement erupted in the Western world during the late 1960s and early 1970s, part of a wider revolutionary fervour in which many of the traditional norms of society came to be challenged by a younger generation. This found graphic form in the publication of radical magazines

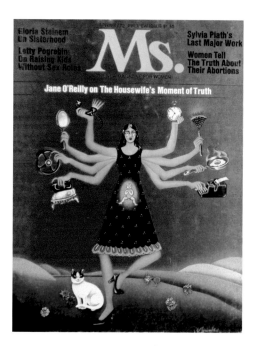

137 Gloria Steinem, *Ms Magazine*, Preview Issue, Spring 1972. The illustration by Miriam Wosk summarizes the pressures women face, including childbearing, cooking and cleaning as well as the need to keep up appearances.

137

such as *Ms*, co-founded by Dorothy Pitman Hughes and Gloria Steinem, the preview edition of which was published as an insert in the *New Yorker* in December 1971. The issue included discussion of abortion, then still illegal in many states, the drudgery of housework and the idea of 'de-sexing' the English language. Its cover was designed by Miriam Wosk (1947–2010) a Canadian-born illustrator who had studied at the Fashion Institute of Technology. Her image depicts Kali, the Hindu goddess of death, time and change, shown with eight arms, each holding a symbol of women's oppression – among them an iron, a typewriter, a frying pan and a looking-glass. This was not the usual fare of women's mainstream magazines of the time, which reinforced patriarchy by extolling the virtues of marriage, beauty products, housework and motherhood. Wosk chose this striking image to speak to all women, and the launch issue was a great success, with the first run of 300,000 selling out in eight days, and 26,000 subscriptions. The next issue came out independently, during election season in the US, with the cartoon character Wonder Woman campaigning for presidency on the cover. The magazine continues to be published today, and Wosk developed a successful fine art career.

The issue of women in design was the subject of feminist debate during this period, as part of a general questioning

of patriarchal systems. In 1974, a conference took place at the Woman's Building, a feminist base in Los Angeles. The Woman's Building had been founded in 1973 by the artist Judy Chicago (b. 1939), designer Sheila Levrant de Bretteville (b. 1940), and art historian Arlene Raven (1944–2006). De Bretteville had founded the Women's Design program at the California Institute of the Arts (CalArts) in 1971 and, with Chicago and Raven, she attempted to move the programme, along with Chicago's Feminist Art Program (FAP), to their new venue, based on the original 1893 Woman's Building at the World's Fair in Columbia (see pp. 16–17). The two-day conference was inaugurated to bring female design practitioners and students together. De Bretteville designed the poster to be produced in cheap blueprint, then used for architect's drawings. Featured on the horizon are the four phases of the moon, based on Angelica Kaufman's oil painting *The Artist in the Character of Design Listening to the Inspiration of Poetry* (1782). The grid pattern that forms the perspective was inspired by the visual language de Bretteville had encountered while working in Milan for Olivetti. The bolts placed on the grid echo the necklaces that she was making at the time, which used an eye bolt as a female pictogram. She set up the Women's Graphic Centre in the Woman's Building in 1973, and the conference was very much a part of this. De Bretteville wrote about the

138

challenges of being a woman and a designer in 1974: 'Design appears to be a particularly ambiguous enterprise – and design for social change, even more so – in comparison with the other arts. The designer is often paid by those very institutions which would be affected by her attitudes in forming and shaping design: the contradictions for a freelance designer who wishes to effect social change are thus apparent.' She managed to maintain her profile as a radical designer, producing her *Pink* broadsheet in 1974, as well as working for commercial clients including Tamla Motown and the *Los Angeles Times*. In 1990, she became the first woman to gain a tenured position at the Yale School of Art, as professor and director of graduate studies in graphic design, where she remains in post.

Second-wave feminism also gained visibility through the magazine *Spare Rib* in Great Britain. Founded in 1972, it aimed to be the voice of the women's liberation movement. Its founders, Rosie Boycott and Marsha Rowe, wanted a cover design that was witty but also communicated the seriousness of their aims for the magazine. They approached Kate Hepburn (b. 1947) and Sally Doust (b. 1944), who created the famous *Spare Rib* title by manipulating pieces of tissue paper, with the word 'Rib' in much larger letters than the 'Spare'. The magazine was run on a collective basis, with a tiny budget,

139

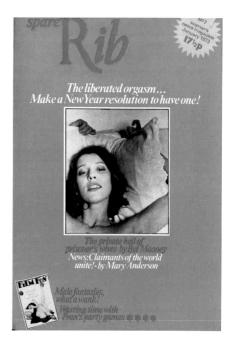

138 OPPOSITE Sheila Levrant de Bretteville, 'Women in Design' exhibition poster, 1975. The conference looked forward to the next ten years of feminist activism in design.
139 RIGHT Kate Hepburn and Sally Doust, *Spare Rib* magazine, issue 7, January 1973. Valerie Santagto's central documentary photograph of a woman is contrasted with the sexualized image of a fantasy woman from *Film Fun* in this radical cover design.

Design Activism

and was restricted to two colours plus black for the covers, which gave them a certain style. The first cover carried a black-and-white photograph of two ordinary women without make-up, not posing for the camera. *Spare Rib* continued in print until 1993, and the British Library have produced an excellent digital research resource to mark its importance.

Punk also grew during the 1960s and 1970s in music and fashion, as a reaction to the perceived pomposity of the hippy revolution. Vivienne Westwood (b. 1941) is particularly known for her involvement in the movement. Hailing from the north of England, she challenged the status quo through the shock tactics and deliberate vulgarity of her work with Malcolm McLaren (1946–2010), whom she met in 1962. The couple opened a clothing shop on London's King's Road in 1971 to sell their radical designs, which frequently defied norms regarding gender, beauty and style. Over the years the shop was known variously as SEX, Let It Rock, Too Fast To Live Too Young To

Die, Seditionaries and, lastly, World's End. Stock included black leather jackets and bondage trousers, brothel creeper shoes and miniskirts. Politically, punk's impetus came from the French Situationist Internationale (SI) and an anarchic view of the world. This was embodied in Westwood and McLaren's involvement with the creation and management of the punk band The Sex Pistols, who launched in 1974 and wore Westwood's deconstructed, fraying garments. Punk had died out by the later 1970s, replaced by the New Romantic look that Westwood embraced in her Pirate collection of 1981, with its flamboyant frills and tricorn hats. Vivienne Westwood is now a successful global brand with branches worldwide selling clothing, jewelry and perfume, and Westwood herself continues her interest in the cutting edge with support for the UK Green Party and for sustainable fashion.

Katharine Hamnett (b. 1947) is a fashion designer who uses her work to communicate strong, political messages, including her long-standing environmentalism. She studied fashion at Central Saint Martins in London and launched her own label in 1979, becoming best known for the political slogan t-shirts she launched in 1981. These simple, loose, white tops had phrases such as 'Choose Life', 'Stop Killing Whales' and 'Ban Pollution' emblazoned across them in black lettering. At a London

Fashion Week reception, Hamnett met the then-UK Prime Minister, Margaret Thatcher, wearing her anti-nuclear '58% Don't Want Pershing' t-shirt in protest against the government's support for American nuclear submarines stationed in the UK. She then opened a shop in London's Sloane Street with a massive fish tank in the window, rather belying her concern

140 Vivienne Westwood in Seditionaries, the shop she ran with Malcolm McLaren in the 1970s. The tartan bondage jacket she is wearing typifies her radical punk design language, which she also used to style the Sex Pistols.

Design Activism

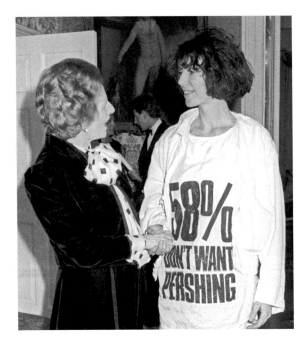

141 Katharine Hamnett meets Margaret Thatcher at a reception for London Fashion Week, Downing Street, 1984. The designer entered wearing a coat, then opened it to reveal her t-shirt's slogan to the Prime Minister, much to Thatcher's consternation.

for the natural world. She still sells slogan t-shirts in organic cotton, alongside slogan-bearing water bottles and bags, and in a post-punk world continues to use her skills and knowledge to further the causes she cares about.

Nathalie Du Pasquier (b. 1957) was a central figure in the Milan-based postmodern design group Memphis, although it is usually the group's founder, Ettore Sottsass, who receives the majority of attention. Launched at the Milan Furniture Fair in 1981, this band of radical designers questioned the orthodoxies of Modernism by introducing clashing colours, bravado, bold prints and popular culture into their work. Du Pasquier was a textile designer, and contributed to the development of the Memphis look with patterns such as Gabon (1982) and Zambia (1983). Her pattern designs would also be used for the surface treatments of other members' furniture, including her partner George Sowden's Antibes cabinet of 1985. Her two rugs, Arizona and California, both 1983, perfectly summarize the Memphis colour palette and format, with black and white chequers, yellows and nursery hues. Du Pasquier also designed furniture, including the 1983 Royal sofa. Memphis was about the ephemeral and the short-lived, the fashionable and fleeting, against a backdrop of increasing consumer demand and joy in shopping.

142

A similarly radical, avant-garde design group was established in the Netherlands in 1993: Droog, meaning 'dry' in Dutch. Co-founded by the curator Renny Ramakers (b. 1948) and designer Gijs Bakker (b. 1942), Droog introduced a more mindful and critical approach to design. Ramakers was educated in art history at the University of Leiden, and saw the need to challenge the ubiquity of simple Modernism, which still dominated furniture design despite the popularity of Memphis. She wanted to tell stories through design, to create more thought-provoking objects and to explore the limits of design by encouraging new designers to experiment. One such designer is Hella Jongerius (b. 1963) who trained at the Design Academy Eindhoven, where she designed a bath mat as her final degree project. The mat was made from a cushioning material used in the bronze-making industry and was exhibited in the first Droog show at the Milan Furniture Fair, where it immediately attracted attention. It is still in production today. Jongerius went on to combine an interest in craft processes with industrial design, as evident in her Soft Urn (1993), which is made from pliable silicon with visible seams, rather than the hard surfaces one would expect. In 2013, she was commissioned to design the Delegates' Lounge for the United

143

142 Nathalie Du Pasquier, Royal Sofa for Memphis, 1983. The couch's structure is covered in patterned plastic laminate, and the seat, cushion and armrest are covered in cotton fabric designed by George J. Sowden. The pastel colours and fun, asymmetrical design typify postmodernism.

143 Hella Jongerius, Delegates' Lounge, United Nations Headquarters, New York, 2013. Jongerius worked with Rem Koolhaas on this prestigious refit of the original 1950s interior. She designed the UN Lounge Chair for the space, to complement the original Knoll furniture.

Nations Headquarters in New York. The furniture is an unusual combination of traditional Windsor chairs, brightly coloured single seats and sofas with the threads holding the upholstery buttons still visible.

The boundary-pushing work of Droog frequently intersected with fine art, and, conversely, fine artists have also begun to work critically with design. Judi Werthein (b. 1967) is an Argentinian artist who studied architecture at the University of Buenos Aires. Her piece *Brinco* ('Jump' in Spanish) was shown at Tate Modern, London, in 2019. In 2005, the artist started the trainer brand Brinco. The shoes were manufactured in China and included a torch, pockets for medicines and money and a compass. The insole was printed with a map of the Tijuana area, and the shoes were given away free to people attempting to cross the border illegally from Mexico to the US. Werthein also sold the trainers as limited-edition art objects over the border in San Diego at $200 a pair, and the money raised was

144

donated to a Tijuana-based shelter for migrants. Thus, goods crossing one border (with relative ease) assisted people crossing a different border.

This critical use of design to raise issues for disadvantaged groups also informed the work of the UK-based Matrix Feminist Design Co-operative, which was established in 1980. They ran an ideas workshop and an advice centre, and designed local authority projects for family groups, succeeding in raising discussions of feminism and the relationship between architecture and women. They published a book, *Making Space: Women and the Man-Made Environment* (1984), in which they critiqued designs for the home and the public environment in relationship to women's experiences, particularly the home as a site of labour for women. Matrix were also one of the pioneers of co-design, whereby the end users of buildings worked with the designers in order that their needs be met. One of the leading members of the group was Susan Francis (1952–2017), who had studied at the Architectural Association (AA) during the 1970s and contributed towards the 100-year anniversary celebration of women being allowed to study at the AA in 1917. Entitled 'AA XX 100', the exhibition and conference celebrated the presence of women at this important architectural school, reclaiming their history as a part of design activism.

144 Judi Werthein, *Brinco*, 2004. The artist created the *Brinco* (Jump) shoes to highlight the issue of immigration from Mexico into the US. A helpful map is built into the sole of the trainers.

The push to establish women as a vital part of architectural and design history has been ongoing since the 1980s. In 1984, the groundbreaking exhibition 'Women Architects: Their Work' was held at the Royal Institute of British Architects (RIBA)'s gallery in London, with an exhibition catalogue edited by the leading expert in the field, Lynne Walker. There was an energy and impetus in the newly formed discipline of design history to give women due credit, and the second Twentieth Century Design History (now the Design History Society) conference held in 1977 at Middlesex Polytechnic (now University) included papers by Lisa Tickner on 'Women and Trousers', Ann Thackeray on 'Marion Dorn' and 'The Silver Cross Regency Baby Carriage' by Peter Vickers. Work by members of the society, including Judy Attfield, Cheryl Buckley, Pat Kirkham and Penny Sparke, has achieved much in putting the contribution of women to the history of design on the map.

Historical investigation highlighted the amateur tradition of craft, predominately undertaken by women, singly or in a group, and often within a domestic setting. Historians such as Buckley investigated the practice of home dressmaking; Catherine Harper studied quilting; and Pat Kirkham's monumental exhibition and accompanying book, 'Women Designers in the USA: Diversity and Difference' in 2000, not only presented a thorough overview of women as designers, but also included women working in craft, in particular Native American women. Jewelry-making, basketry, pottery, bead-making, clothing and textiles by Indigenous women are the subject of a chapter in Kirkham's book and samples of their work were included in the exhibition. These objects were not only examples of authentic traditional crafts, passed down through generations of mainly women, but also more contemporary works, including 'Star' quilts created in variations on the traditional formation to be given to basketball players, produced by Indigenous designer–makers such as Rae Jean Walking Eagle. The broader study and recognition of such work has since been enhanced further by the design activism of scholars through publications and exhibitions.

The 'Women Architects: Their Work' exhibition included a recent painting by Zaha Mohammad Hadid (1950–2016) for the Hong Kong Peak Competition. Following the year of the exhibition, she rose to fame as one of the era's few 'starchitects', designing for corporations such as BMW and creating the Aquatics Centre for the 2012 London Olympics. She is best known for her designs for museums and cultural centres. Born in Iraq, her father was the co-founder of the democratic party, and Hadid was brought up to believe women could achieve the

145

145 Zaha Hadid, Aquatics Centre, Olympic Park, London, 2012. This bold signature building was designed by the British Iraqi architect for the London Olympics. The sweeping, aluminium-covered roof was inspired by the form of a wave and is 160 metres (525 ft) in length.

same professionally as their male counterparts. It was with this confidence that she joined the AA school in 1972 alongside the likes of Rem Koolhaas, Daniel Libeskind and Nigel Coates, in an atmosphere of intellectual challenge and radical design values. Hadid established her own architectural practice in 1980, and began entering competitions, winning her first in 1982 for a Leisure Club on the Peak in Hong Kong. The project was never realized, but her signature style of colliding, geometric shapes drew international attention. The Fire Station at the Vitra Design Museum in Germany, beginning in 1994, was Hadid's first built project, composed of a collection of angular concrete blocks cast on site. In 2004, she was the first woman and first Muslim to win the Pritzker Architecture Prize, the highest honour in the field. Other important works include the National Museum of 21st Century Arts in Rome, from 2010, but her Aquatics Centre remains the most famous, and her tenacity in succeeding in the male-dominated world of architecture has been much admired.

Vivienne Tam (b. 1957) is a Chinese-born fashion designer who grew up and studied in Hong Kong before moving to

New York, where she launched her first collection, EAST
WIND CODE, in 1982. She is one of a group of designers to
challenge the dominance of Western culture in her work.

146 Her controversial 1995 MAO collection, for example, used the
Chinese artist Zhang Hongtu's (b. 1943) humorous, pop art-style
images of the former head of the Communist Party of China on
a range of garments. The iconic portraits were used on t-shirts,

146 Vivienne Tam,
MAO dress, 1995, in
multicoloured nylon. Part
of the MAO collection
of t-shirts, dresses and
skirts, in which Tam used
images of the Chinese
communist leader to
decorate the garments
as a political critique.

suits and dresses as a political critique. However, Mao's image continues to be both revered and reviled, and Tam encountered difficulty in finding a factory to produce her designs. Shops in Taiwan refused to stock the collection while in Hong Kong angry protestors threw stones at the items on display.

The interior designer Khuan Chew (b. 1953) is the founder and lead designer of KCA International, first based in London, followed by Dubai and, in 2008, Hong Kong. Born in China, Chew studied music as well as interior architecture in the UK, and the transnational nature of her style plays out in her hotel designs and palaces, including the Burj Al Arab (Tower of the Arabs) hotel in Dubai, UAE, dating from 1999. Designed by the British architects W. S. Atkins, the building mirrors the shape of a traditional sailing vessel or *dhow*. Chew won a competition to work on the interiors, with a design that did not copy Modernist, Western prototypes but used sources from the heritage of the Gulf region combined with elements of luxurious Art Deco and Baroque.

Neri Oxman (b. 1976) heads The Mediated Matter Group, part of the Media Laboratory at the Massachusetts Institute of Technology (MIT), which researches the ways in which natural forms and growth patterns can be harnessed using digital technology for the production of design artifacts. Born in Israel, Oxman studied at the AA in London, graduating in 2004, after which she undertook a PhD at MIT, studying the interrelationship between materials and natural processes. This grew into the Mediated Matter Group, which launched in 2010. Their projects include The Silk Pavilion (2013) made by 6,500 silkworms, which provided data for building similar structures, and, in 2016, animal masks for the singer Björk. Oxman's work was celebrated in a MOMA New York exhibition, 'Material Ecology', in 2020.

Patricia Urquiola (b. 1961) is a Spanish-born, Italy-based designer who has succeeded in challenging the norms of the design industry. She graduated from the Politecnico di Milano (Milan Polytechnic) in 1989, where she taught briefly before going to work with Vico Magistretti for De Padova, an Italian furniture company founded by Fernando and Maddalena de Padova (1928–2016) in 1956. De Padova had begun by importing Scandinavian and Eames furniture to Italy, and soon branched out to work with contemporary designers. Widowed in 1967, Maddalena continued to run the business alone and was an important role model for Urquiola, who designed the mid-century modern Flower Chair for the company in 1996, the year she left. From De Padova, she transferred to a role as head of design at Lissoni Associati, where she created designs for Alessi,

147

148

147 OPPOSITE Khuan Chew, interior design of the Burj Al-Arab Hotel, Dubai, 1999. The Skyview Bar sits on the twenty-seventh floor, at the tip of the sail form that defines this world-class hotel. A sense of luxury is created by the vibrant colour palette, glossy materials and picture windows.

148 ABOVE Neri Oxman, 'Material Ecology' exhibition, Museum of Modern Art, New York, 2020. The structure formed by silkworms can be seen to the right, part of a manifesto representing Oxman's approach, which fuses biology and technology.

Cassina and Kartell, among others. In 2001, Urquiola opened her own design studio, and worked in particular with Patrizia Moroso, art director of the Morosa family furniture company. It was during this time that Urquiola felt able to express a more feminine approach to chair design, incorporating a softer, more homely aesthetic. Designs such as the Tropicalia daybed for Moroso secured her position as an international creative force in design. The lounger is designed for outdoor use, and has a painted stainless steel structure in a cradle shape, with multicoloured polymer cord woven around it to disguise the frame and a foam mattress covered in light pink and textured cushions. It was a complete departure from the monochrome office chairs that typified classic Modernism. Urquiola is also concerned with environmental issues and in 2014 worked with the Spanish textiles company GAN to produce a sustainable felt from scraps of fabric leftover from wool production. The speckled, thick material is deliberately irregular in appearance,

a feature that Urquiola sees as a positive for the creation of rugs and a pouffe. In 2016, Urquiola joined Cassina as art director; in that same year she designed one of her most powerful pieces, the Gender Armchair. Based loosely on the Eames' Easy Chair, it introduces more colour and texture into the design, which comes in several colourways. It has a curved, tubular steel frame that is sensuous as well as solid, and is covered in a slick mixture of contrasting leather and fabric. The chair has a headrest that leans back fifteen degrees, and the matching footstool affords extra comfort.

149

Urquiola is, as her 2014 project with GAN showed, concerned with using scrap materials and rescuing them from landfill. The architectural partnership of Anne Lacaton (b. 1955) and Jean-Phillippe Vassal (b. 1954) supports such rescue on a grand scale, seeking to re-use existing buildings rather than demolishing them and replacing them with new-builds. The pair studied at the School of Architecture in Bordeaux and established Lacaton & Vassal in 1987. Since then, they have undertaken projects around the world, including the redesign

of a public square in Bordeaux for which their advice was not to demolish and rebuild, but to add new gravel. As Lacaton explained: 'Demolishing is a decision of easiness. It is a waste of energy, a waste of material, and a waste of history. Moreover, it has a very negative social impact. For us, it is an act of violence.' Lacaton & Vassal were awarded the Pritzker Architecture Prize in 2021; notably, the award came to them as an equal partnership, unlike that of Denise Scott Brown and Venturi (see p. 130).

While women such as Lacaton, Urquiola, Oxman, Hadid and Jongerius have succeeded in breaking into the masculine sphere of design, the writer Caroline Criado Perez (b. 1984) has succeeded in revealing the ways in which ours is often not only a man-made world, but a world made *for* men, with little regard for the physicality and needs of women. Her book *Invisible Women: Exposing Data Bias in a World Designed for Men* was first published in 2019, to widespread acclaim. She writes: 'Seeing men as the human default is fundamental to the structure of human society. It's an old habit and it runs deep – as deep as theories of human evolution itself.' Perez demonstrated the design bias of objects from piano keyboards, cars through to Apple i-Phones which were designed around the male body as a given, making them awkward, or even more dangerous, for women to use. The book's UK cover was

150

149 OPPOSITE Patricia Urquiola, Gender Armchair, for Cassina, 2016. Available in seven colours with contrasting leather trim, the chair's sensuous profile envelops the sitter and also tilts back for added comfort. 150 RIGHT Sophie Harris, book cover for Caroline Criado Perez's *Invisible Women* (2019). The prominent male pictogram largely obscures the female symbol behind, encapsulating the central argument of the book about women being overlooked in the design process.

Design Activism

179

designed by Sophie Harris (b. 1993), and consists of green male pictograms raining down, with no women in sight. Hannah Rozenberg's (b. 1993) award-winning 'Building Without Bias' RCA student project highlighted the gender bias of Artificial Intelligence (AI) and its coding of words. Rozenberg discovered that the words 'architect', 'steel', 'cement' and 'screw' were associated with men and 'tearoom', 'kitchen' and 'nursery' with women. She succeeded in revealing one of the inherent biases of AI, which is still frequently assumed to be neutral on matters such as gender and race. Katrine Marçal (b. 1983) has further demonstrated the deep-seated and restrictive gender assumptions at work in the history of technology and innovation in *Mother of Invention: How Good Ideas Get Ignored In An Economy Built for Men* (2021).

Perez, Rozenberg and Marçal have made visible the invisible presence of women in data and design, and a number of designers are working to move past or blend gender differences, chiming with more fluid conceptions of gender as 'spectrum' rather than 'divide'. Non-binary and gender-fluid identities are increasingly a part of the mainstream, and designers such as Gucci and Harris Reed now include gender-neutral or androgynous offerings. In 2021, Indy Mellink (b. 1997), a forensic psychology graduate from the Netherlands, designed a set of gender- and race-neutral playing cards, GSB, challenging the normalized hierarchy of kings trumping queens. What of the future?

151

151 LEFT Indy Mellink, GSB Gender Neutral Playing Cards, 2021. This ingenious set of cards replaces the usual King, Queen and Jack with gold, silver and bronze, challenging existing hierarchies in these everyday objects.
152 OPPOSITE An example of 'jugaad', an Indian 'hack' approach to design whereby ingenious solutions to problems are crafted, mainly by women. Here, a plastic bottle is attached to an outside tap to create a supply of water for a pipe.

In 2020, Cheryl Buckley argued that the impetus for a feminist study of design history has declined, with publications in the *Journal of Design History*, for example, featuring few examples. Buckley sees the reason for this as the apparent disjuncture between design practice and design history. It could also be argued that the journal has privileged a transnational focus over a feminist agenda. Design History Society conferences now take place in India, the US, Norway and Switzerland, in an example of cross-cultural exchange that can only be of benefit. The Western bias of design history has been also challenged by the impetus to decolonize the design (and wider) curriculum, which has gained momentum as a result of campaigns for racial justice such as Black Lives Matter. Research is now underway into cultural exchanges that reveal the history of slavery in relation to design; for example, displays at the Victoria and Albert Museum in Dundee explore the complex narratives of colonization and class surrounding paisley fabrics.

More quotidian relationships between women and design, an important part of feminist design history, are also being more widely researched. In India, particularly in the northern part of the country, the Hindi word 'jugaad' means a 'quick-fix' solution or 'hack' usually born out of necessity, using materials available to those who are living subsistence lives. Perhaps the most public manifestation of this is the adjustments made to road vehicles to accommodate more passengers. But

the practice is also carried out by women within the home, to address the everyday problems of leaking taps or faulty home appliances for those with few resources. As Rina Arya has argued, this term has been appropriated by the world of management studies to stand for entrepreneurship on a global scale, thus obliterating its roots in the role of women in design.

In Australia, design research has focused on the legacy of colonialism and the exploitation and marginalization of Aboriginal Australians and Torres Strait Islanders. Alice Hinton-Bateup (b. 1950), an Aboriginal woman and design activist, was, like many Aboriginal children, taken from her birth family at eleven months old to be institutionalized by European Australians. She entered service as a maid at the age of fifteen. In the 1980s, she trained in screenprinting at Garage Graphix Community Art Workshop, which was founded in Sydney in 1981, and began working with them in 1983. She produced striking political posters, including *Dispossessed* (1985) and *Peace* (1986), which drew attention to the Aboriginal loss of their traditional lands, a crucial part of their heritage and understanding of their place in the world.

The next stage of research and development on women in design might be a feminist approach within a transnational, postcolonial framework. Together, the two perspectives can be woven together as the warp and weave of history: a case of *both/ and*, rather than *either/or*. In one example of this, the 2021–22 exhibition at the Vitra Design Museum in Germany, 'Here We Are! Women in Design 1900–Today' highlighted the work of eighty women, including the Matri-Archi(tecture) collective. Founded by architectural designers Khensani de Klerk and Solange Mbanefo, the collective is based between Switzerland and Africa and aims to highlight the role of women working in African architecture. Through activism and a particular emphasis on spatial education, the intersectional group seeks to challenge existing hegemonies.

The main challenge facing the world over the coming decades is its survival. With global heating and the challenges of sustainability, the future of design is about the future of the planet. The built-in obsolescence of the motor industry, fast fashion and disposable plastic products can no longer be supported. Designers such as Stella McCartney (b. 1971) have used their design work to promote sustainability at the top end of the market. McCartney has undertaken research into using plant-based materials rather than those derived from animals, and innovative technology to reuse waste materials. Her design philosophy is contained in her *A to Z manifesto*, in which 'Z' stands for Zero Waste.

Another woman to lead the way in terms of sustainable design is the English sailor and charity founder Ellen MacArthur, who has established a foundation to promote the value of circular design, whereby no waste is generated. In 2016, the Ellen MacArthur Foundation launched the New Plastics Economy to encourage the elimination of single-use plastic products. So far, over 1,000 organizations have signed up to the initiative. Overall, however, what is needed is a new attitude to consumerism and a realignment of what and who design is for. In 2018, the UK produced a total of 222.2 million tonnes of waste. Aside from the efforts of designers, consumer action can also have an impact upon reducing such figures, and in this arena, too, women have found significant and increasing agency.

In the twenty-first century, women in design are ever more visible and successful; but despite improvements since the end of the nineteenth century, where this book begins, the statistics still stack up against women realizing their ambitions or reaching the upper echelons of the design profession. According to a 2021 report by the World Economic Forum, the Covid-19 pandemic has had a 'a scarring effect on future economic opportunities for women, risking inferior reemployment prospects and a persistent drop in income'. The pressures of childcare and home-schooling for women with children, for example, have created unexpected pressures on time and energy that detract from the world of work.

Women have emerged from the shadows of their partners or employers, and receive equal star billing in design history. By and large, women now have the same access to design education; but the power of patriarchy still remains in place, with the digital assistant Alexa, there to serve your every need, specified as female. Design is a tool that can improve and shape our everyday lives and enhance our experiences, and a more inclusive approach to this process can only act as a catalyst for the best of futures.

Select Bibliography

Kirkham, Pat (ed.), *The Gendered Object*
(Manchester, 1996)
Kirkham, Pat (ed.), *Women Designers in the USA:
Diversity and Difference* (New Haven and
London, 2000)
Massey, Anne, *Interior Design Since 1900* (London,
2020)
Sellers, Libby, *Women Design: Pioneers in
architecture, industrial, graphic and digital
design from the twentieth century to the present-
day* (London, 2018)
Sparke, Penny, *As Long as It's Pink: The Sexual
Politics of Taste* (Nova Scotia, 1995; revised
edition 2010)
Trant, Caroline, *Voyaging Out: British Women Artists
From Suffrage to the Sixties* (London, 2019)
Wilson, Elizabeth, *Adorned in Dreams: Fashion
and Modernity* (London, 1985)

General

Anscombe, Isabelle, *A Woman's Touch: Women in
Design From 1860 to the Present Day* (London,
1984)
Ash, Juliet and Elizabeth Wilson (eds), *Chic
Thrills: A Fashion Reader* (London, 1992)
Attfield, Judy, 'FORM/female FOLLOWS
FUNCTION/male: Feminist Critiques of
Design', in Walker, John (ed.), *Design History
and the History of Design* (London, 1989),
pp. 199–225
Attfield, Judy and Pat Kirkham (eds), *A View from
the Interior: Feminism, Women and Design*
(London, 1989)
Buckley, Cheryl, 'Made in Patriarchy: Toward a
Feminist Analysis of Women and Design',
Design Issues Vol. 3 No. 2, 1986
Chadwick, Whitney, *Women, Art, and Society*
(London and New York, 2020)
Darling, Elizabeth and Nathaniel Robert Walker
(eds), *Suffragette City: Women, Politics and
the Built Environment* (London and New York,
2019)
Darling, Elizabeth and Lesley Whitworth (eds),
*Women and the Making of Built Space in
England, 1870–1950* (London and New York,
2007)
'The Design Economy', British Design Council
https://www.designcouncil.org.uk/what-
we-do/research/design-economy [Accessed
18/8/2021]
Fiell, Charlotte and Clementine Fiell, *Women in
Design: From Aino Aalto to Eva Zeisal* (London,
2019)
Forty, Adrian, *Objects of Desire: Design and Society
1750–1980* (London, 1986)

Chapter One
Shifting Barriers

Brandow-Faller, Megan, *The Female Secession:
Art and the Decorative at the Viennese Women's
Academy* (University Park, PA, 2020)
Brandstätter, Christian, Daniela Gregori and
Rainer Metzger, *Vienna 1900 Complete*
(London, 2018)
Chalmers, F. Graeme, 'The Early History of the
Philadelphia School of Design for Women',
Journal of Design History Vol. 9 No. 4, 1996,
237–52
Ferry, Emma, '"Decorators May be Compared
to Doctors": An Analysis of Rhoda and Agnes
Garrett's *Suggestions for House Decorating in
Painting, Woodwork and Furniture* (1876)', *Journal
of Design History* Vol. 16 No. 1, 2003, 15–33
Garrett, Miranda and Zoe Thomas (eds), *Suffrage
and the Arts: Visual Culture, Politics and
Enterprise* (London, 2019)
Helland, Janice, 'The Critics and the Arts and
Crafts: The Instance of Margaret Macdonald
and Charles Rennie Mackintosh', *Art History*
Vol. 17 No. 2, June 1994, 209–27
Helland, Janice, *The Studios of Frances and
Margaret MacDonald* (Manchester, 1996)
Loeb, Lori Anne, *Consuming Angels: Advertising
and Victorian Women* (Oxford, 1994)
Mason, Anna, Jan Marsh, Jenny Lister, Rowan
Bain and Hanne Faurby (eds), *May Morris: Arts
& Crafts Designer* (London, 2017)
Parker, Rozsika, *The Subversive Stitch: Embroidery
and the Making of the Feminine* (London, 2012)
Yamasaki, Akiko, 'Handicrafts and Gender in
Modern Japan', *The Journal of Modern Craft*,
Vol. 5 No. 3, November 2021, 259–74

Chapter Two
Behind the Scenes

Buckley, Cheryl, *Potters and Paintresses: Women Designers in the Pottery Industry 1870–1955* (London, 1990)

Charleston Press (eds), *Post-Impressionist Living: The Omega Workshops* (Lewes, 2019)

Evans, Caroline, *The Mechanical Smile: Modernism and the First Fashion Shows in France and America 1900–1929* (London and New Haven, 2013)

Gronberg, Tag, *Designs on Modernity: Exhibiting the City in 1920s Paris* (Manchester, 1998)

Kelly, Jessica (ed.), 'Behind the Scenes: Anonymity and Hidden Mechanisms in Design and Architecture', *Architecture and Culture* special issue Vol. 6 No. 1, 2018

Poiret, Paul, *King of Fashion: The Autobiography of Paul Poiret* (London, 1931; reissued 2009)

Protheroe, Karen, *Petal Power: Floral Fashion and Women Designers at the Silver Studio* (London, 2011)

Savoie, Alice, 'The Women Behind Times New Roman: The Contribution of Type Drawing Offices to Twentieth Century Type-Making', *Journal of Design History* Vol. 33 No. 3, July 2020, 209–24

Chapter Three
Pioneers of Modern Design

Barsac, Jacques, *Charlotte Perriand: Complete Works Volume 1: 1903–1940* (Chicago, 2015)

Barsac, Jacques, *Charlotte Perriand: Complete Works Volume 2: 1940–1955* (Chicago, 2015)

Baumhoff, Anja, *The Gendered World of the Bauhaus: The Politics of Power at the Weimar Republic's Premier Art Institute, 1919–1932* (Frankfurt-am-Main, 2001)

Colomina, Beatriz, 'Battle Lines: E1027', *Renaissance and Modern Studies* Vol. 39 No. 1, 1996, 95–105

Eggler, Marianne, 'Divide and Conquer: Ludwig Mies van der Rohe and Lilly Reich's Fabric Partitions at the Tugendhat House', *Studies in the Decorative Arts* Vol. XVI No. 2, Spring–Summer 2009, 66–90

Groot, Marjan, Helena Seražin, Caterina Franchini and Emilia Garda (eds), *MoMoWo: Women Designers, Craftswomen, Architects and Engineers between 1918 and 1945* (Ljubljana, 2017)

Henderson, Susan J., 'Housing the Single Woman: the Frankfurt Experiment', *Journal of the Society of Architectural Historians* Vol. 68 No. 3, September 2009, 358–77

Heynen, Hilde and Gulsum Baydar (eds), *Negotiating Domesticity: Spatial Productions of Gender in Modern Architecture* (Abingdon, 2005)

McLeod, Mary (ed.), *Charlotte Perriand: An Art of Living* (New York, 2003)

Rault, Jasmine, *Eileen Gray and the Design of Sapphic Modernity: Staying In* (Abingdon and New York, 2011)

Sparke, Penny, *The Modern Interior* (London, 2008)

Chapter Four
Decorating Women

Blossom, Nancy and John Turpin, 'Risk as a Window to Agency: A Case Study of Three Decorators', *Journal of Interior Design* Vol. 34 No. 1, 2008, 1–13

Boydell, Christine, *The Architect of Floors: Modernism, art and Marion Dorn designs* (Coggeshall, 1996)

Campbell, Louise, 'Eileen Agar at Home: Domesticity, Surrealism, and Subversion', *Interiors: Design, Architecture, Culture* Vol. 3, November 2012, 227–46

Connolly, Shane, *Constance Spry and the Fashion for Flowers* (London, 2021)

Elliott, Bridget and Janice Helland (eds), *Women Artists and the Decorative Arts, 1880–1935: The gender of ornament* (Aldershot, 2002)

Joel, Betty, 'A House and a Home', in John de la Valette (ed.), *The Conquest of Ugliness: A Collection of Contemporary Views on the Place of Art in Industry* (London, 1935), pp. 87–97

Kelleway, Philip, *Highly Desirable: the Zinkeisen Sisters and their legacy* (Leiston, 2008)

Massey, Anne, *Designing Liners: Interior Design Afloat* (Abingdon, 2006; second edition 2021)

May, Bridget, 'Nancy Vincent McClelland (1877–1959): Professionalizing Interior Decoration in the Early Twentieth Century', *Journal of Design History* Vol. 21 No. 1, 2008, 59–74

Metcalf, Pauline, *Syrie Maugham: Staging the Glamorous Interior* (New York, 2010)

Powers, Alan, *Enid Marx: The Pleasures of Pattern* (London, 2018)

Rault, Jasmine, 'Designing Sapphic Modernity: Fashioning Spaces and Subjects', in Alla Myselev and John Potkin (eds), *Fashion, Interior Design and the Contours of Modern Identity* (Farnham and Burlington, VC, 2010), pp. 185–203

Reed, Christopher, 'A *Vogue* That Dare Not Speak its Name: Sexual Subculture During the

Editorship of Dorothy Todd, 1922–26', *Fashion Theory* Vol. 10 Nos 1 and 2, 2006, 39–72

Robbins, Trina, *Nell Brinkley and the New Woman in the Early 20th Century* (North Carolina and London, 2001)

Svinhufvud, Leena, 'Handwoven Fabrics by the Yard: Unveiling the Modern Design Industry of the Interwar Period', in Kjetil Fallan (ed.), *Scandanavian Design: Alternative Histories* (London and New York, 2012), pp. 48–64

Sparke, Penny, *Elsie de Wolfe: the Birth of Modern Interior Decoration* (New York, NY, 2005)

Sugg-Ryan, Deborah, 'Towards an Uncensored History of Design: *Ideal Homes* and *Constance Spry* at the Design Museum, London', in Liz Farrelly and Joanna Weddell (eds), *Design Objects and the Museum* (London, New York, NY, New Delhi and Sydney, 2016), pp. 51–60

Troy, Nancy, *Modernism and the Decorative Arts in France* (New Haven, CT, 1991)

Wilk, Christopher, 'Who was Betty Joel? British Furniture Design Between the Wars', *Apollo* Vol. CXLII, July 1995

Worden, Suzette and Jill Seddon, 'Women Designers in Britain in the 1920s and 1930s: Defining the Professional and Redefining Design', *Journal of Design History* Vol. 8 No. 3, 1995, 177–93

Chapter Five
Partners in Design

Anelli, Renato, Simone Bader and Gabriela Cianciolo, *Lina Bo Bardi 100: Brazil's Alternative Path to Modernism* (Berlin, 2014)

Chadwick, Whitney and Isabelle de Courtivron (eds), *Significant Others: Creativity and Intimate Partnership* (London, 1993)

Colomina, Beatriz, 'Couplings', in 'Rearrangements: A Smithsons Celebration', *OASE* No. 51, June 1999, 22–33

Jackson, Ian, 'Tropical Modernism: Fry and Drew's African experiment', Architectural Review, 4 July 2014 <www.architectural-review.com/essays/tropical-modernism-fry-and-drews-african-experiment?tkn=1> [Accessed 21/12/2021]

Jackson, Iain and Jessica Holland, *The Architecture of Edwin Maxwell Fry and Jane Drew: Twentieth-century architecture, pioneer Modernism and the tropics* (Farnham, 2014)

Kirkham, Pat, *Charles and Ray Eames: Designers of the Twentieth Century* (London and Cambridge, MA, 1995)

Lehmann, Steffen, 'An environmental and social approach in the modern architecture

of Brazil: The work of Lina Bo Bardi', *City, Culture and Society* No. 7, 2018, 169–85

Parnell, Stephen, 'A Semi-Social Magazine: Love, Life, and Architectural Design', *Histories of Postwar Architecture* No. 6, 2021, 133–61

Penick, Monica, *Tastemaker: Elizabeth Gordon, House Beautiful, and the Postwar American Home* (London and Cambridge, MA, 2017)

Pinto, Shiromi, *Plastic Emotions* (London, 2019)

Rossi, Catharine, 'Furniture, Feminism and the Feminine: Women Designers in Post-war Italy, 1945–70', *Journal of Design History* Vol. 22 No. 3, 2009, 243–57

Scott Brown, Denise, 'Room at the Top? Sexism and the Star System in Architecture', in J. Rendell, Barbara Penner and Iain Borden (eds), *Gender Space Architecture: An Interdisciplinary Introduction* (London and New York, 2000), pp. 258–65 <online:isites.harvard.edu/fs/docs/icb.topic753413.../Brown_Sexism.pdf> [Accessed 22/7/2021]

Seddon, Jill, 'The Architect and the "Arch-Pedant": Sadie Speight, Nikolaus Pevsner and "Design Review"', *Journal of Design History* Vol. 20 No. 1, 2007, 29–41

Shoshkes, Ellen, *Jaqueline Tyrwhitt: A Transnational Life in Urban Planning and Design* (London and New York, 2016)

'Women at the hfg Ulm' <http://www.frauen-hfg-ulm.de/index.html> [Accessed 13/7/2021]

Chapter Six
Brand New Women

Aav, Marianne, *Marimekko: Fabrics, fashion, architecture* (New Haven, CT, and London, 2003)

Bartal, Ory, *Critical Design in Japan: Material Culture, Luxury and the Avant Garde* (Manchester, 2020)

Brook, Tony, Andrew Shaughnessy and Paula Scher, *Paula Scher: Work* (London, 2017)

Clarke, Alison J., *Tupperware: The Promise of Plastic in 1950's America* (Washington DC, 1999)

Greiman, April, *Something For Nothing* (Hove, 2001)

Hulanicki, Barbara, *From A to Biba* (London, 1983)

Martin, Earl, Paul Makovsky, Bobbye Tigerman, Angela Völker and Susan Ward (eds), *Knoll Textiles, 1945–2010* (London and New Haven, CT, 2011)

Quant, Mary, *Quant by Quant* (London, 1966)

Reinfurt, David, Robert Wiesenberger, Lisa Strausfeld and Nicholas Negroponte, *Muriel Cooper* (Cambridge, MA, 2017)

Tigerman, Bobbye '"I Am Not a Decorator":
 Florence Knoll, the Knoll Planning Unit and
 the Making of the Modern Office', *Journal of
 Design History* Vol. 20 No. 1, 2007, 61–74
Tyne & Wear Museums, *BIBA: the Label: the
 Lifestyle: the Look* (Newcastle-upon-Tyne, 1993)
Vignelli, Massimo, *Designed by: Lella Vignelli*
 (Rochester, NY, 2014) <https://www.rit.edu/
 vignellicenter/sites/rit.edu.vignellicenter/files/
 documents/Designed%20by%20Lella.pdf>
 [Accessed 30/07/2021]

Chapter Seven
Design Activism

Antonelli, Paola (ed.), *The Neri Oxman: Material
 Ecology Catalogue* (New York, NY, 2020)
Arya, Rina, 'Jugaad: A study in Indian ingenuity
 and improvisation', 9 March 2020 [Accessed 12/8/2021]
Buckley, Cheryl, 'Made in Patriarchy II:
 Researching (or Re-Searching) Women and
 Design', *Design Issues* Vol. 36 No. 1, Winter
 2020, 19–29
Darling, Elizabeth and Lynn Walker, *AA Women in
 Architecture 1917–2017* (London, 2017)
Spare Rib archive, British Library <https://www.
 bl.uk/spare-rib> [Accessed 6/08/2021]
de Bretteville, Sheila Levrant, 'Some Aspects
 of Design from the Perspective of a Woman
 Designer', *Icographic* No. 6, 1973, 4–11
Flood, Catherine and Gavin Grindon (eds),
 Disobedient Objects (London, 2014)
Matrix, *Making Space: Women and the Man-
 Made Environment* (London and Sydney,
 1984)
Mauriere, Patrick, *Androgyne: Fashion and Gender*
 (London, 2017)
Moran, Anna and Sorcha O'Brian (eds), *Love
 Objects: Emotion, Design and Material Culture*
 (London, New Delhi, New York, NY, and
 Sydney, 2014)
St John, Nicola, 'Australian Communication
 Design History: An Indigenous Retelling',
 Journal of Design History Vol. 31 No. 3, 2018,
 255–73
Tam, Vivienne, *China Chic: A personal journey
 through Chinese Style* (New York, 2006)
Triggs, Teal, 'Graphic Design', in Fiona Carson
 and Claire Pajaczkowska (eds), *Feminist Visual
 Culture* (Edinburgh, 2000), pp. 147–70
Walker, Lynne (ed.), *Women Architects: Their Work*
 (London, 1984)

Acknowledgments

I would like to thank Roger Thorp at Thames &
Hudson for his invaluable help with developing
the proposal from the very beginning. Thanks
to Kate Edwards for informed and diligent
editing, Anabel Navarro for the excellent picture
research, Mohara Gill for support throughout the
process and production controller Poppy David,
for making it happen. To Rina Arya, Harriet
Atkinson, Elizabeth Darling, Zoe Hendon, Jessica
Kelly, Stephen Parnell, Keren Protheroe, Libby
Sellers and Patricia Tzortzopoulos for help with
queries, general inspiration and support. For
their unstinting enthusiasm for the project,
thanks are due to my sister Judith Massey, and
to my daughters, Louise Tullin and Amy Dixon.
Finally, gratitude to my partner Jimmy for his
unfailing support and encouragement.

Illustration List

1 Hodder/ANL/Shutterstock
2 National Museums Scotland
3 Victoria and Albert Museum, London. Given by Mrs. F. W. Templeton
4 © National Trust Images/Andreas von Einsiedel
5 Cooper-Hewitt, Smithsonian Design Museum, New York. Smithsonian Design Library
6 Courtesy of Kelly Hayes McAlonie, FAIA
7 Library of Congress Prints and Photographs Division Washington, D.C.
8 Shawshots/Alamy Stock Photo
9 © Museum of London/Bridgeman Images Reproduced with permission of Helen Pankhurst on behalf of the Pankhurst family
10 Caroline Marsh Watts, *The Bugler Girl*, 1908
11 Pictorial Press Ltd/Alamy Stock Photo
12 William Morris Gallery, London Borough of Waltham Forest, London
13, 14 © CSG CIC Glasgow Museums Collection/Bridgeman Images
15 Photo Victoria and Albert Museum, London
16, 17 Museum of London
18 © CSG CIC Glasgow Museums Collection/Bridgeman Images
19 Glasgow School of Art Archives and Collections
20 Private Collection. Bridgeman Images
21 Courtesy bel etage, Wolfgang Bauer, Vienna
22 Granger Historical Picture Archive/Alamy Stock Photo
23 Imagno/Getty Images
24 © Galerie bei der Albertina – Zetter, Wien
25 Look and Learn/Valerie Jackson Harris Collection/Bridgeman Images
26 Philadelphia Museum of Art. Purchased with the Costume and Textiles Revolving Fund, 2016
27 Winifred Gill and Nina Hamnett modelling dresses at the Omega Workshops, *c.* 1913
28 Vanessa Bell © Estate of Vanessa Bell. All rights reserved, DACS 2022. Duncan Grant © Estate of Duncan Grant. All rights reserved, DACS 2022
29 Photo The Art Institute of Chicago/Art Resource, NY/ Scala, Florence, 2022 © Estate of Vanessa Bell. All rights reserved, DACS 2022
30, 31, 32 Museum of Domestic Design & Architecture, Middlesex University, London
33 DeAgostini/Al Pagani
34 Courtesy of the U.S. Government Publishing Office
35 Monotype archives, Massachusetts
36 Bruun Rasmussen Auctioneers, Copenhagen
37 Wedgwood® Fiskars, Barlaston, Stoke-on-Trent, ST12 9ER, England Fiskars/Victoria and Albert Museum, London
38 Bonhams, London, UK/Bridgeman Images
39 Robert Bird Photography/Bridgeman Images
40 The Metropolitan Museum of Art, New York Photo The Metropolitan Museum of Art/Art Resource/Scala, Florence, 2022
41 Illustrated London News Ltd/Mary Evans
42 Granger Historical Picture Archive/Alamy Stock Photo
43 Swann Galleries, New York
44 © Pracusa 20211004
45 Bauhaus-Archiv/Museum für Gestaltung, Berlin
46 Bauhaus-Archiv Berlin © Estate of T. Lux Feininger. Photo T. Lux Feininger
47 Photo © President and Fellows of Harvard College. Stölzl © DACS 2022
48 Leon Neal/AFP/GettyImages
49 The Metropolitan Museum of Art, New York. Purchase, Everfast Fabrics Inc. and Edward C. Moore Jr. Gift, 1969. © The Josef and Anni Albers Foundation/Artists Rights Society (ARS), New York and DACS, London 2022
50 Photo Helen Margaret Post. © Amon Carter Museum of American Art
51 Bauhaus-Archiv/Museum fur Gestaltung, Berlin. Marianne Brandt © DACS 2022
52 INTERFOTO/Alamy Stock Photo
53 Štenc archiv, Prague, Czech Republic
54 The Museum of Modern Art (MoMA), New York. Mies van der Rohe Archive, gift of the architect. Digital image 2022, The Museum of Modern Art, New York/Scala, Florence
55 Photo Hermann Collischonn. © Collection and Archive, University of Applied Arts, Vienna

Index